IMAGES
of America

SCHENECTADY

IMAGES
of America

SCHENECTADY

Susan Rosenthal

ARCADIA
PUBLISHING

Published by Arcadia Publishing
Charleston, South Carolina

Library of Congress Catalog Card Number: 2004114583

For all general information contact Arcadia Publishing at:
Telephone 843-853-2070
Fax 843-853-0044
E-mail sales@arcadiapublishing.com
For customer service and orders:
Toll-Free 1-888-313-2665

Visit us on the Internet at www.arcadiapublishing.com

CONTENTS

ACKNOWLEDGMENTS

Books dealing with the past do not happen without much cooperation. The author has been very fortunate in having received a lot of assistance and would be remiss in failing to acknowledge the generosity of the following people who gave freely of their time and information:

Maureen Gebert of the Schenectady Heritage Area, who not only spearheaded and guided the project from its conception but also did a large part of the research throughout;

Scott Haefner, who spent hours reviewing the work and checking the facts, provided many interesting insights into Schenectady's past, and lent photographs from his collection;

Don Hulett, archivist of the city's Efner History Research Center, who assisted with information and provided many photographs;

Larry Hart, city/county historian, for his cooperation, the loan of photographs from his vast collection, and the wealth of knowledge contained in his many existing books on Schenectady;

The research committee that labored on the earliest beginnings of this project—George Marshall, John Alois, and Paul Heckman, who earned special thanks for his countless hours spent collecting material.

In addition, many thanks go to the following individuals and groups: The office of Mayor Al Jurczynski, for cooperation and the loan of images of previous mayors; Laura Linder and Elmer Priess and the Schenectady Museum Hall of Electrical History; Elsie Maddaus, Bill Dimplefield, and Virginia LaGoy and the Schenectady Historical Society; Betty Allen and Ellen Fladger of the Special Collections at Schaffer Library, Union College; Rosemary Taylor, director of the YWCA; the Dutch Reformed Church; and Frank Karwowski, historian of St. George's Masonic Lodge.

Thanks also go to Jane Weyers and the Schenectady Chamber of Commerce; Matthew Moross and the Schenectady Civic Players; Kathy Jarvis, Gloria Lamere, and Proctor's Theater; Barbara Walton, Heather Meany, Nancy Heller, and the Schenectady County Community College; and, of course Ralph Rosenthal.

INTRODUCTION

Situated amongst the towns of New York State's Heritage Corridor, Schenectady began as an early outpost to the fur trade in the west and as an agricultural society. Its location on two major water transportation routes—the first a natural one, the Mohawk River, and the second man-made, the Erie Canal—enabled the community to develop and grow. An early example of this growth was the thriving boat-building business of Durham boats along Schenectady's Binnekill.

Schenectady experienced both long periods of slow, measured development and shorter periods of rapid expansion. By the 1780s, new streets were being created, pushing Schenectady's boundaries past their old limits. It was no longer a community of Dutch burghers; many nationalities were now present. New settlers came from the ranks of those who had fought for the British in the French and Indian wars; they also included British soldiers who stayed after the fighting rather than returning home.

After the Civil War, Schenectady shared in the nation's Golden Era, from 1880 to 1920. This period was one of astounding growth in all areas of community life: industry and commerce flourished, large elegant homes were constructed, and entire neighborhoods were built to house the work force. The era closed forever the chapter of agrarian heritage and opened the new one of industrialization.

The old broom factories and grain mills of Schenectady were now joined by knitting mills, paint works, marble works, and carriage and sleigh builders. Numbers of new businesses started small and disappeared. Others, such as the Schenectady Locomotive Works and Thomas Edison's Electric Machine Works, mushroomed into large enterprises employing many people and having a significant impact on the development of the nation as a whole. The construction in Schenectady of the turret for the ironclad ship *Monitor* during the Civil War was but a precursor to ALCO's building of hundreds of M7 tanks and General Electric's contributions in radio and radar equipment during World War II.

In 1998, Schenectady celebrated the bicentennial of its charter. Signed on March 26, 1798, the charter came close on the heels of a difficult period of national upheaval, the American Revolution. Schenectady became the third incorporated city in the state of New York. When the charter was signed, the city was 12 miles long by 18 miles wide—much larger than the stockaded settlement of some 300 people and 60 houses that existed at the time of the 1690 massacre.

In the past two centuries, much has changed. The cobblestone streets, the horses and their watering troughs, the gaslights, the trolley cars, and the neighborhood theaters are gone.

Television, which was first broadcast from the old WGY studios, and video have replaced mass public entertainment. The automobile and, in some cases, the computer have enabled residents to live far from where they work. Shopping malls, with ample parking and expanded hours, have turned shoppers away from downtown stores.

As our needs and the manner in which we live change, so do our cities. No city exists in a vacuum. We must accept this reality, recognize the city's importance in our life, and move forward together to discover new roles the city can play.

At the same time, we should not forget the past. We need the past to entertain and to instruct us. One way we keep the past alive is by revisiting the wonderful resources we have available: the Efner History Research Center at City Hall, the Schenectady Historical Society, the Special Collections at Union College's Schaffer Library, the Schenectady County Public Library, and the Hall of Electrical History at the Schenectady Museum. Wherever and whenever possible, we should support these resources through membership and donations of photographs, paintings, and memorabilia for future generations to enjoy.

—*Susan Rosenthal*

One

THE EARLY DAYS

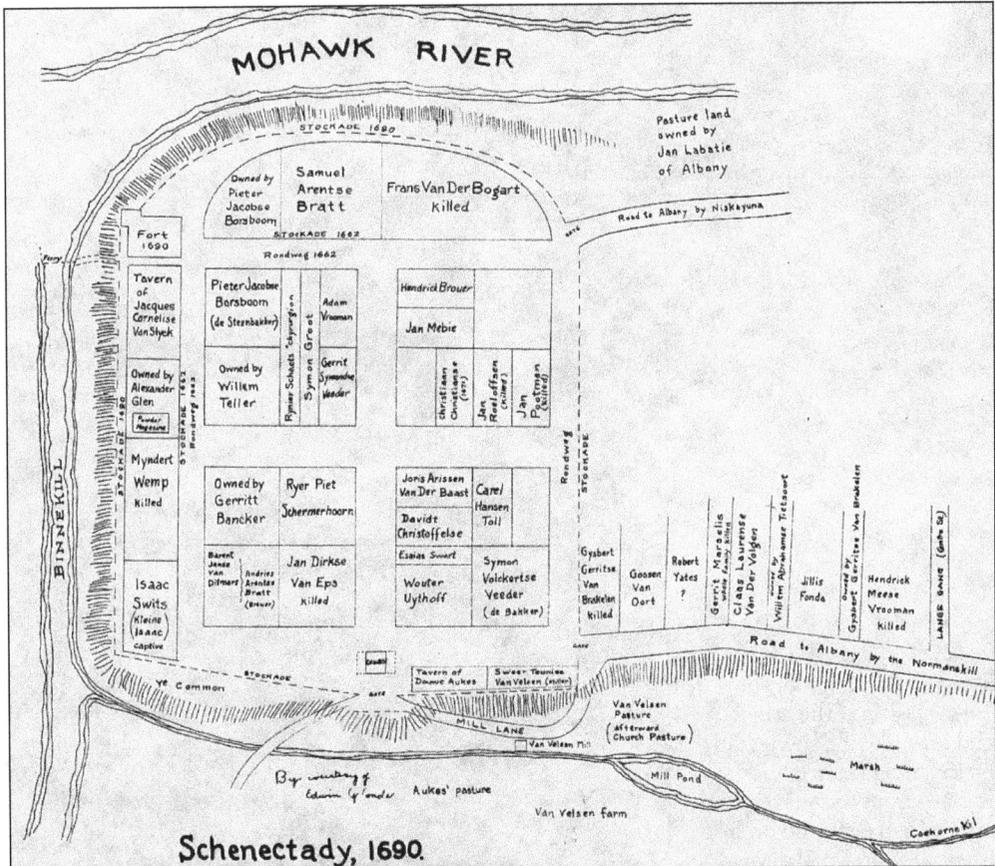

This map shows the Dutch village of Schenectady at the time of the 1690 massacre, with dwellings located both inside and outside the stockaded area. Drawn in 1936 by local historian Edwin G. Conde, the map represents the area some 30 years after its founding and also shows the boundaries of 1662. (Courtesy of Edwin G. Conde Estate/Efner History Research Center.)

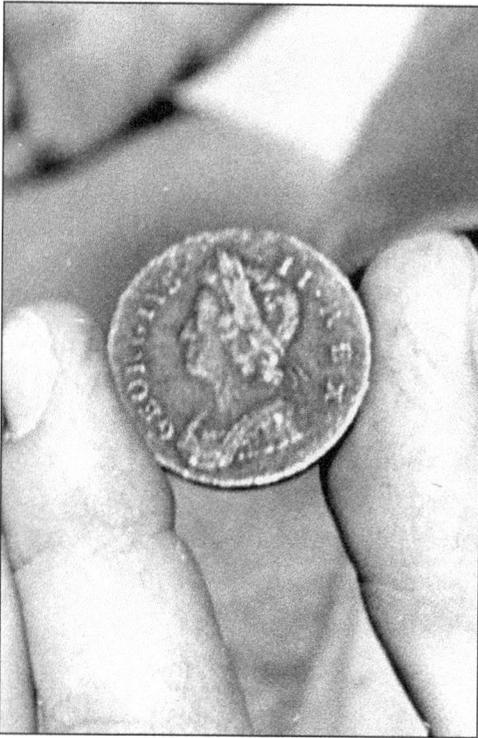

Dutch, British, and American flags have all flown over Schenectady. Not until after the Revolutionary War was there a Continental currency. The only sound money in circulation was hard coin of the British, French, or Spanish. This British coin of the 1730s was discovered in the area of North Church and Front Street in a 1972 dig. (Efner History Research Center.)

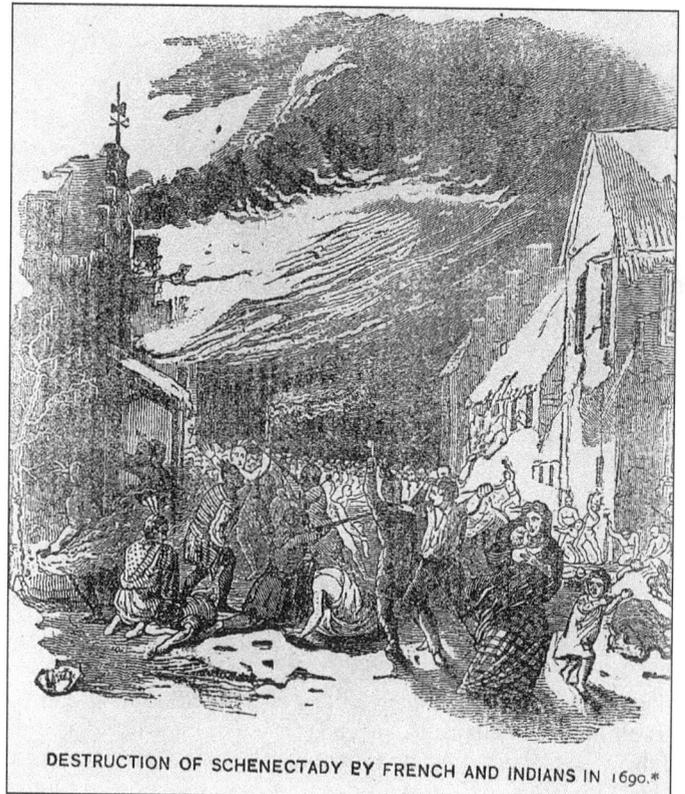

This is a depiction of the 1690 massacre, the attack and burning of Schenectady by invading French and Indians from the north. The raid, which occurred on a freezing winter night, was part of the French's third attempt to take over North America. (Efner History Research Center.)

DESTRUCTION OF SCHENECTADY BY FRENCH AND INDIANS IN 1690.*

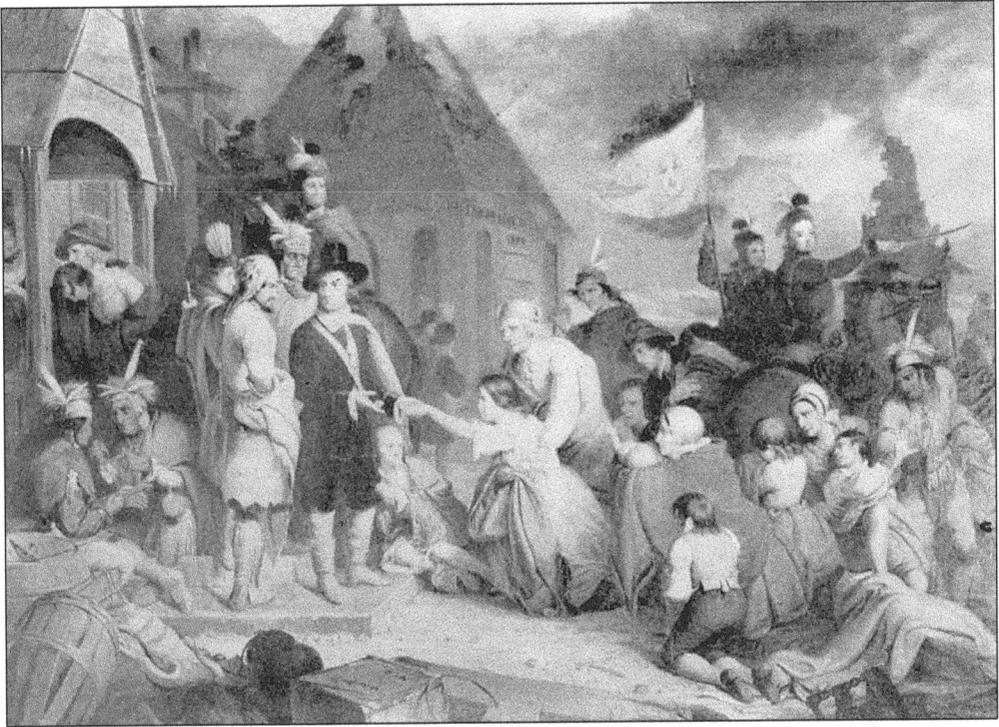

On Sunday, February 9, 1690, the morning after the stockade massacre, Capt. John A. Glen claimed as many prisoners as possible as his "relatives" to obtain their release from their captors. This scene is from Tompkins H. Matteson's painting, c. 1840. (Efner History Research Center.)

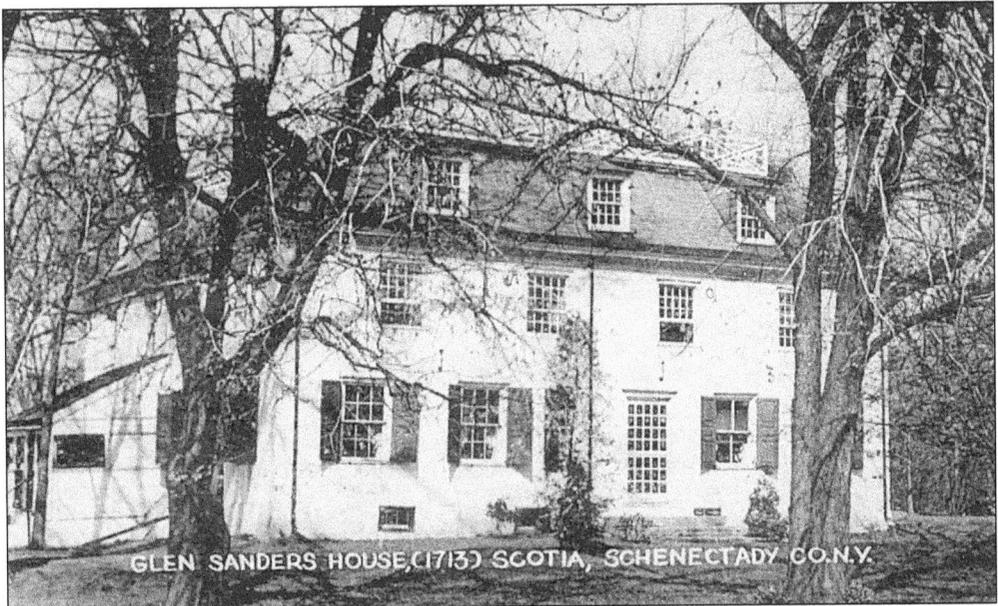

GLEN SANDERS HOUSE,(1713) SCOTIA, SCHENECTADY CO.N.Y.

This was the home of John A. Glen, who was instrumental in saving many lives after the massacre. The Glens and Sanders were the earliest settlers in the area. Located across the river in Scotia, Glen's house originally stood adjacent to the Mohawk River but had to be moved to higher ground due to flooding. (Efner History Research Center.)

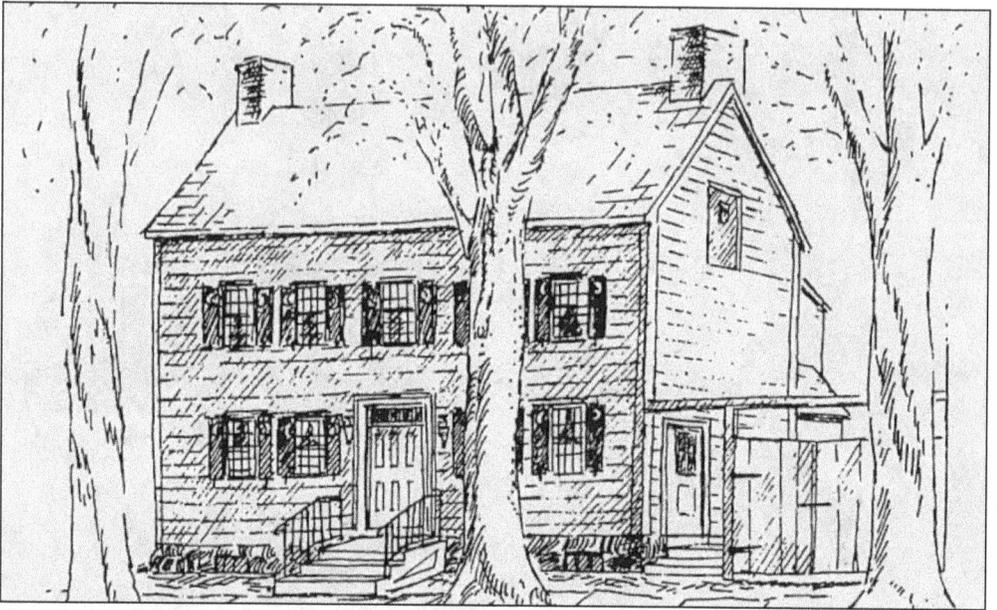

The Hendrick Brouwer House was one of the earliest homes in the former stockaded area. Built in the late 1600s, the house was owned by a fur trader, whose fair dealings with the Indians probably spared it from being burned in the massacre. It is likely that parts of the original house are incorporated into the present structure at 14 North Church Street. The house possesses several secret rooms. (Drawing by Janet Winter/Courtesy of the Schenectady Museum.)

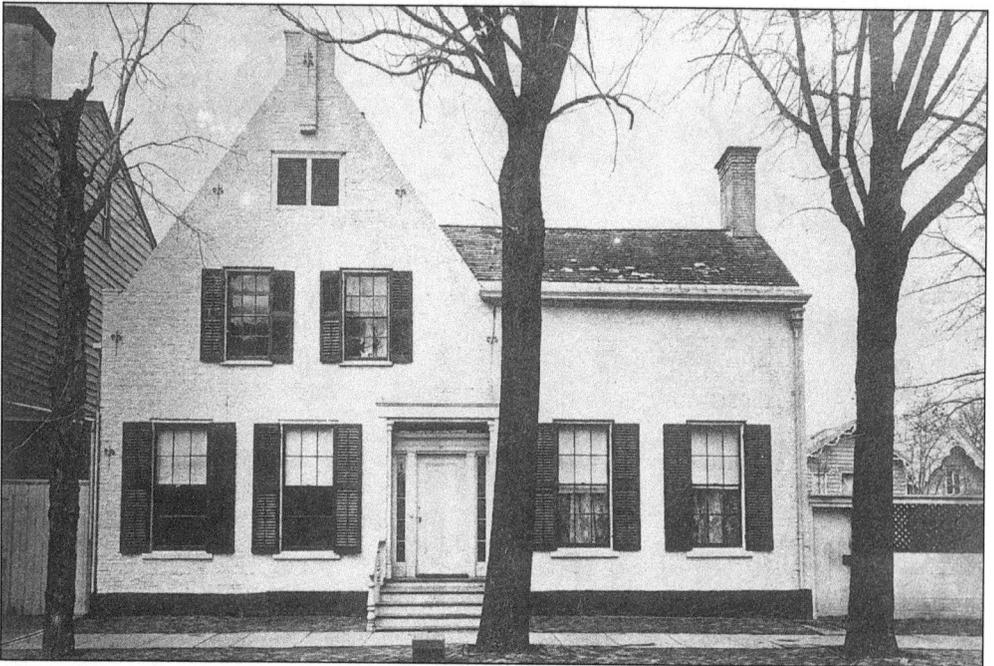

The Abraham Yates House was built c. 1700 on the site of Jan Roeleffson's home, which was burned in the 1690 massacre. Located at 109 Union Street, the Yates House is one of the oldest dwellings in the city and is a fine example of early Dutch architecture. (Efner History Research Library.)

The First Reformed Church was dedicated in 1734. Here the Sons of Liberty gathered and Gen. George Washington paused to worship during his 1782 visit. The building was the third to house the church, located at the corner of Church and Union Streets. In 1814, it was replaced by a new church on the same site following a destructive fire. (J.W. McMurray drawing/Efner History Research Center.)

St. George's Episcopal Church, the second oldest church in the city, was designed by Samuel Fuller and built between 1759 and 1763. It was used as a hospital, barracks, and stable during the Revolution. This 1954 photograph shows the church before its alterations of the mid-1950s. (Efner History Research Center.)

The John Glen House was built *c.* 1775. It was owned by John Glen, Deputy Quartermaster of the army, who was stationed in Schenectady during the Revolutionary War. Gen. George Washington slept in the northeast second-floor bedroom. Since that time, the house has had a number of expansions both up and out. This photograph shows the house, located at 58 Washington Avenue, as it appeared in the 1930s. (Efner History Research Center.)

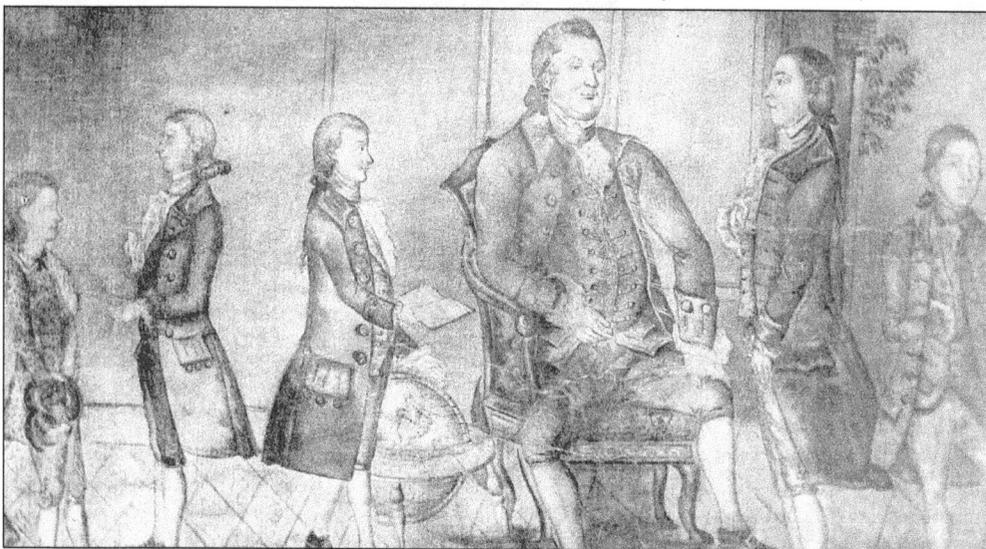

A pen and ink drawing *c.* 1785 shows Col. Christopher Yates, a great patriot of the Revolutionary War, seated probably at his 26 Front Street home. Joseph Yates, about 17 years old, is pictured to his father's immediate left; farther left are brothers Andrew and Henry; and to Yates's right are his nephews Myndert and Andrew Wemple. The drawing is attributed to the tutor employed by Yates. (Efner History Research Center.)

14

Joseph C. Yates served as Schenectady's first mayor at the time of the charter. Appointed by the governor, Yates served one-year terms from 1798 to 1808. Mayors did not become elected officials until 1860. One of the early acts of the first mayor and the new Schenectady Common Council was to decree that new city streets be developed to the south and east beyond the boundaries of the former stockade, which had been torn down at the close of the war. Yates later became the seventh governor of New York State. (Efner History Research Center.)

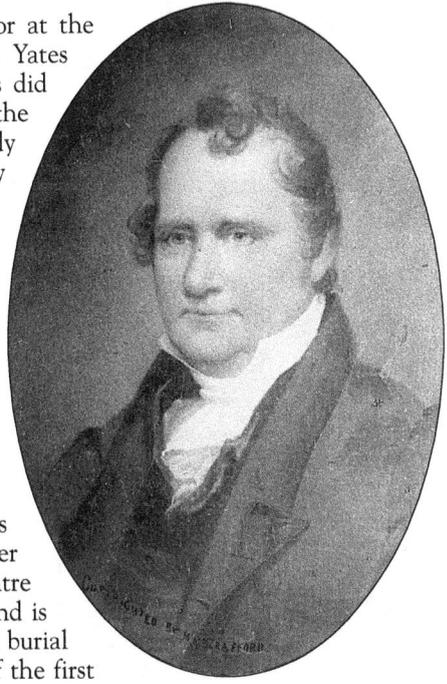

A map representing the boundaries at the time of the charter of 1798 does not show the stockaded area that appears on the 1690 map (see p. 9). Many new streets have been added and some older streets have new names. Today, the Mill Creek no longer flows under Water Street. Maiden Lane became Centre Street and later Broadway. The Dutch Burial Ground is located between Front and Green Streets. The first burial grounds had been in the village on the west side of the first Dutch church at State and Church Streets. Niskayuna Street had been changed in 1795 in honor of the newly formed Union College. (Efner History Research Center.)

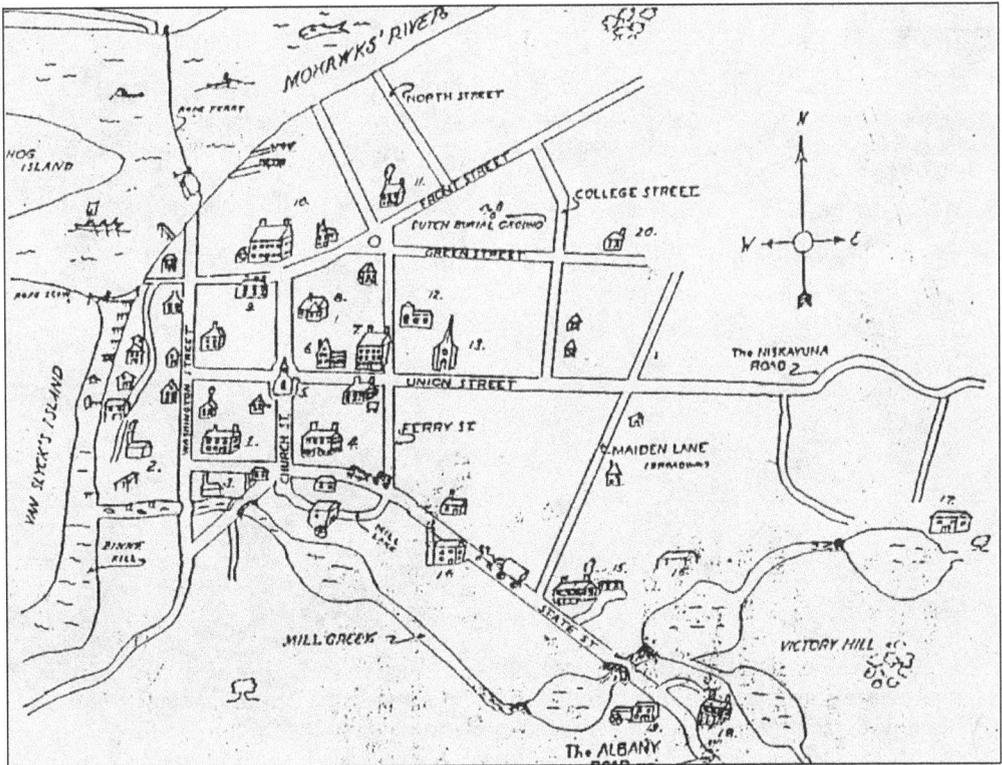

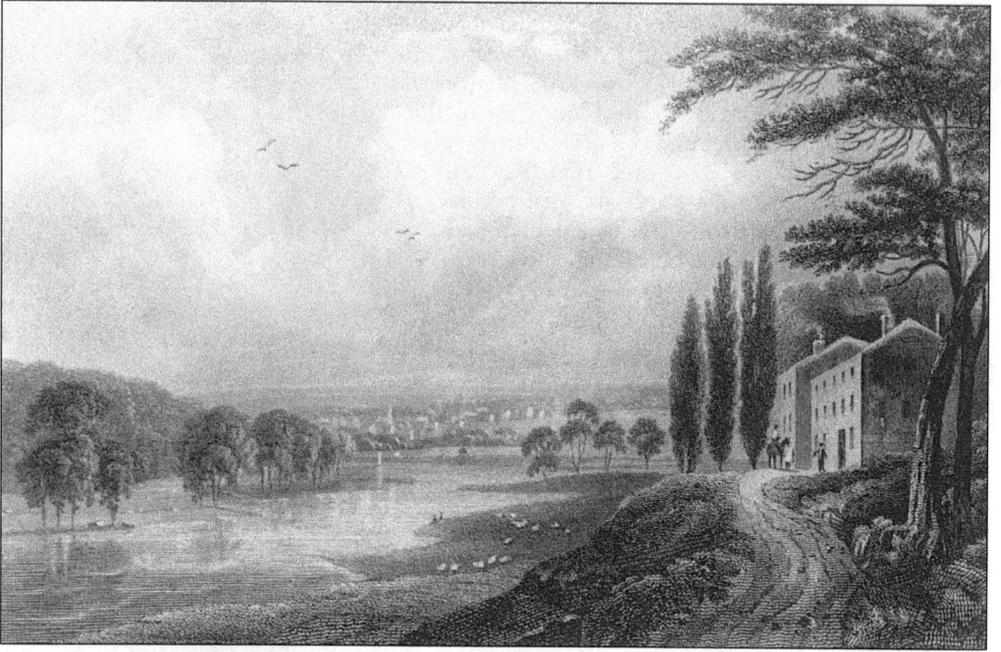

A woodcut taken from *Spafford's Gazetteer* printed in 1824 inaccurately depicts a bucolic Schenectady in the distance along the Mohawk River to the west of the Glen Sanders Mansion. Schenectady was described in the *Gazetteer* as "a quiet place of 400 houses." The woodcut was by W.G. Wall, painter, and J. Archer, engraver. (Courtesy of Schaffer Library/Union College/Schenectady.)

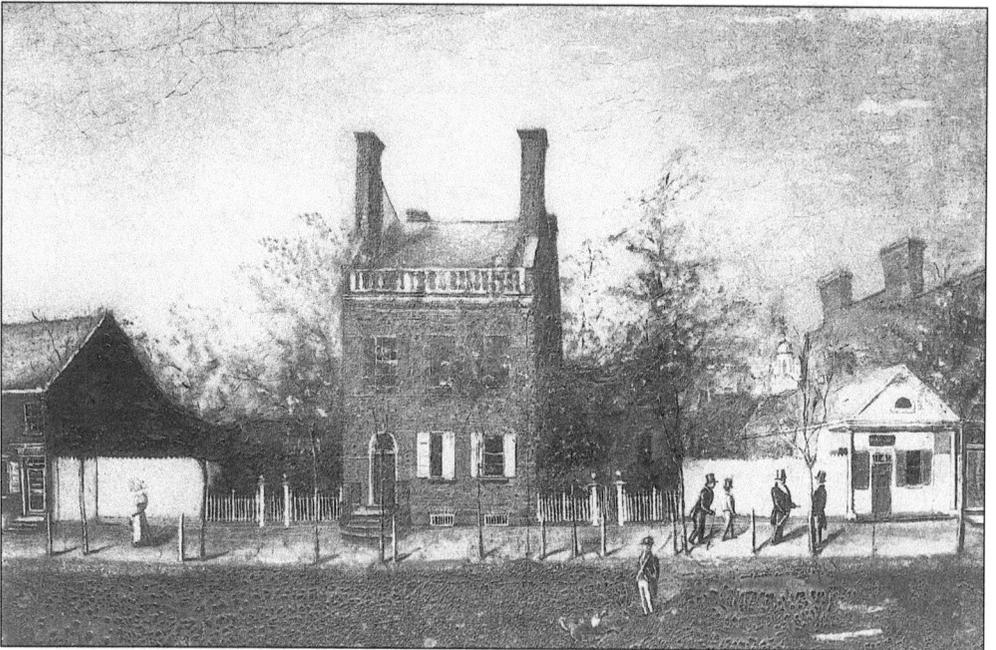

This oil painting by Cornelius Van Patten shows lower State Street in 1832. Many streets were cobblestone at that time. The small white building was the law office of John Isaac De Graff. It is now the site of Kentucky Fried Chicken. (Courtesy of the Schenectady Historical Society.)

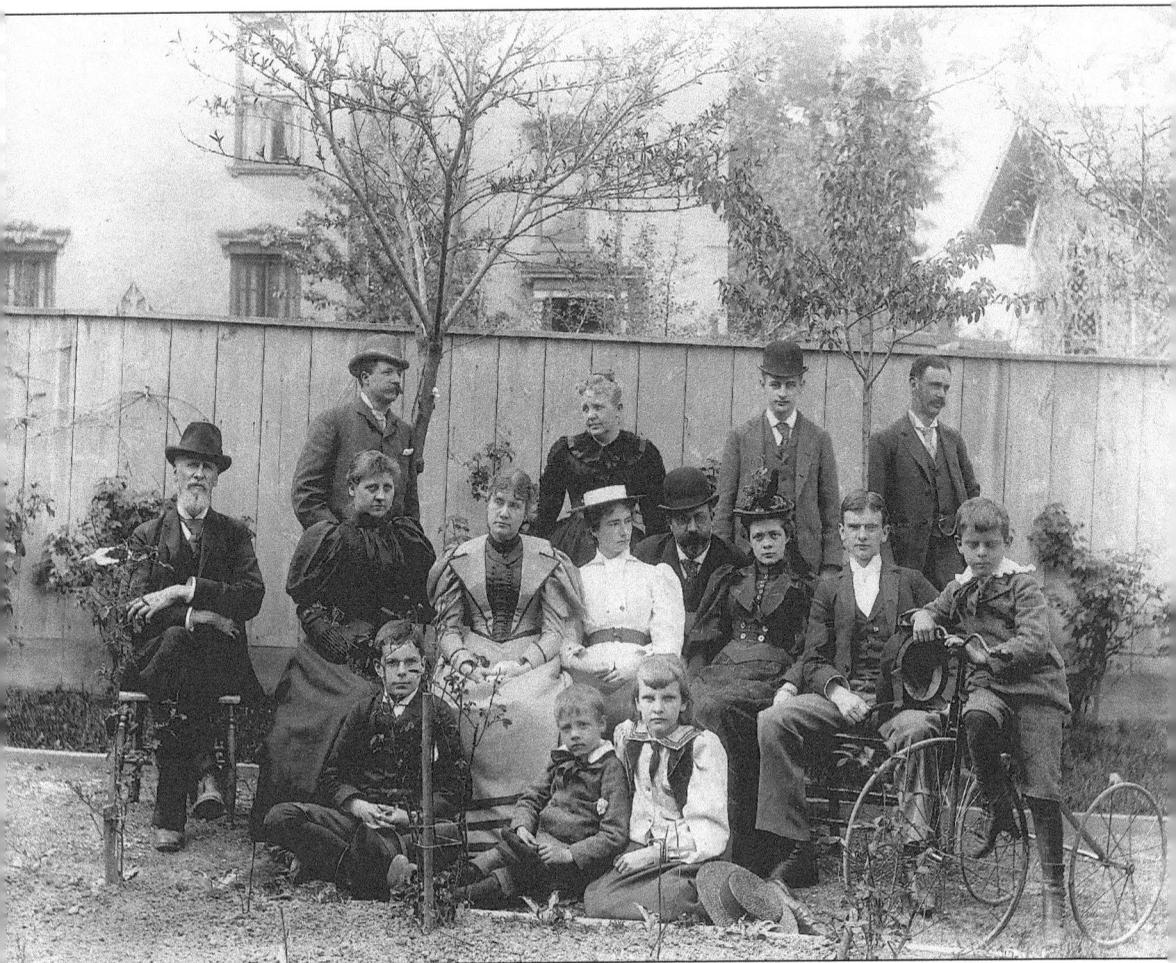

The Yateses, the Vroomans, and the Veeders gather in the Veeder home garden at 5 South Church Street in May 1893. These families had been part of the city for more than 200 years; as a result, they had become interrelated. Each of the families has had a Schenectady street named in their honor. The formidable looking gentleman seated on the far left is "Long John" W. Veeder, postmaster. (Efner Collection/Efner History Research Center.)

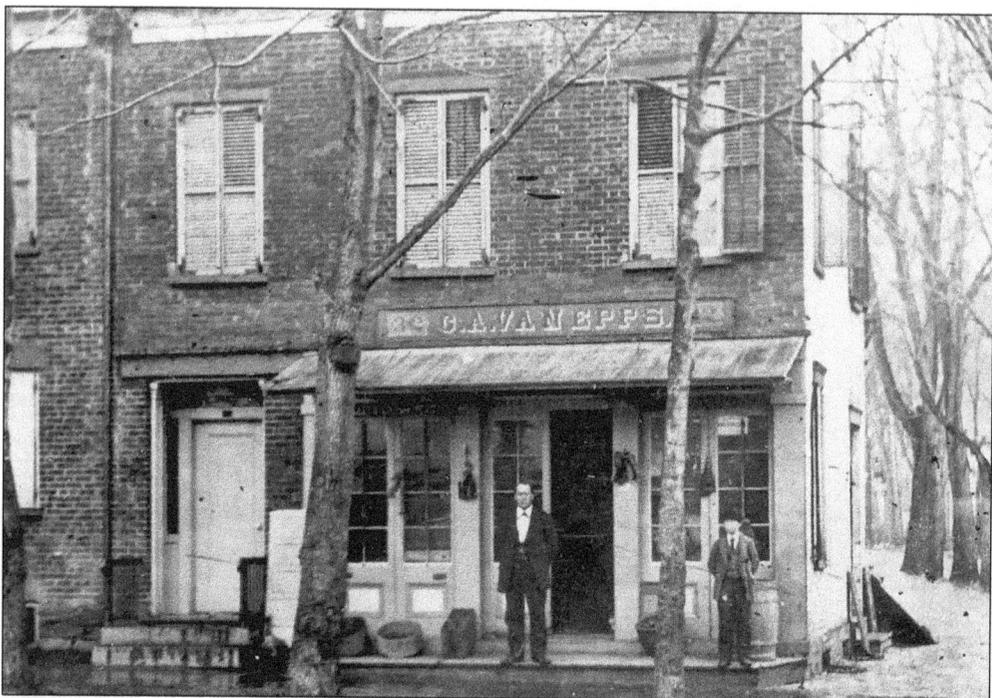

A long-standing institution in the city is the building on the corner of Ferry and Front Streets. Since 1792, a store has operated at that site. In this 1880s photograph, it was the G.A. Van Epps Store. Today, it is Arthur's Market. (Courtesy of Scott Haefner.)

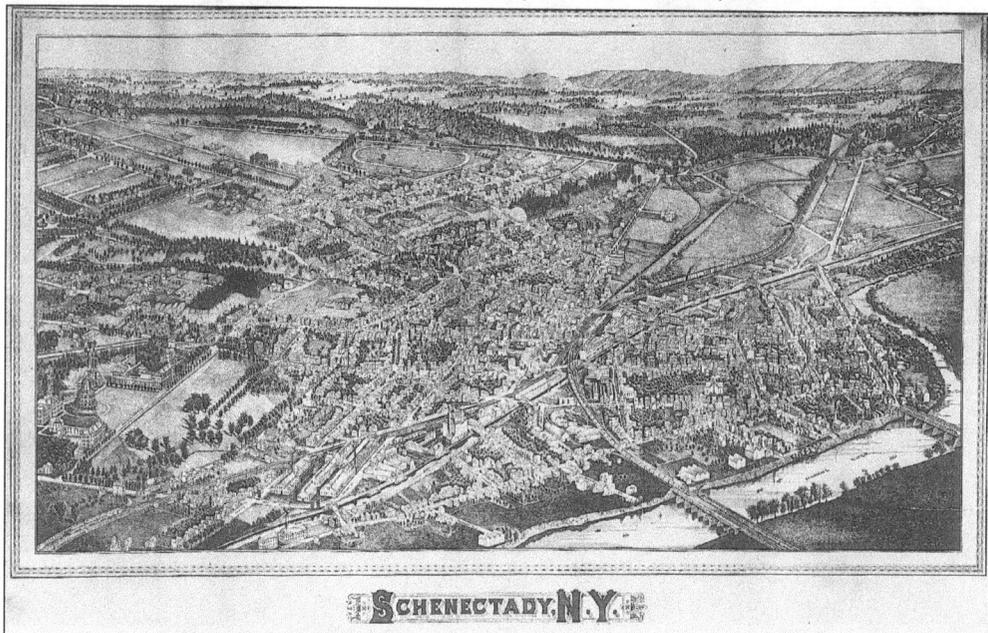

This bird's-eye view shows Schenectady in the 1880s. Union College is on the left, and General Electric is at the front center. Also visible are both the Erie Canal and the Mohawk River, the State Armory, Crescent Park, the railroad bridge and Burr bridge across the Mohawk, the stockade area, and Daniel Campbell's horse track. (Courtesy of Scott Haefner.)

Two

THE CHANGING FACE OF DOWNTOWN

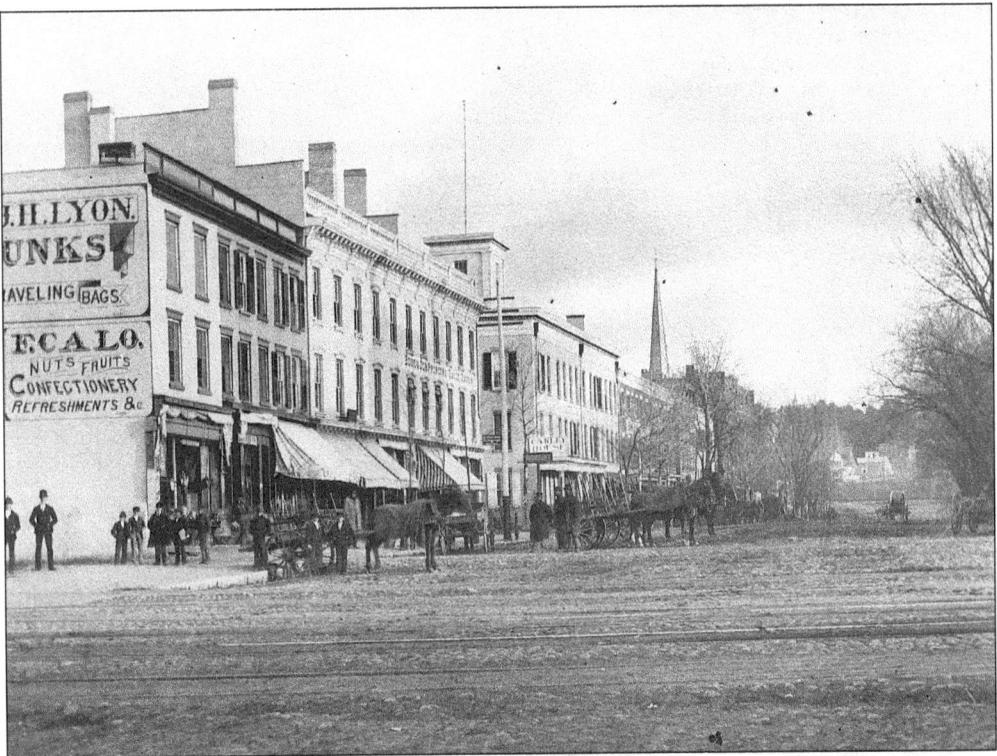

Earliest streets were plain dirt roads, and there were few of them. Visible in this 1868 photograph are the Carley House, which was later replaced by the Vendome Hotel; the Daily Union printers; and up the hill the land for Crescent Park, which was donated by Col. Robert Fuller in 1864. (Courtesy Scott Haefner.)

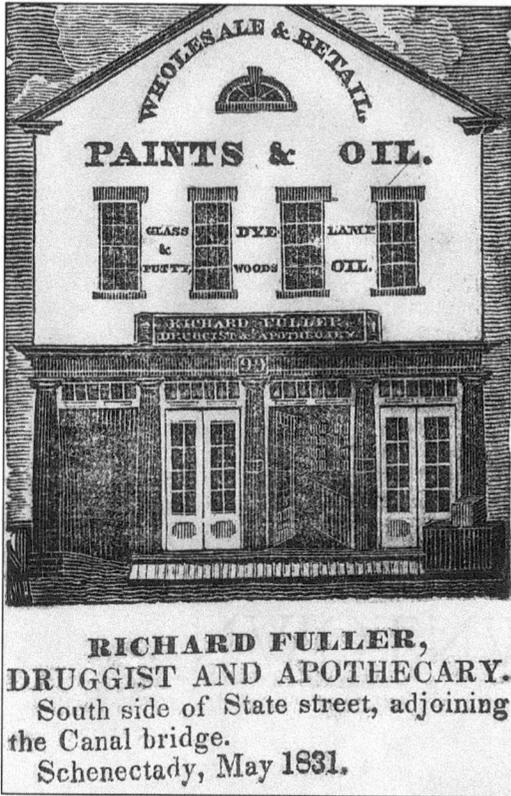

This 1831 woodcut advertises Richard Fuller's Apothecary, which stood on the south side of State Street, adjoining the canal bridge. This location, the current site of the Nicholaus Building, was convenient for the delivery of goods from canal barges. The canal, completed in 1825, fostered the mercantile trade. (Efner History Research Center.)

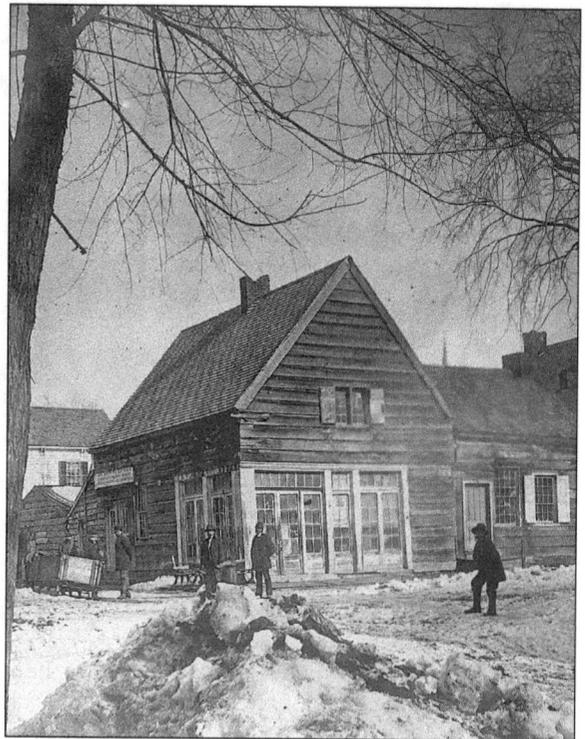

The city's first newspaper, the *Mohawk Mercury*, was once located in this wooden building at the northeast corner of State Street and Washington Avenue. At the time of this photograph, c. 1870, the building was occupied by carriage and sleigh maker James Simpson. (Courtesy Larry Hart.)

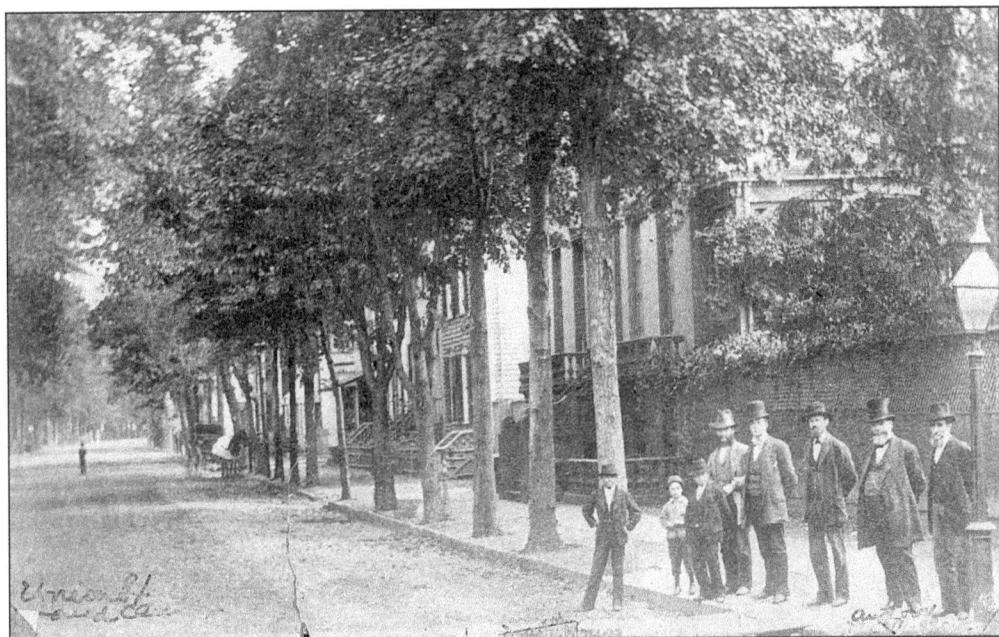

Some men and boys stand in front of the Maxon home at 404 Union Street, on the south corner of Centre Street, in the 1870s. At that time the streets were still being lit by whale oil lights. This building served as the Spencer Business Institute for a number of years. (Henry Tripp photograph/Efner History Research Center.)

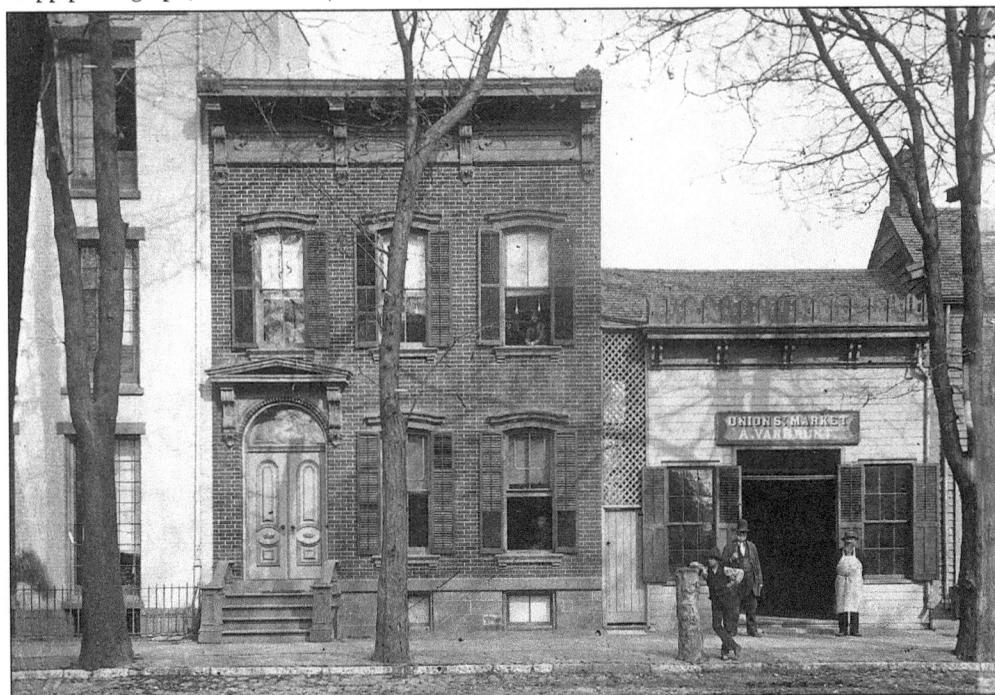

The butcher, the owner, and probably a delivery boy pose in front of A. Van Brunt's Union Street Market. Barely visible in the adjoining house are two women seated in the first- and second-story windows on the right. (Courtesy of Scott Haefner.)

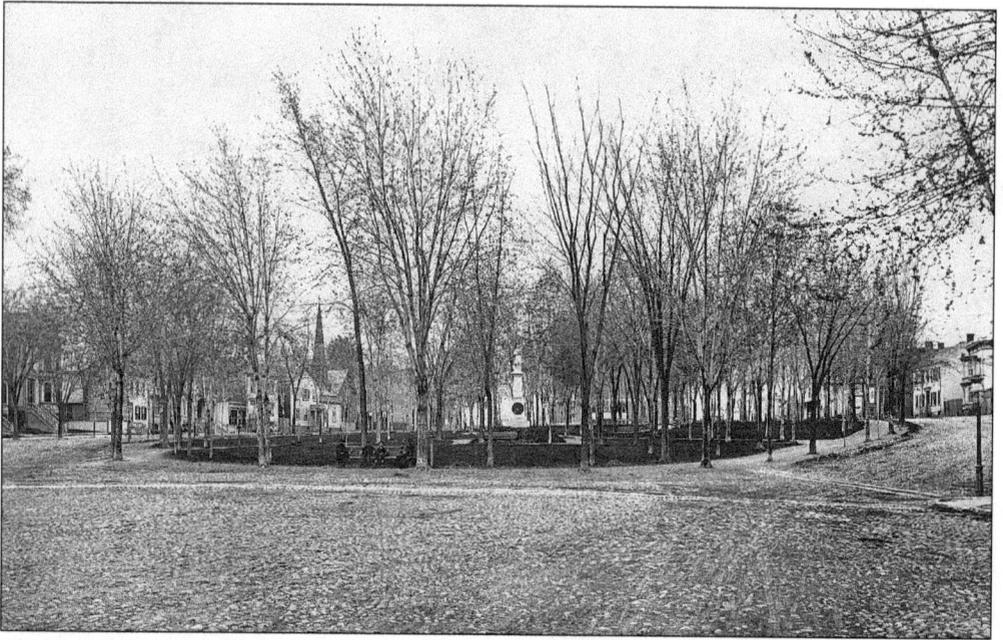

This excellent late-1880s photograph of the eastern side of town was taken facing Crescent Park. The armory is at the top of the hill behind the trees. Houses are located along the right side of the hill, where the county courthouse now sits. The streets are of cobblestone, and the light on the right is gas. (Henry Tripp photograph/Efner History Research Center.)

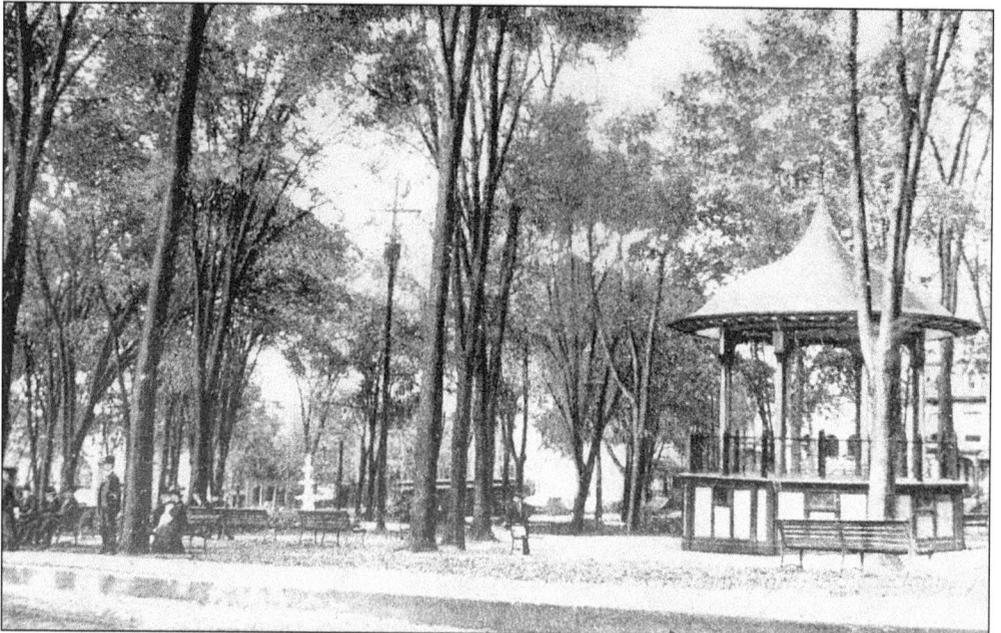

The earliest bandstand in Crescent Park was erected in the late 1880s, torn down in 1916, and replaced by a $15,000 structure under the 1924 urban renewal plan of Mayor George Lunn. The park shrank over time because State Street was widened on its north side from Nott to Lafayette Streets so that the Schenectady Railway Company could install double tracks. (Spoonogle Collection/Efner History Research Center.)

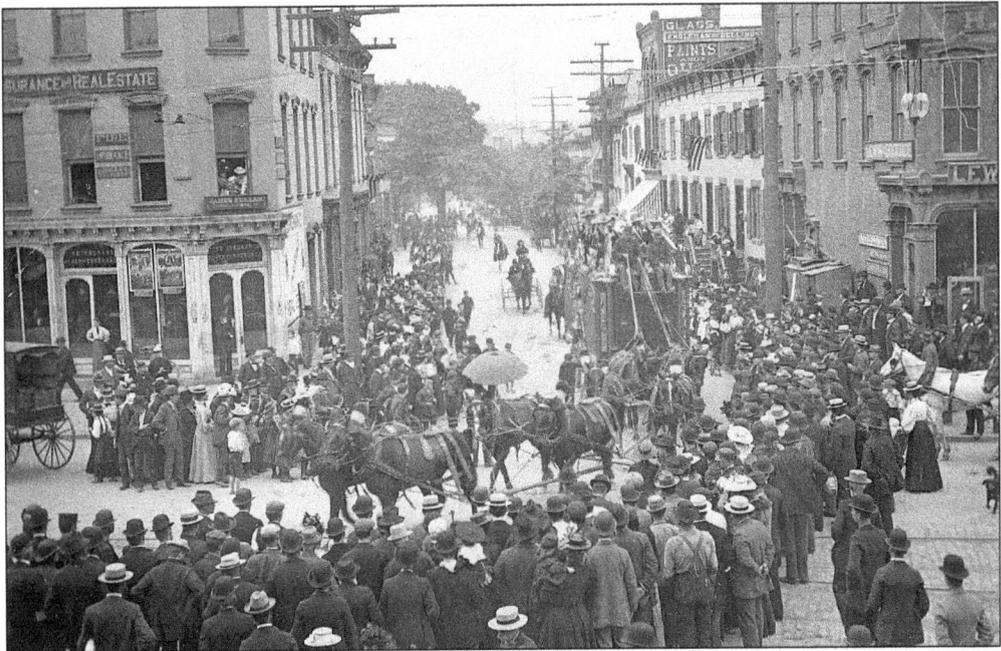

Wagons of a circus parade turn off Old South Centre Street, now Broadway, onto State Street *c.* 1895. The overhead street light is of the carbon arc variety. The electric trolley cars were installed in 1888, and their tracks remained until their removal in the early 1950s. (Peck photograph/Efner Collection/Efner History Research Center.)

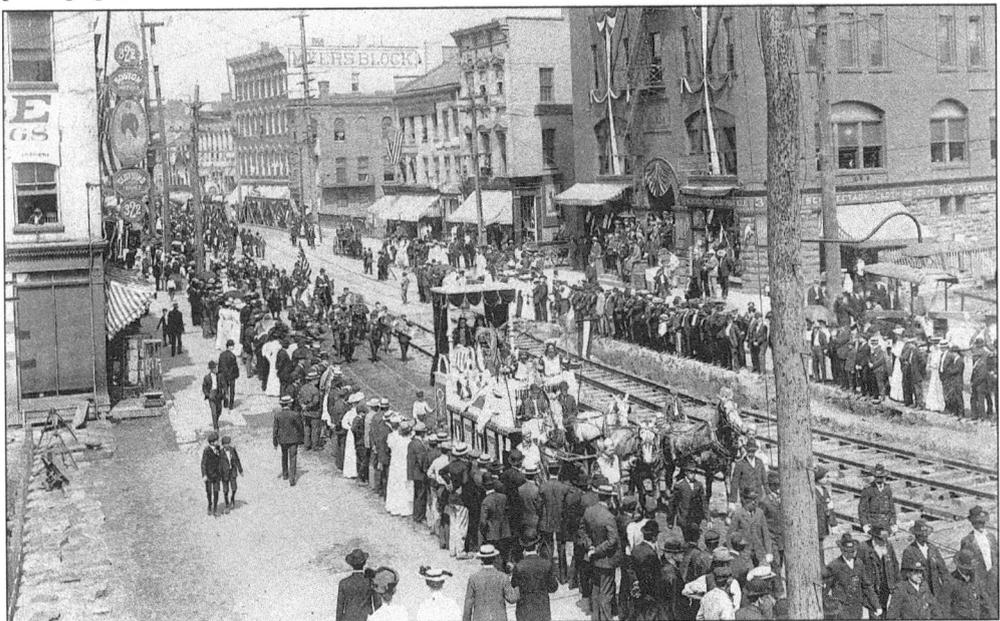

In this parade photograph of 1905, the Edison Hotel's facade is decorated, on the right. Opposite is the Boston One Price Clothing House. This is State Street west of the grade crossing. The road bed is being lowered preparatory to elevating the railroad tracks. The parade is led by the Grand Army of the Republic veterans who were Union Army veterans from the Civil War. (Luddon photograph/Efner History Research Center.)

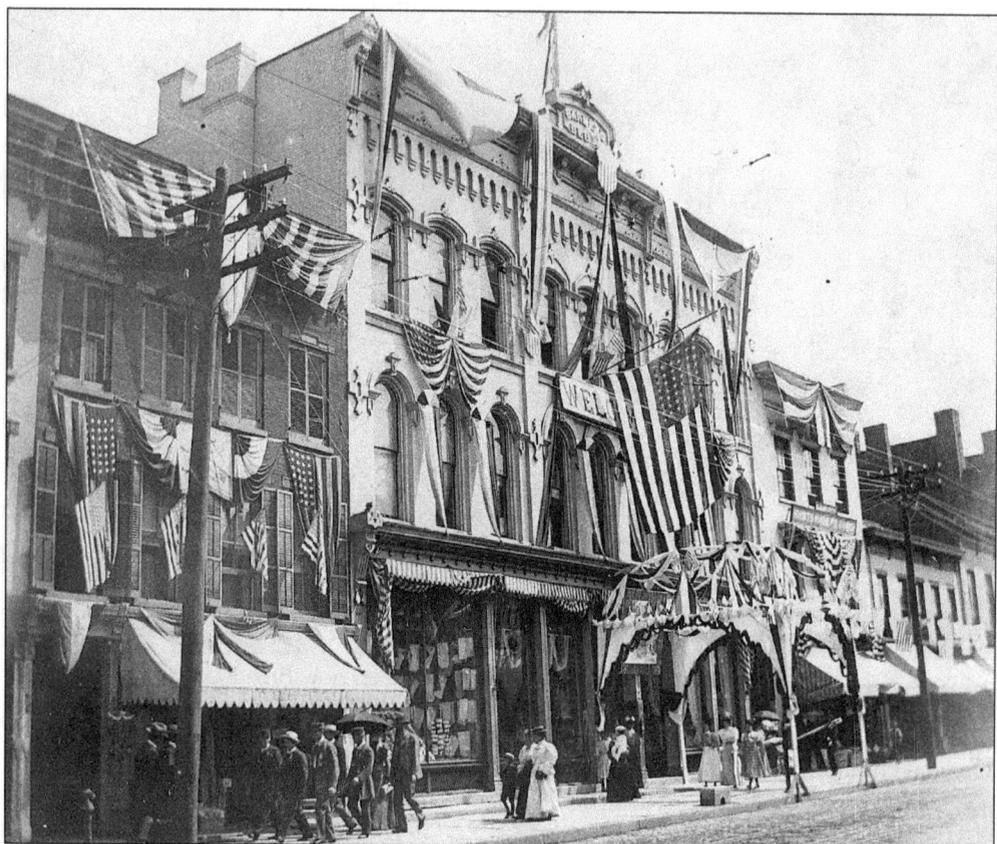

The Barney Building at 213-215 State Street, erected in 1873, is all decked out for the 1897 Fireman's Convention. Barney's was the leading department store; it sold everything from thread to furniture. The facade was remodeled in 1924. The building is now the Barney Square Apartments. (Efner History Research Center.)

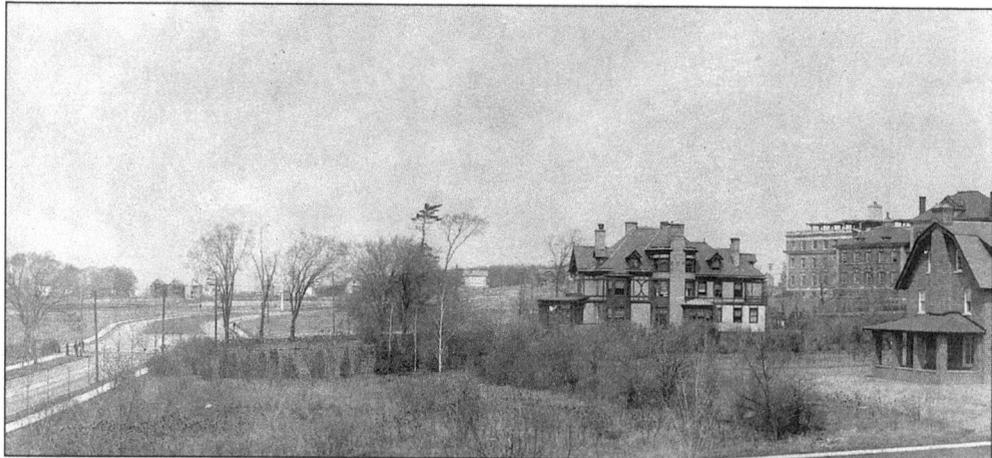

By the early 1900s, development pushed the city farther to the north and west. Many homes in the Realty Plot were under construction. In the center of this photograph is the Darling House, built in 1901 on Nott Street. The new Ellis Hospital is at the right rear. (Efner History Research Center.)

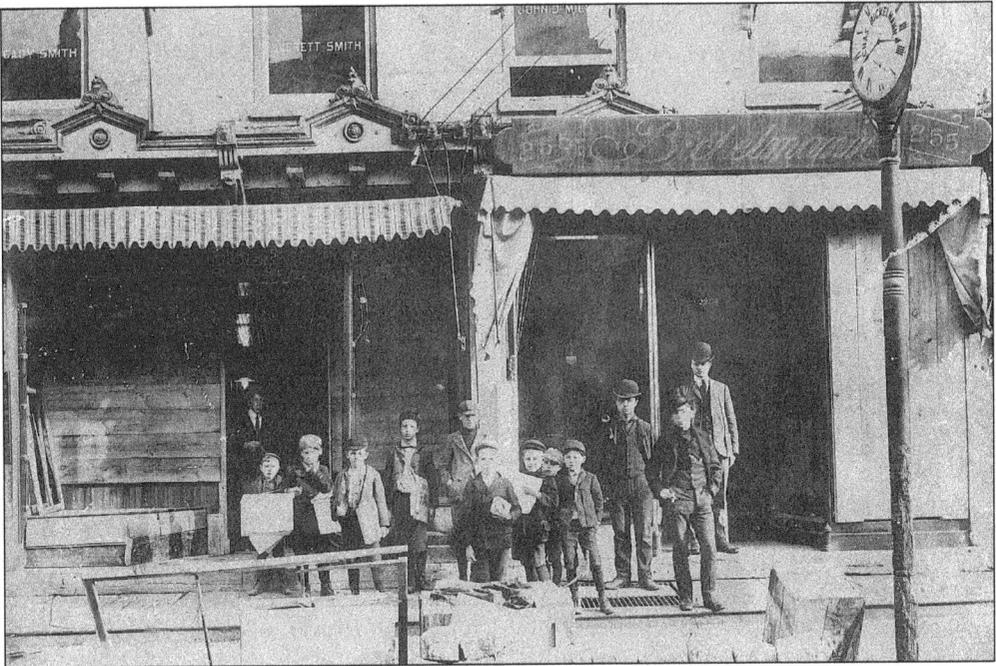

This photograph, taken on November 21, 1902, shows 255 State Street in front of Bickleman's Jewelers. The Hanson granite blocks in the foreground were being used in the repaving of State Street to accommodate the new trolley line. (Efner History Research Center.)

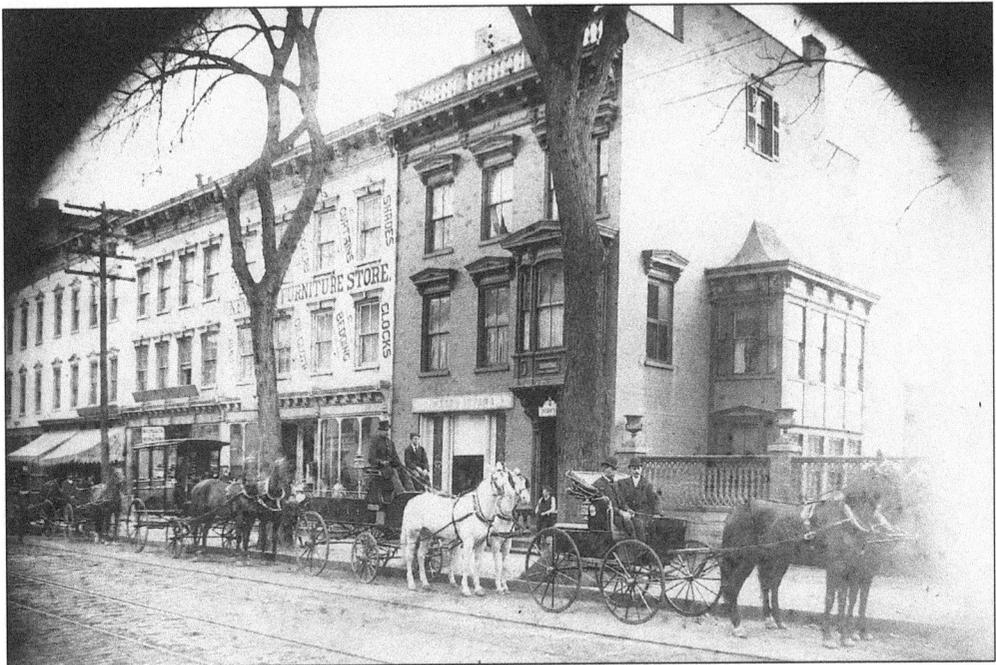

A funeral procession is lined up in front of Timeson & Fronk's Funeral Parlor on lower State Street at Church Street *c.* 1902. This building was adjacent to what was known as State Street Park. The primary modes of transport were trolley cars and horse-drawn vehicles. (Henry Tripp photograph/Spoonogle Collection/Efner History Research Center.)

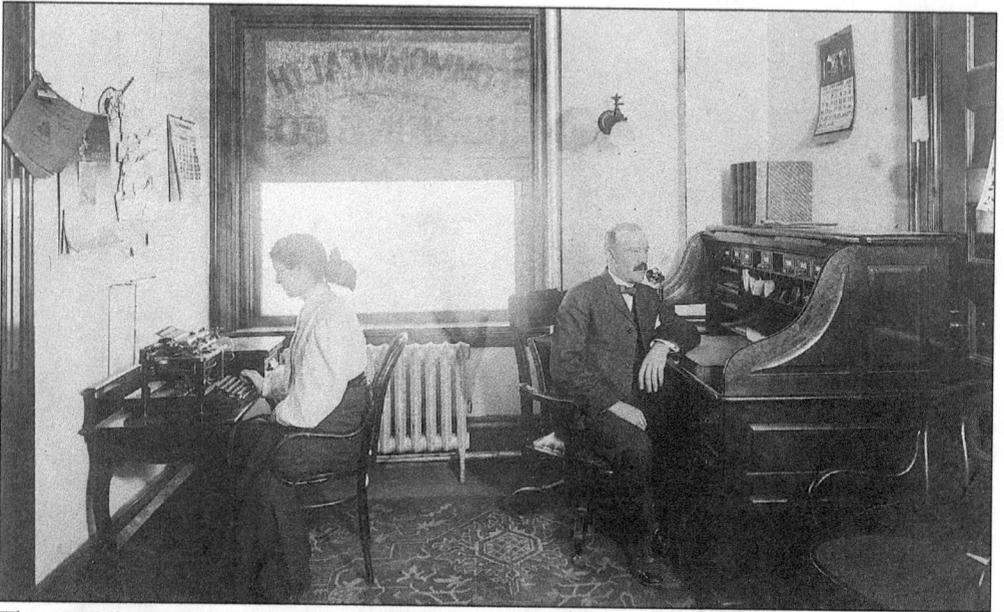

This 1906 photograph shows the interior of the Commonwealth Roofing Company at 119 Lafayette Street, an area that was later demolished to become the site of Two Guys. Commonwealth's small business office is complete with a rolltop desk, a combination gas-and-electric light, an upright typewriter, a telephone, and 19-year-old secretary Alice Unverzagt. (Efner History Research Center.)

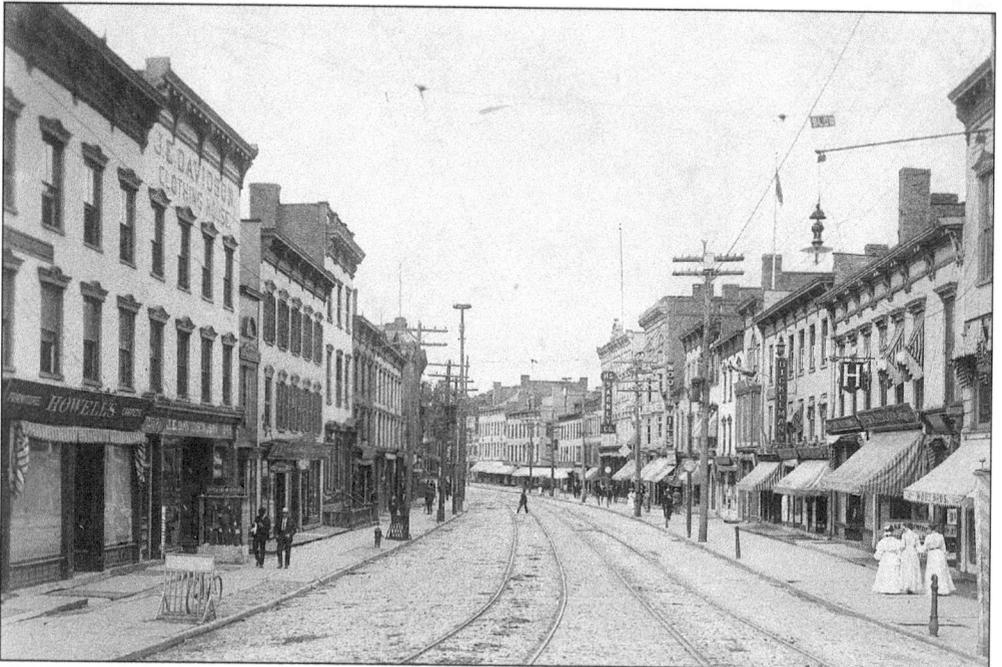

This c. 1910 photograph shows the State Street area below the Erie Canal, with bicycle racks, a telegraph pole in the center distance, arc street lamps, and a canal warning post at the far right. (Courtesy of Scott Haefner.)

26

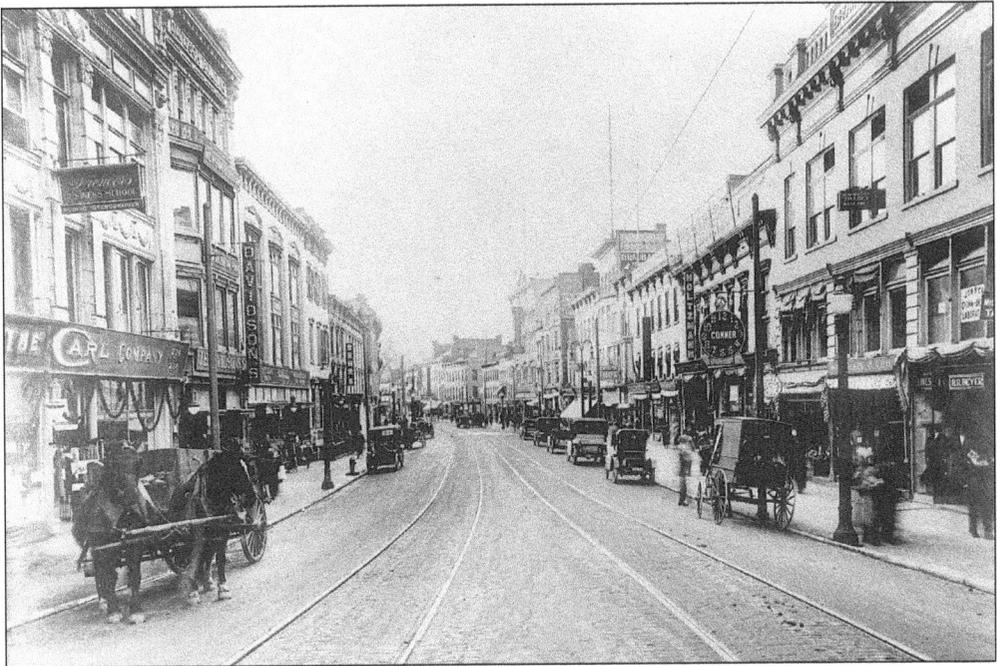

This 1914 westward view shows the State Street area below the Erie Canal bridge. Ferry Street is in the distance. In their early locations are the Carl Company and Spencer's Business School, just up the street from its present site. (Schaffer Library/Union College/Schenectady.)

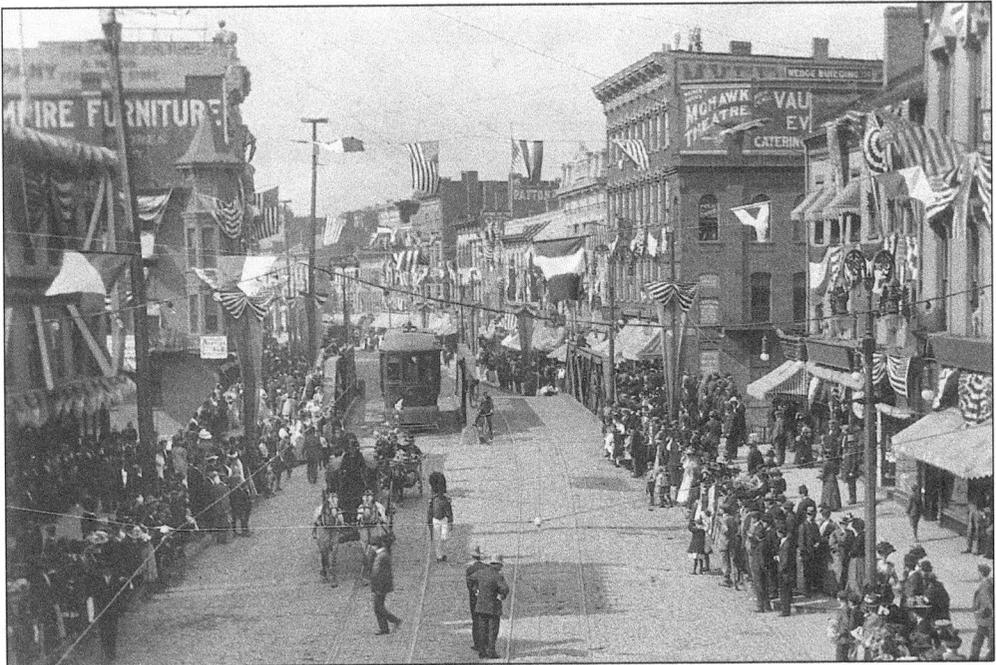

The fall 1909 Schenectady Board of Trade Carnival crosses the Erie Canal at State Street. The tower of the new Nicholaus's Restaurant and Hotel, built in 1901, is visible at the left. Police in the foreground are attired in full uniform, with helmets, white gloves, and nightsticks. (Courtesy of Larry Hart.)

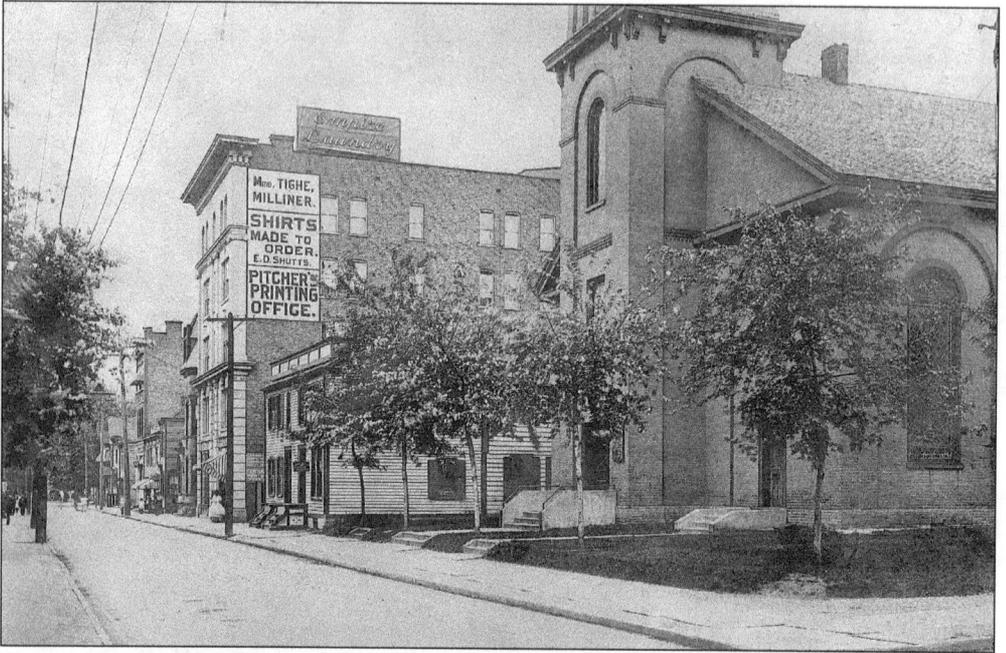

This photograph shows the old Second Reformed Church at Jay and Liberty Streets c. 1910. The church was demolished to make room for the post office building, begun in 1911 and finished in 1913. The building was expanded during the Depression as a Works Progress Administration project, when city hall was built. (Efner History Research Center.)

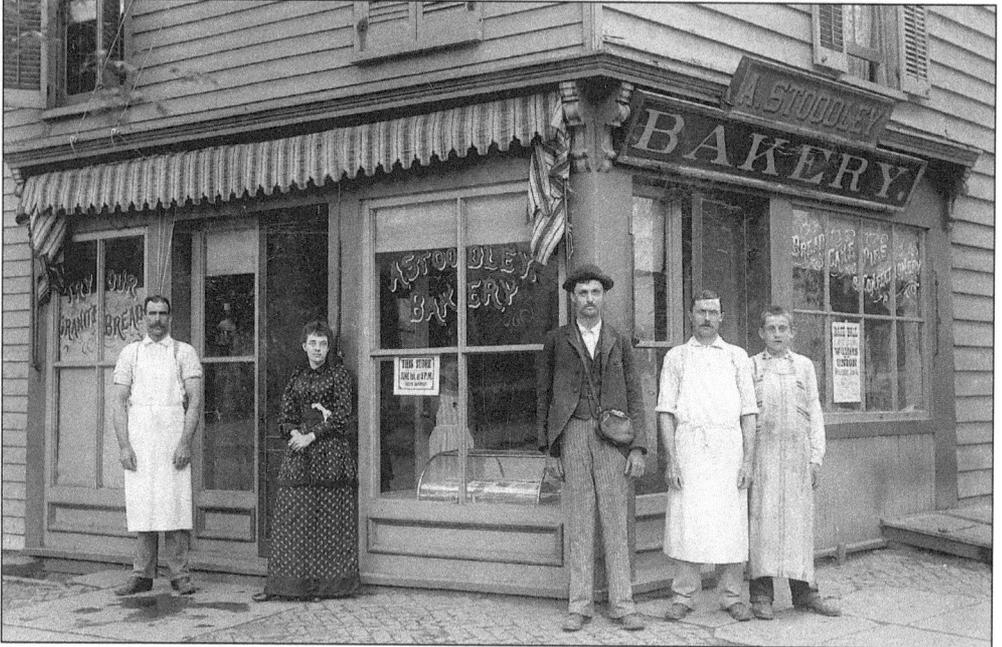

On the corner of Union and Fonda Streets stand the employees of the Alfred Stoodley Bakery, c. 1910. This photograph may have marked the store opening. Note the poster on the window at the right that promotes the last baseball game of the season, on June 14 between Union and Williams. (Efner History Research Center.)

28

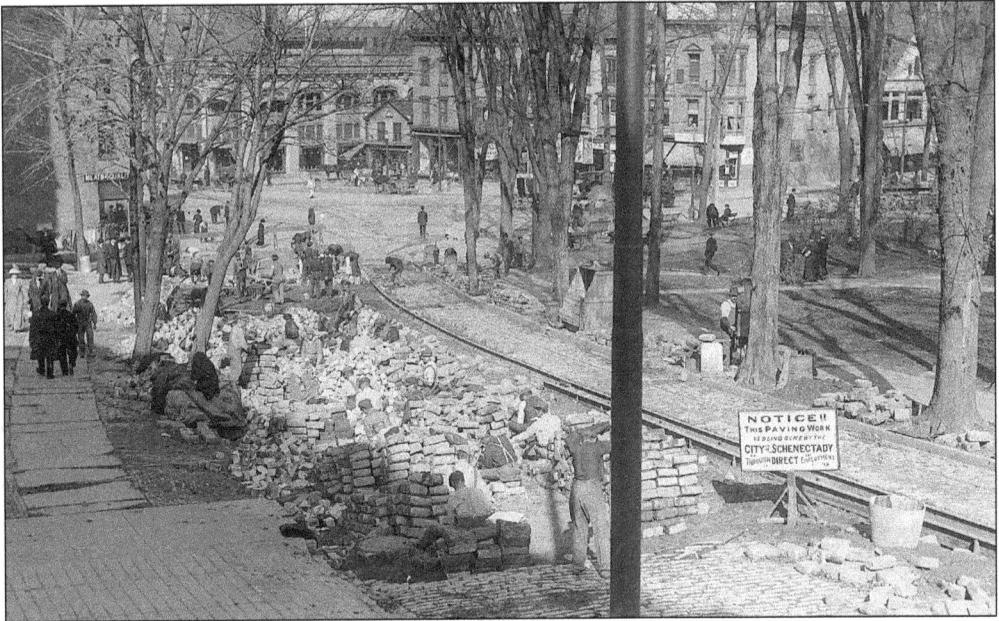

This photograph taken in the fall of 1913 shows the recutting of granite blocks for the repaving of State Street around Crescent Park. Just out of view to the left is the Schenectady County Courthouse, which opened on January 1, 1913. In the rear center is the former Adirondack Power and Light Company building. (Efner History Research Center.)

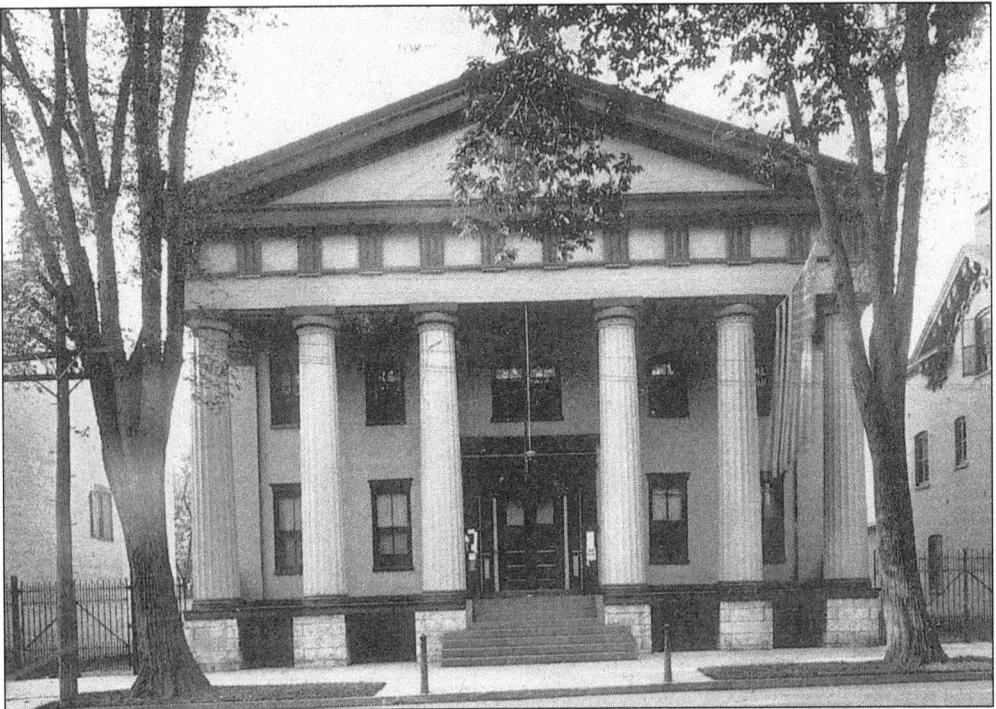

The courthouse at 108 Union Street was built in 1831. When it was replaced by the new courthouse across from Crescent Park, the old courthouse was used by the board of education. (Robson & Adee photograph/Efner History Research Center.)

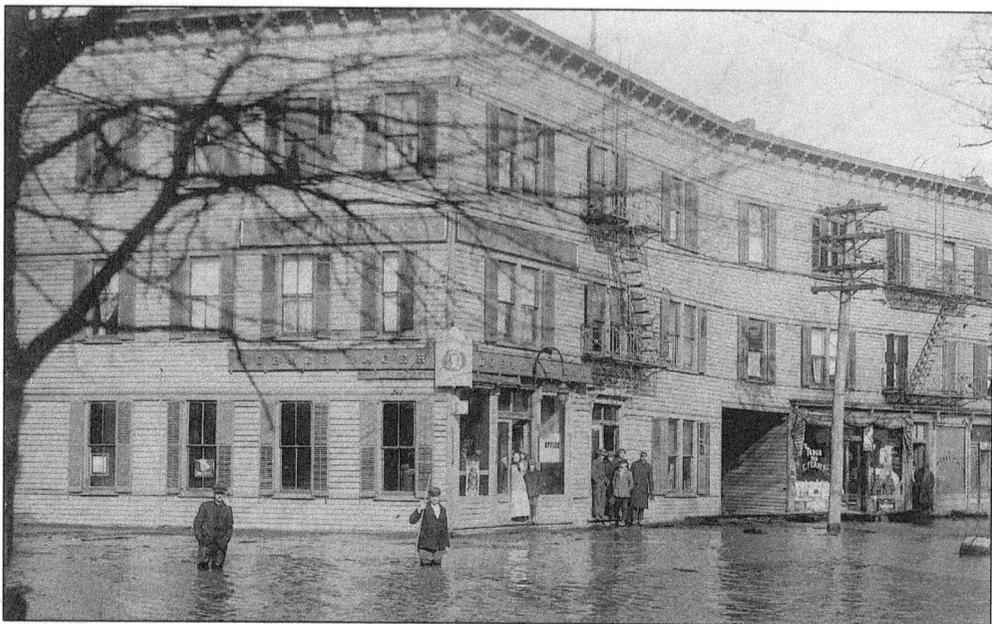

Schenectady has experienced many fast-rising floods of the Mohawk River caused by ice jams that have formed in the water. This picture c. 1913 is of Washington Avenue at Water Street, with the Gilmore House on the northwest corner. (Polacheck Collection/Efner History Research Center.)

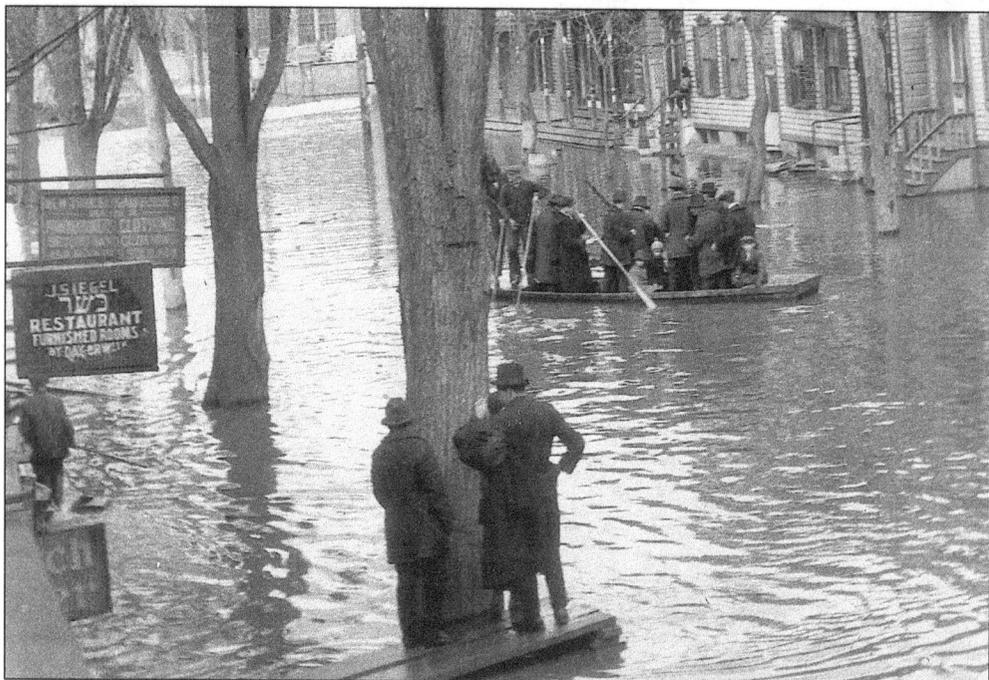

This flood evacuation scene was taken on Broadway near Hamilton Street. Widespread spring flooding was common prior to 1915, when the Barge Canal and the lock system were built. Notice Siegel's Restaurant and Furnished Rooms on the left and the old Weiderhold Factory at the bottom of the hill. (John Papp Collection/Efner History Research Center.)

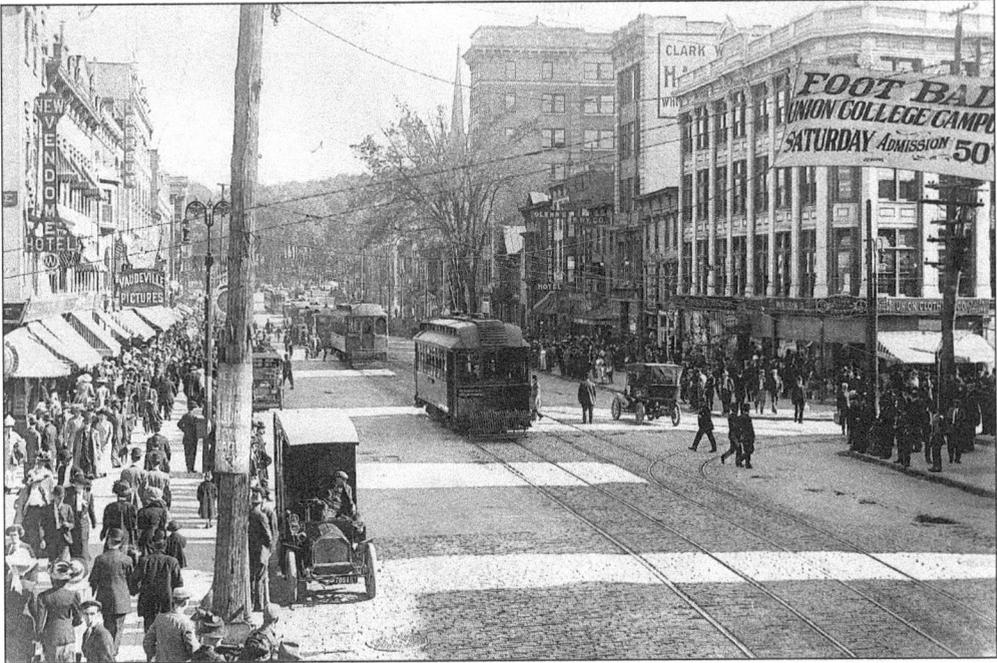

This 1915 view was taken looking eastward from the State Street railroad overpass up State Street toward Crescent Park, now Veterans Park. In view are the "new" Vendome Hotel, where in 1938 the F.W. Woolworth Company erected its building; the Parker Building, Schenectady's first skyscraper, erected in 1906; the old Schenectady Railway Waiting Room; the Orpheum vaudeville house; and a number of buildings still in existence. The feminine style of the day included hobble skirts and hats with large feathers. (Efner History Research Center.)

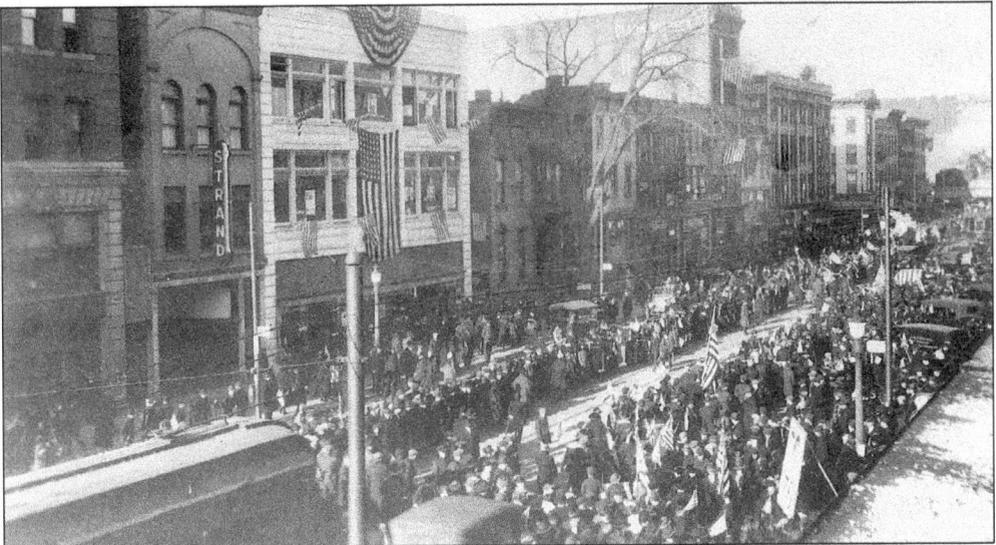

This was the scene on November 11, 1918, Armistice Day, the end of World War I. The celebration was in its eighth hour. In view are the Strand Theater, the Hotel Hough, and the State Street railroad bridge at the far right. The Carl Company was located in this area of State Street, but Proctor's Theater had not yet been constructed. (Courtesy of Schaffer Library/Union College/Schenectady.)

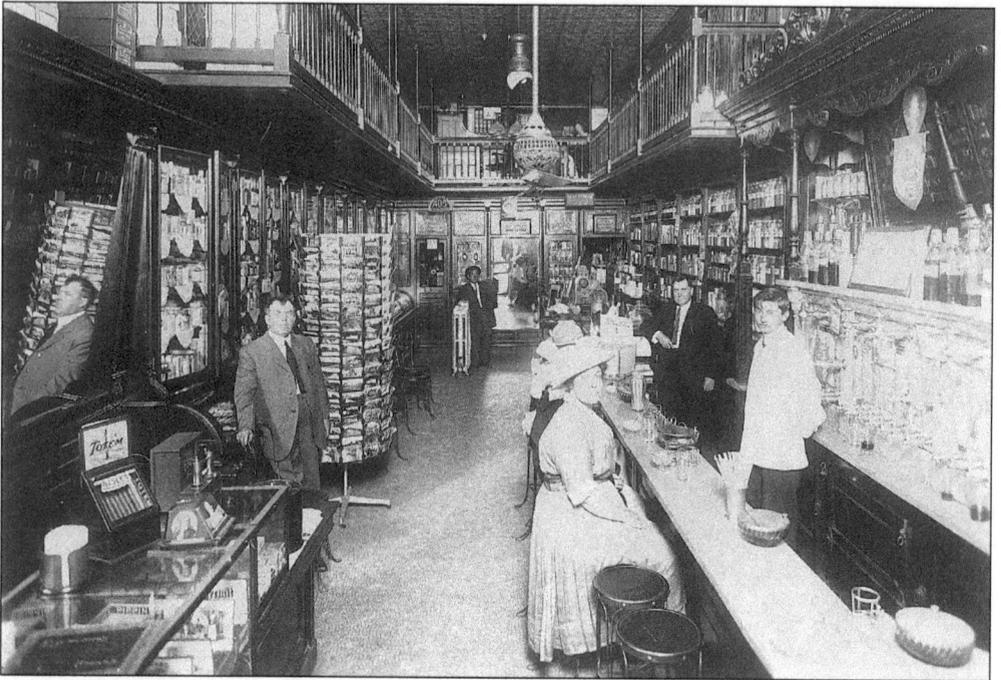

Patrons gather at the soda fountain of Henry A. Kerste's Drugstore on Union Street in the early 1900s. Besides soda and a considerable array of medicines, the store offered a large variety of postcards. According to the sign, all merchandise was being offered at cut prices for strictly cash. The machine on the cigar counter in the left foreground is an automatic electric cigar lighter. (Efner History Research Center.)

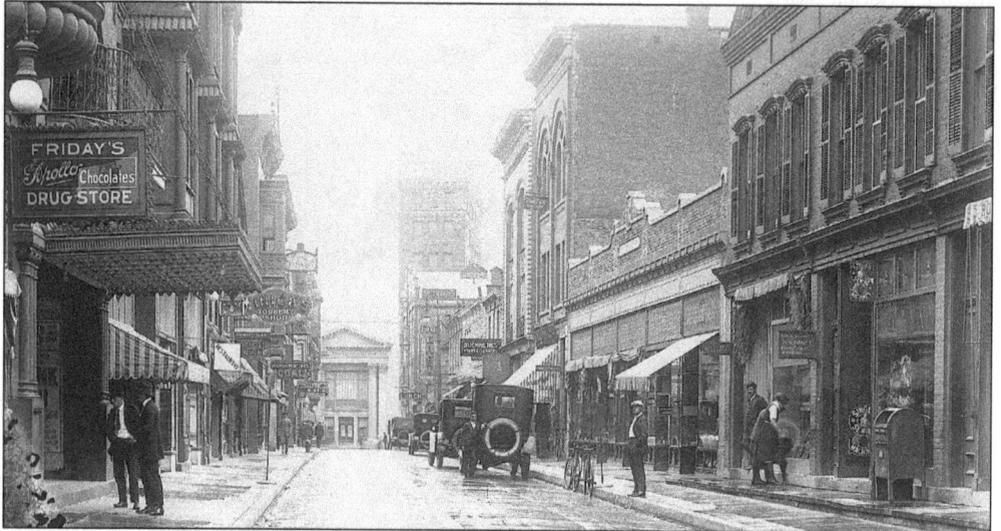

This 1921 photograph of Jay Street was taken from Franklin Street looking toward State Street and the Citizen's Trust Company, now Key Bank. On the left is the marquee of the Van Curler Opera House where George Lunn and his socialists met. The low building on the right was built as an automat. It is interesting to note the variety of businesses on the street, including the Far East Restaurant. Jay Street became a one-way street in the summer of 1926. (Efner History Research Center.)

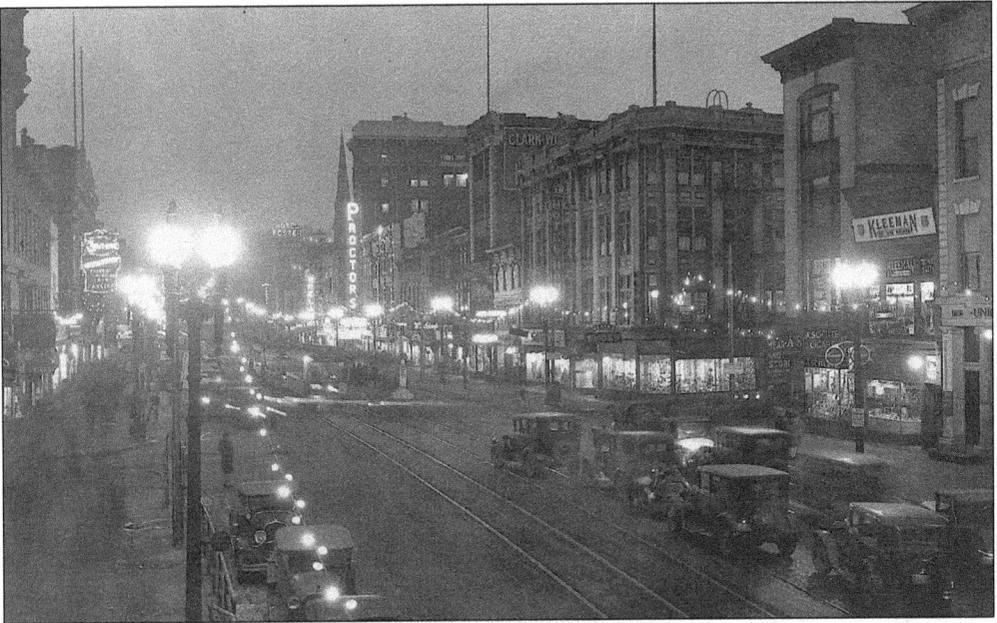

Stores are open late for Christmas shopping in this downtown scene c. 1925. The photograph was taken facing Crescent Park, with State Street and Broadway in the foreground. Trolleys were kept running by governmental decree during the war. The islands, which were still in existence, created a dangerous situation as people had to cross the traffic to get to them. (Courtesy of Scott Haefner.)

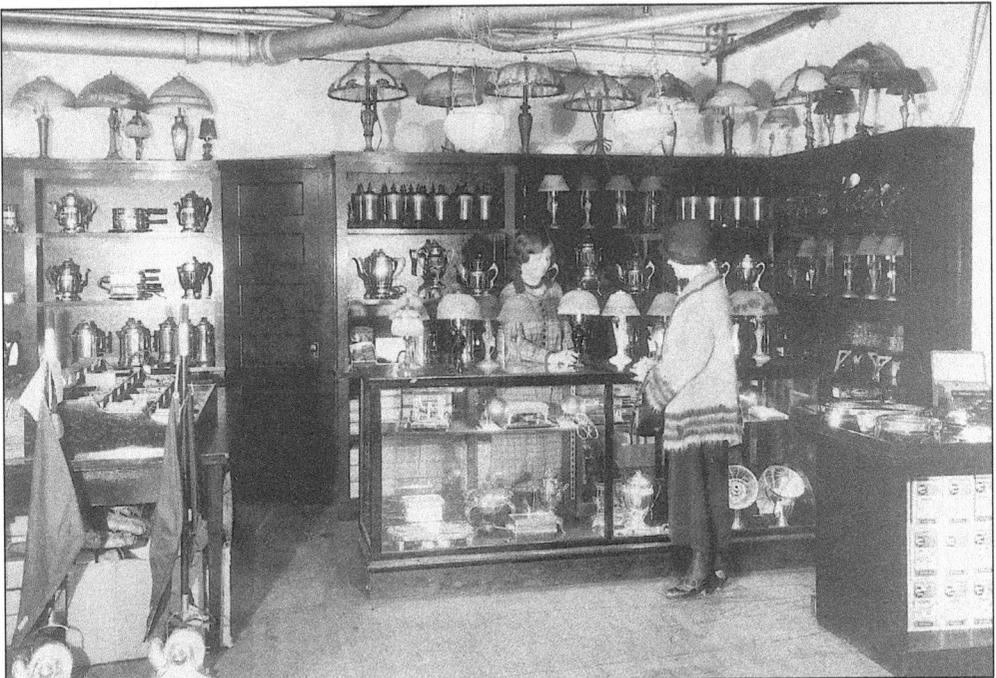

A 1924 photograph of the electrical department of the Carl Company depicts the state-of-the-art small appliances of the time, including a number of Tiffany-style lamps, coffeepots, and vacuum cleaners. (John Papp Collection/Efner History Research Center.)

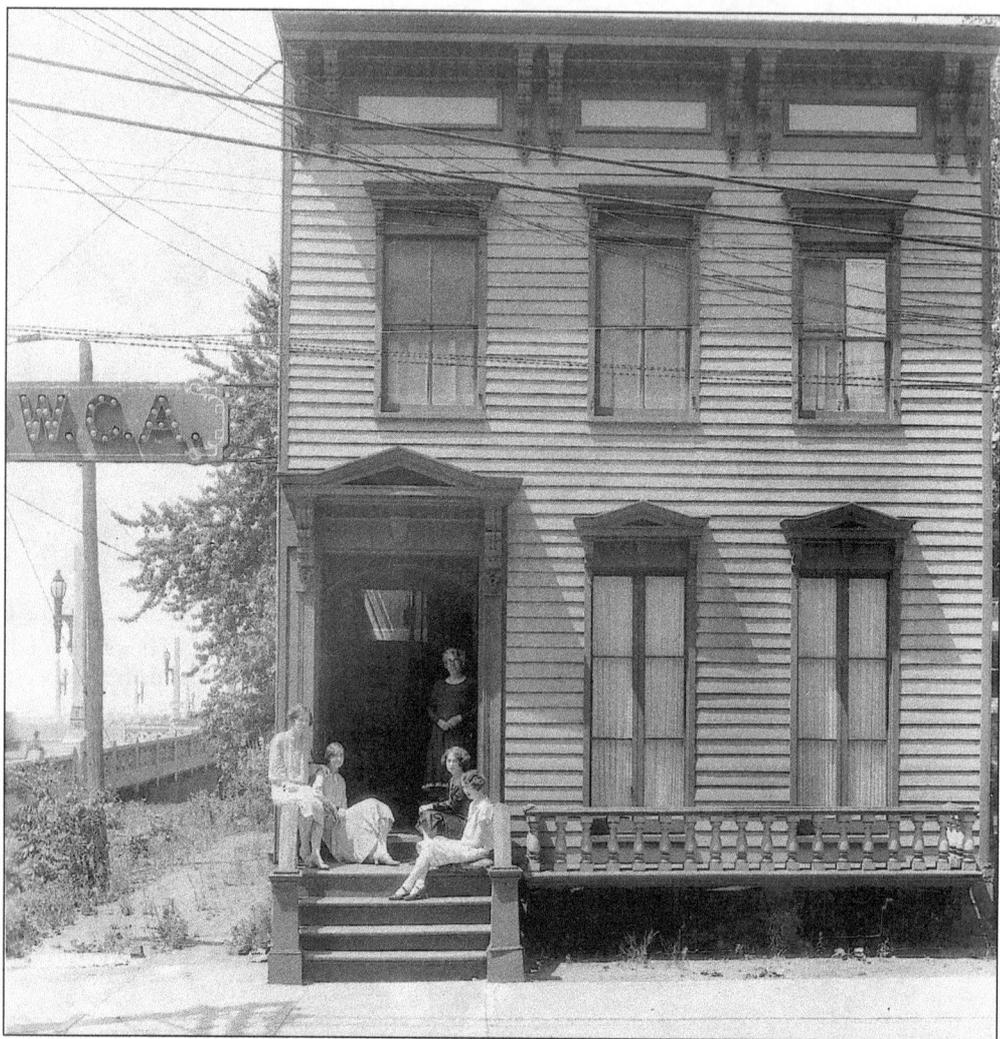

These women pose on the steps of the 1928 home of the YWCA in Schenectady. Standing in the doorway is Mildred March, the president of the Y. The building sits to the right of the entrance to the Western Gateway Bridge, which was about three years old. The Schenectady YWCA was founded in 1888 and was incorporated in 1892. (Courtesy of the Schenectady YWCA.)

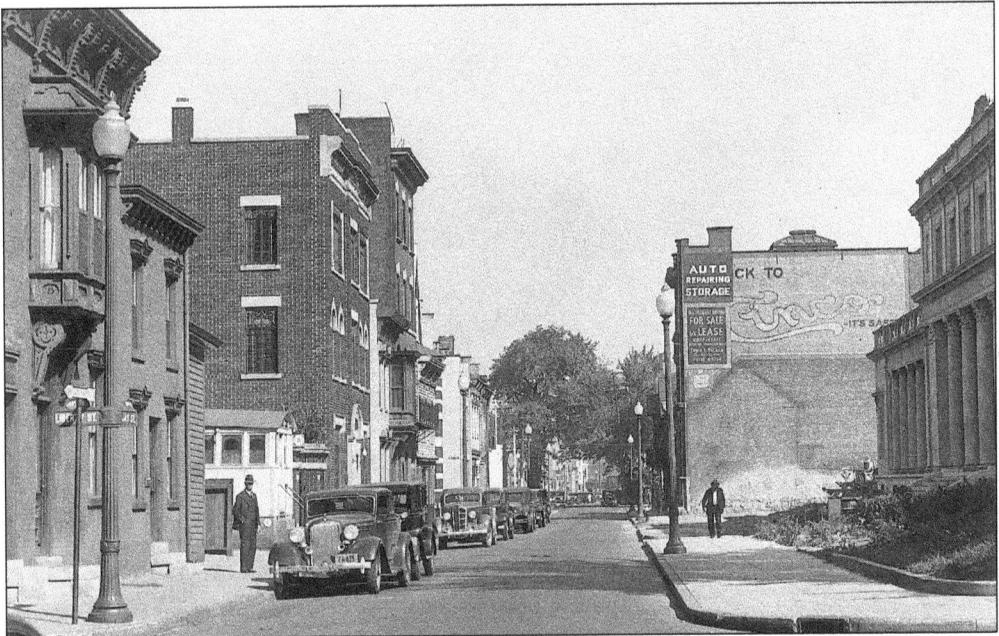

This 1930s view shows the corner of Liberty and Jay Streets, with the post office building on the right. In the distance is the railroad bridge that was removed in 1999. Early 1900s buildings that once stood in the area adjacent to the building with the Auto Repairing Storage sign were demolished to make room for the post office addition, which doubled the size of the existing one. (Efner History Research Center.)

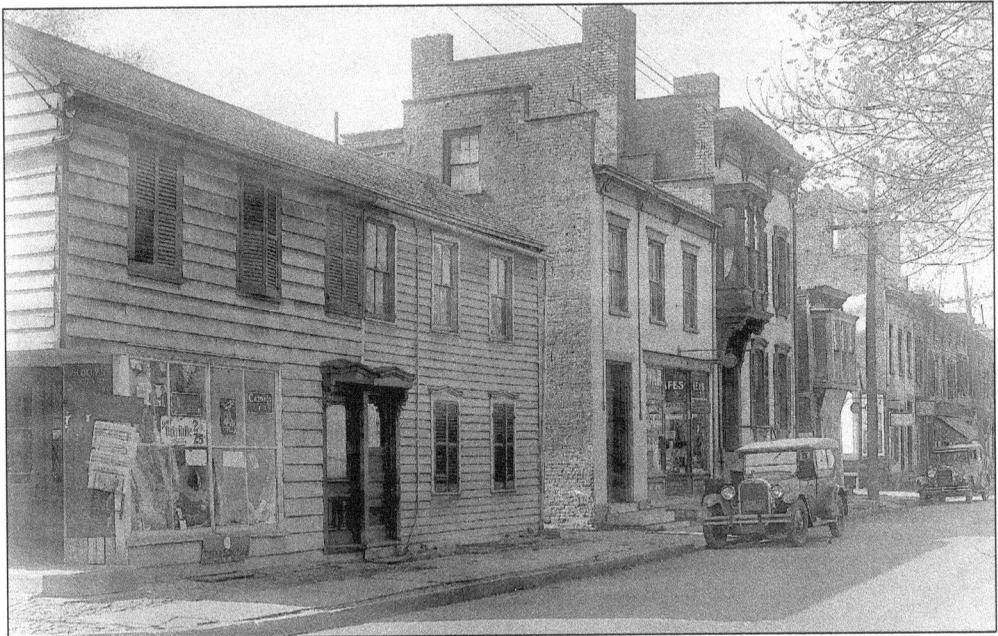

Here is Liberty Street's south side, between Clinton and Jay Streets. Scully's Grocery is on the corner, offering the latest issues of the *New York American*, the *Sunday Telegraph*, the *New York Journal*, as well as two packages of Lucky Strikes for only 25¢. Also on the street is a locksmith, a machine shop, and a laundry. (Efner History Research Center.)

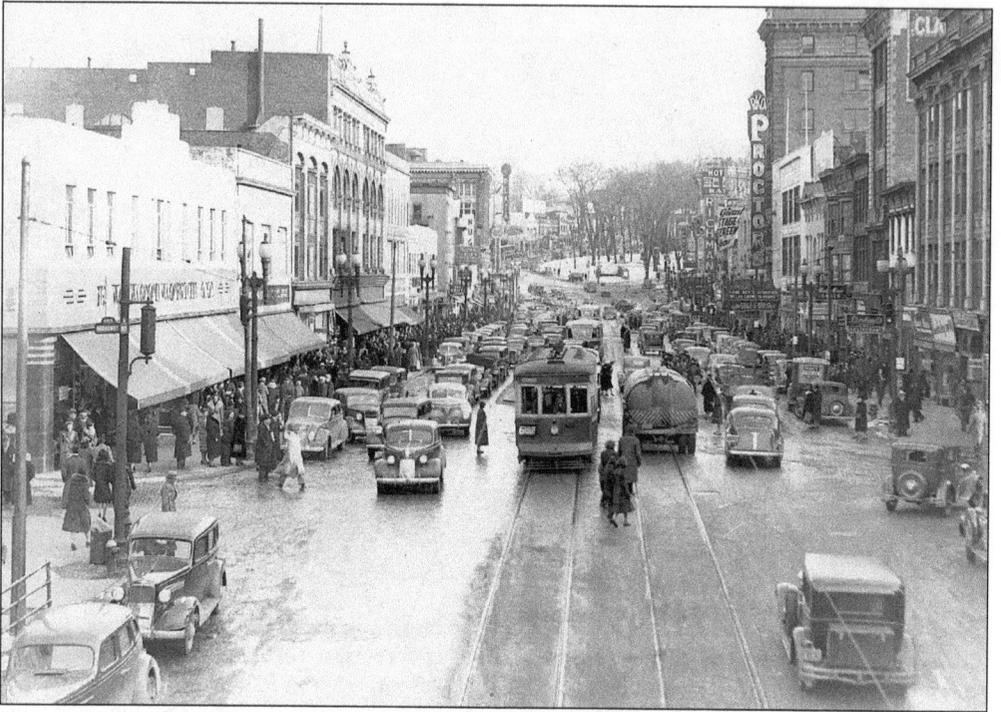

This State Street photograph was taken in 1941. Woolworths was built in 1938. Note the RKO Proctor's sign on the right and the Plaza Theater sign up the hill on the left side. Barely visible through the trees are the old bandstand and the tower of the state armory. The armory was demolished in 1947.(Anderson Collection/Efner History Research Center.)

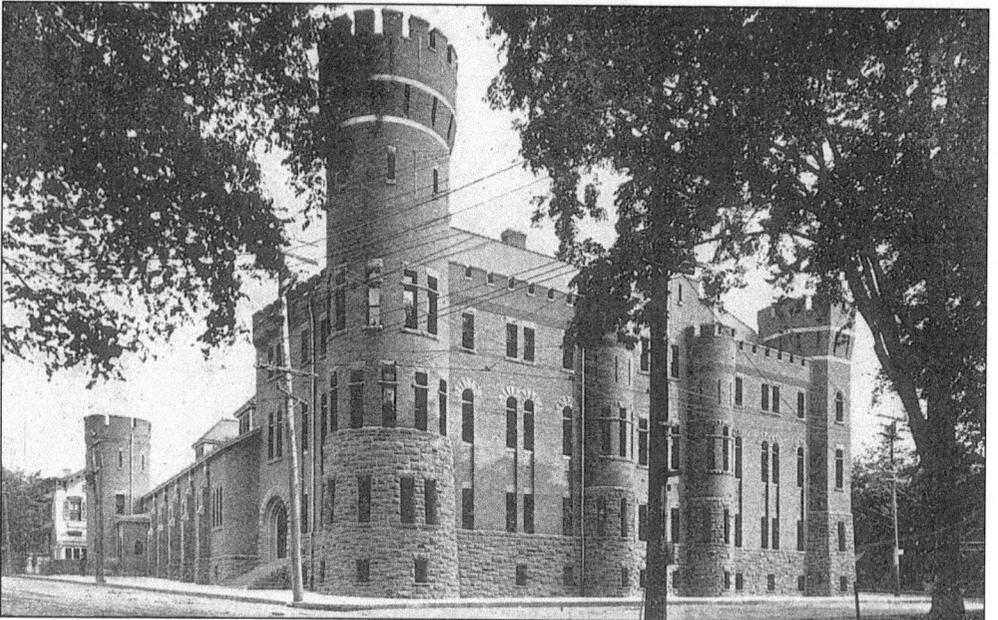

The state armory was a center for all types of community functions, such as dances and basketball games. Opened in 1893, the armory was replaced by a later structure on Washington Avenue in 1936. (Robson & Adee photograph/Efner History Research Center.)

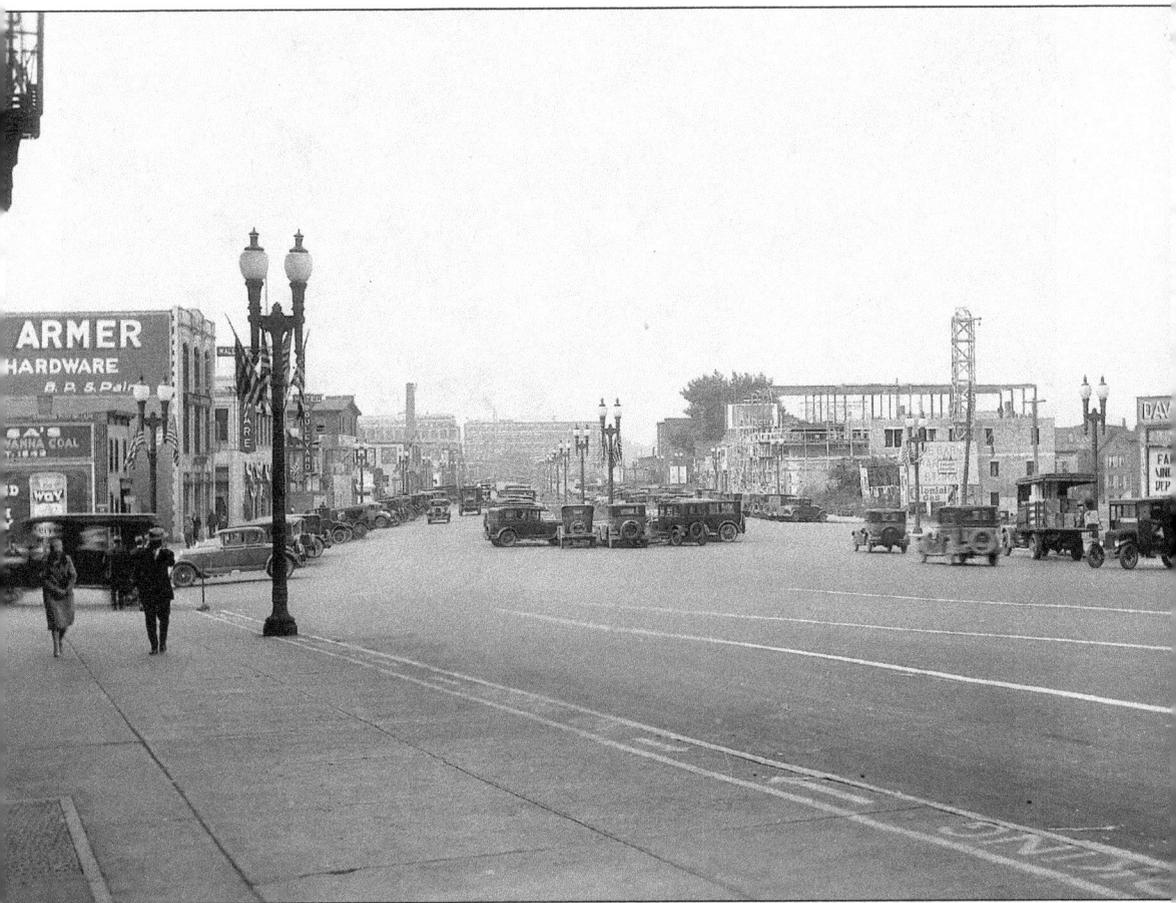

This view of Erie Boulevard, once part of the Erie Canal and opened as a road in 1924, was taken looking southward from State Street toward the General Electric Company. Notice the light standards, the center grassy mall with parking, and on the right the construction site of the main fire station, which opened in 1929. Today, as Edison Plaza, the former station houses a number of businesses. (Albert Gayer Collection/Efner History Research Center.)

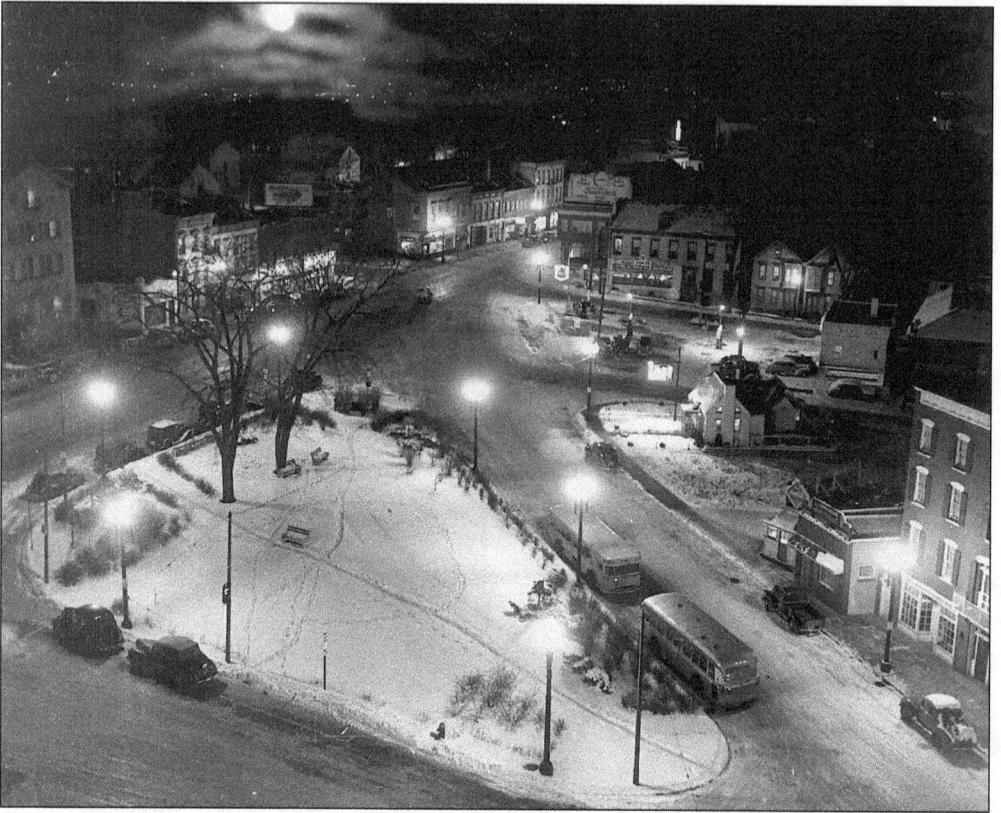

This photograph of Liberty Park was taken from the Van Curler Hotel in 1946. While Crescent Park was known as the "uptown park," Liberty Park stood at the foot of State Street. The George Westinghouse home was at this location prior to the widening of State Street. (Courtesy of Schenectady County Chamber of Commerce.)

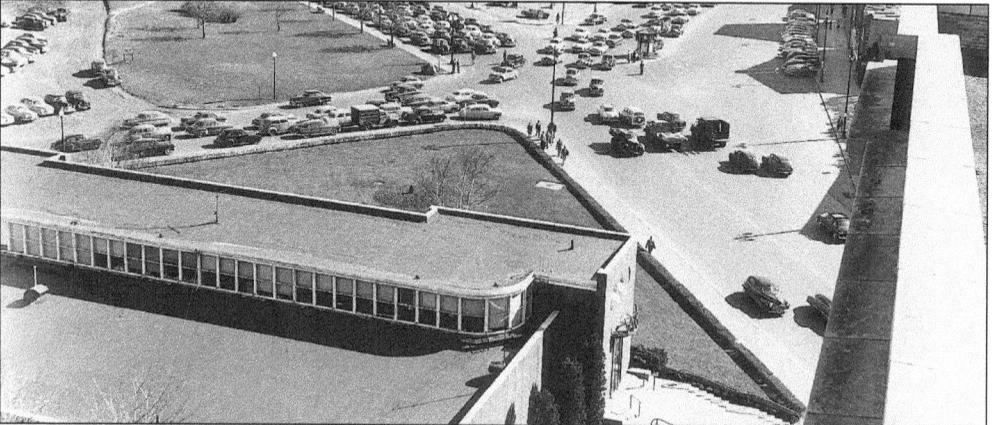

This 1952 view from the top of General Electric's Building No. 38 encompasses Washington Street to Liberty Park and Erie Boulevard to State Street. In the lower foreground is the old WGY studio building. Third shift workers are leaving the plant, and first shift is arriving to begin the day. The mall was removed to accommodate greater traffic flow, but the light standards remain. Today, this view would be vastly different with the presence of the crosstown arterial. (Larry Hart photograph/Efner History Research Center.)

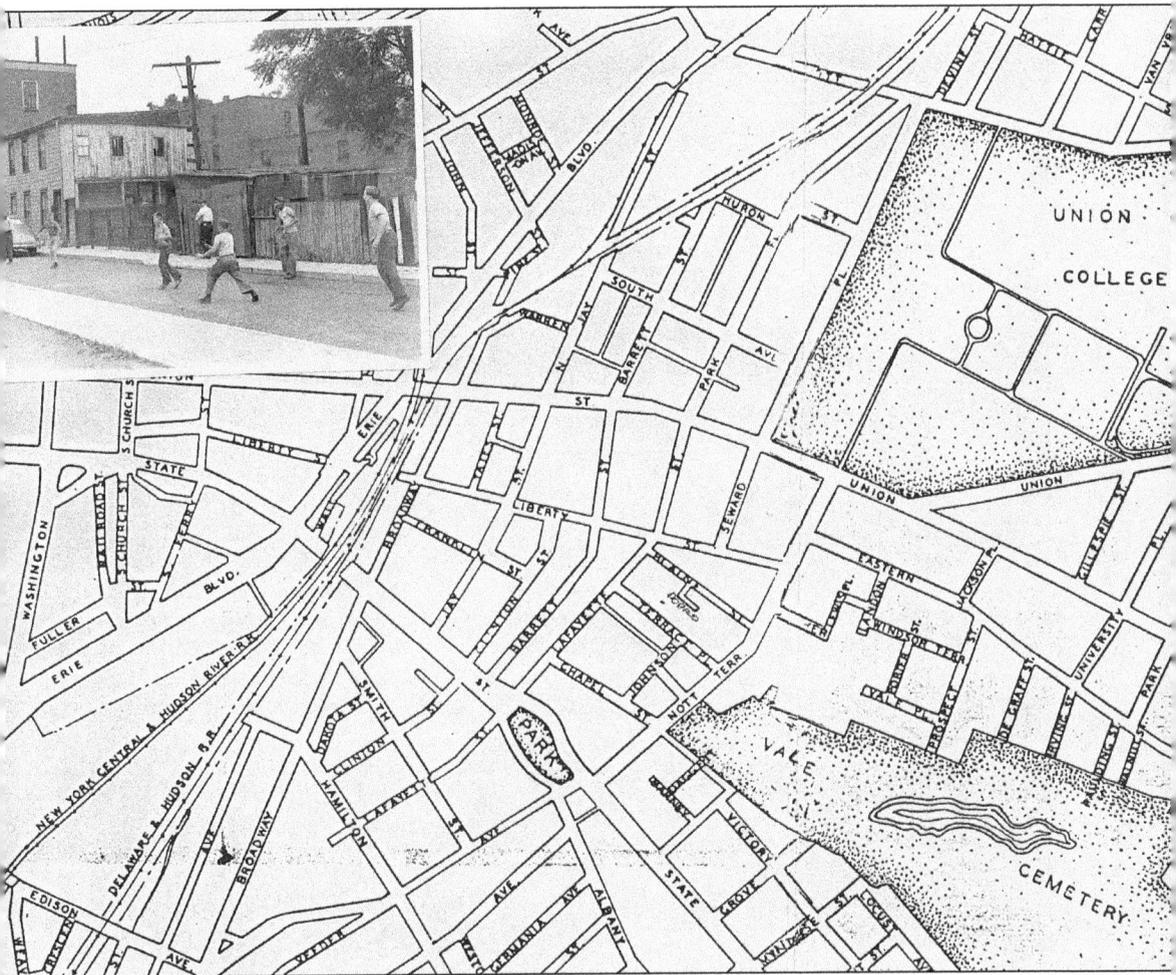

In the early 1950s, boys played street football on Blaine Street, which followed the path of the Cowhorn Creek. The area was razed between 1953 and 1956 in the urban renewal craze of the decade. Two Guys was located here, and more recently this site has been occupied by Machinery Apparatus Operations and CHP. The entire area was redesigned: Franklin Street was extended to Nott Terrace; Barrett Street was dead-ended at Franklin Street; Seward Street was cut off at Union Street; Liberty Street was curved to match Eastern Street; and Terrace Place, Blaine Street, Doboro Street, and Johnson Street were eliminated. (Efner History Research Center.)

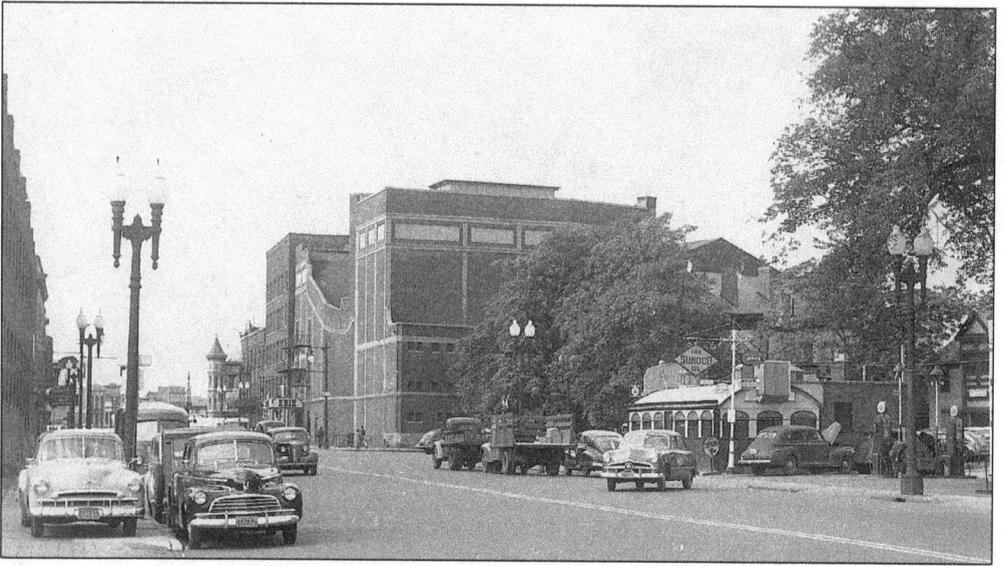

This 1953 photograph of Erie Boulevard was taken facing south toward State Street. In the distance is the tower of the Nicholaus Restaurant, now Maurice's, at State and Erie Streets. Across the street is the Erie Theater, which had two balconies; in the foreground is an old train car-style diner. The theater portion of the Erie building was demolished in 1963 for more parking, and the diner is the present-day location of Burger King. (Efner History Research Center.)

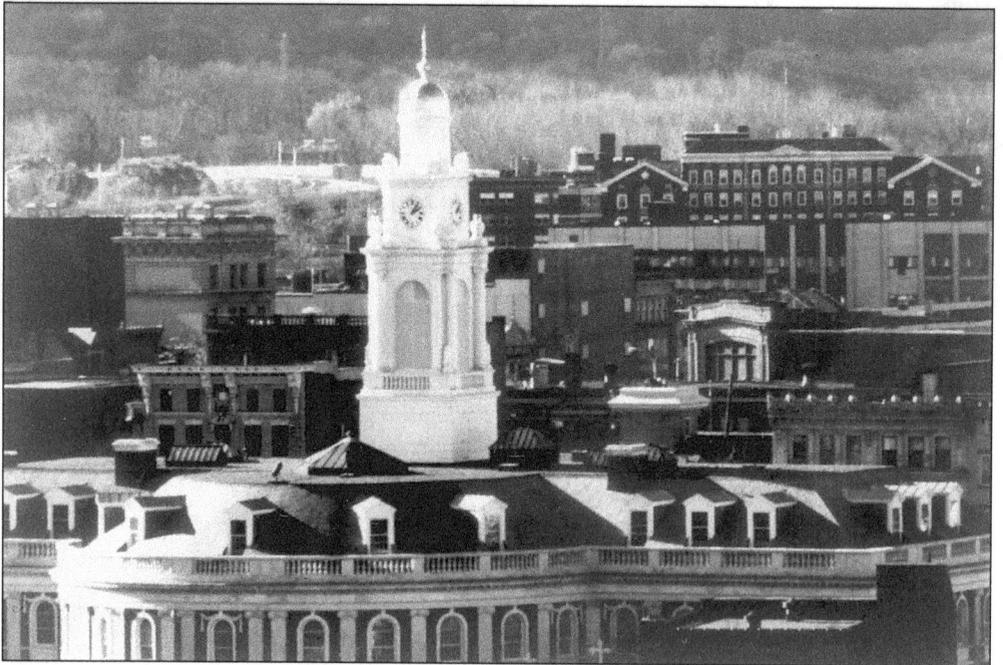

This photograph of the city's skyline was taken in late 1997. Visible are City Hall's clock tower, the tops of the Gleason Building and the Seneca Buildings and the former Masonic Temple, the State Theater marquee, Schenectady County Community College, and Interstate 890 curving toward the west. (Susan Rosenthal photograph/Efner History Research Center.)

Three

IN SERVICE
TO THE PUBLIC

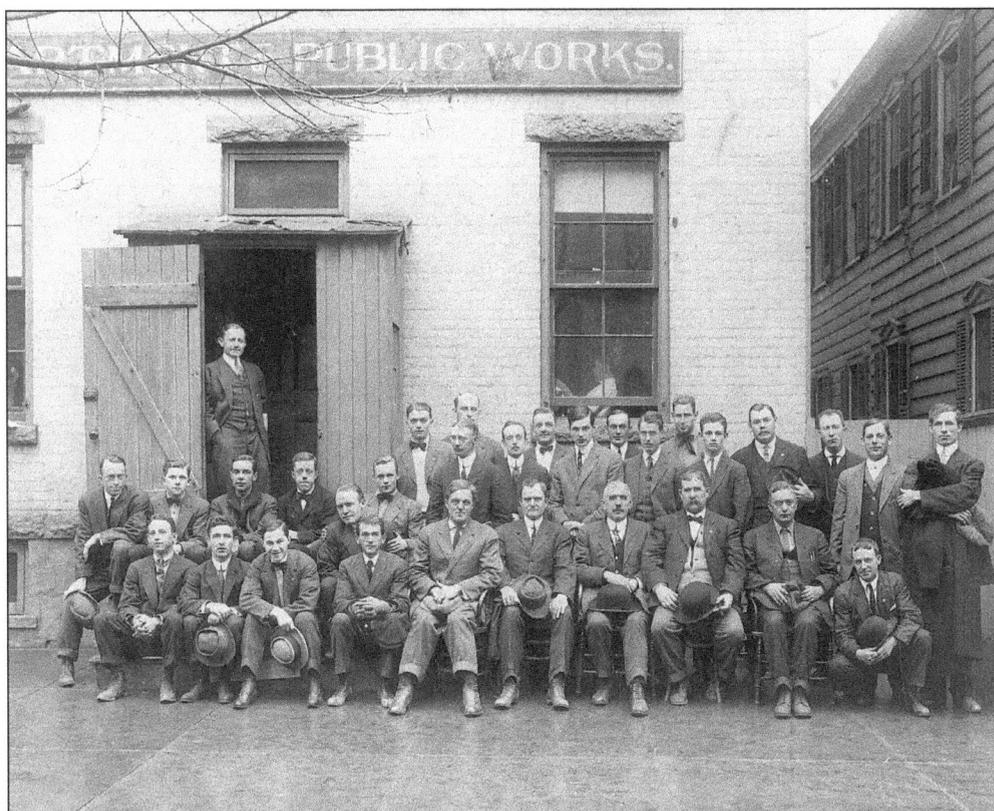

This photograph shows the employees of the city's department of public works *c.* 1915. Notice the large cut stones on which their feet are resting. (Efner History Research Center.)

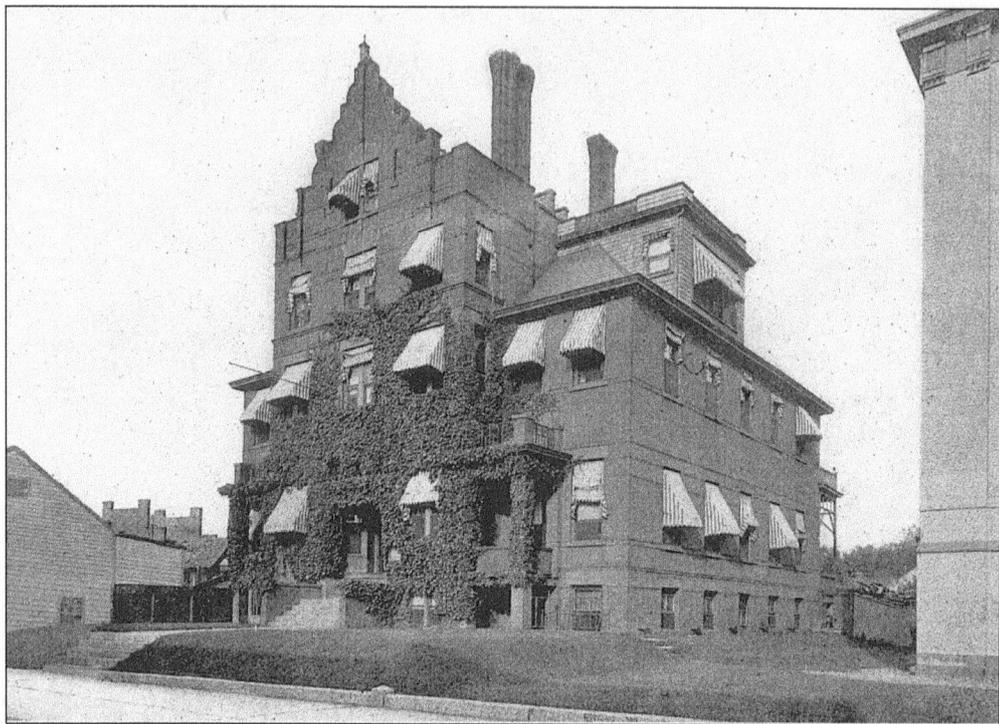

A $25,000 bequest from Charles G. Ellis enabled a new hospital to be built on Jay Street. The hospital was used from 1893 until 1906, when it was relocated and expanded on the outskirts of town. The move enabled the expansion of city hall, located next door. (Robson & Adee photograph/Efner History Research Center.)

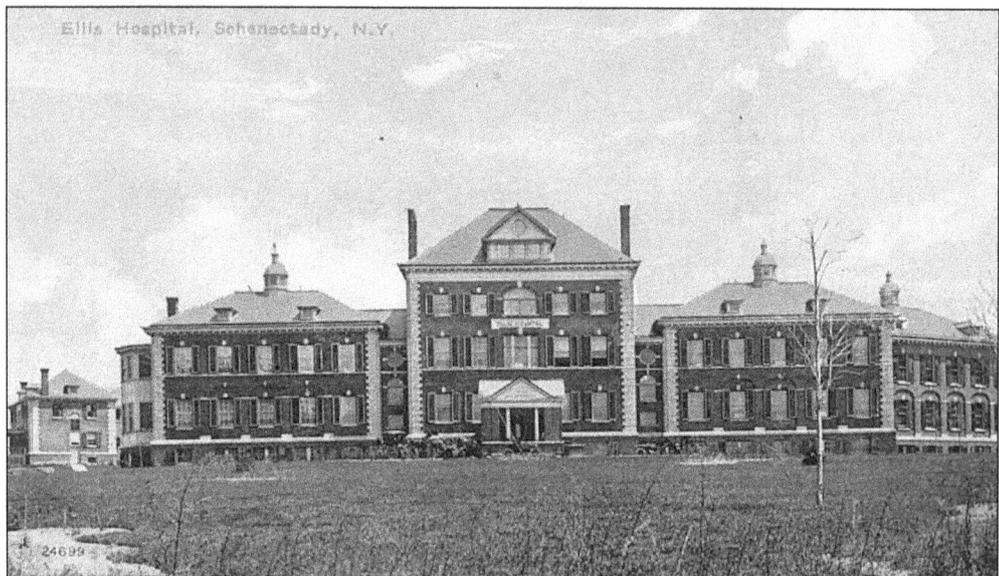

The new Ellis Hospital opened in October of 1906 on the crest of Nott Street hill. The hospital was built at a cost of $165,000 on the site of the former Mohawk Golf Club. On the far left of the postcard is the Whitmore Nurses' Home, which later became the site of Sunnyview Rehabilitation Hospital on Rosa Road. (Efner History Research Center.)

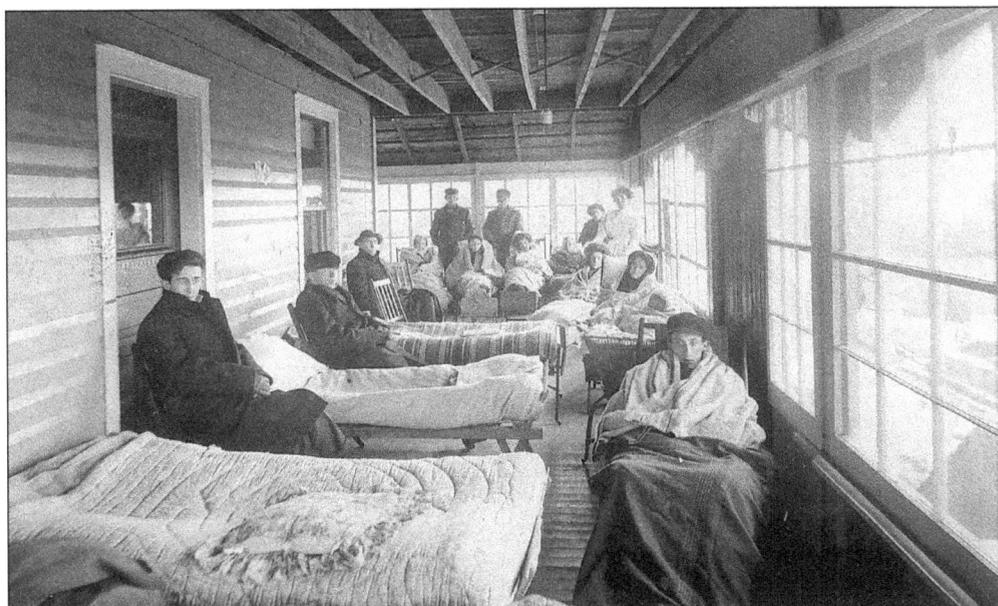

On the sun parlor are a nurse and her patients—men, women, and a baby—who are receiving the "ozone treatment." From 1909 to 1911, this building operated as the second temporary site of the Schenectady County Tuberculosis Hospital in Aqueduct. The building burned in 1911. (Efner History Research Center.)

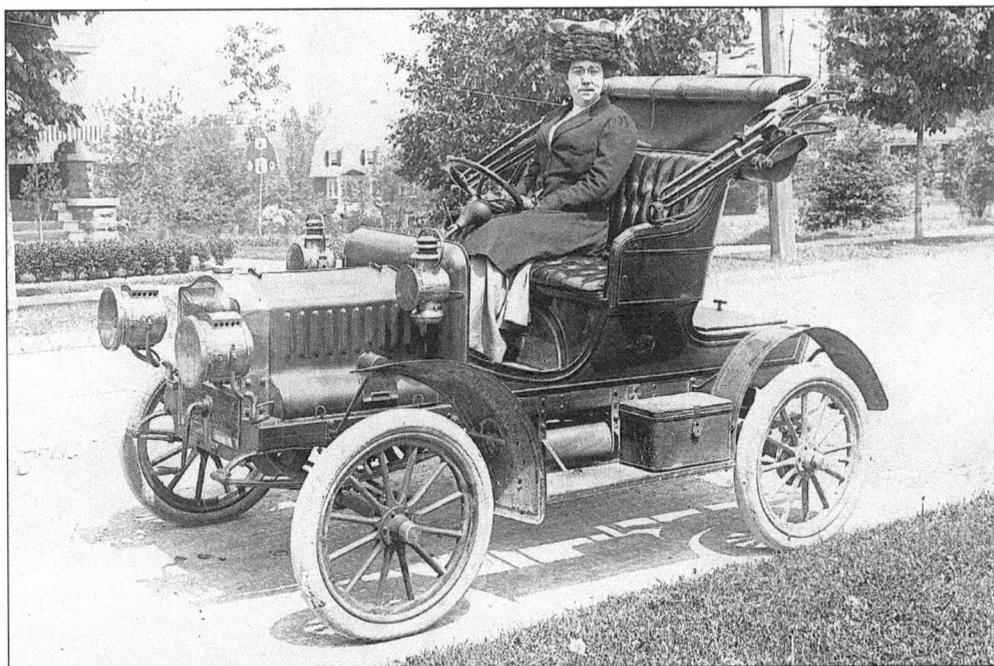

Dr. Elizabeth Gillette (1876-1965) came to Schenectady in 1900 and opened her own practice as a physician and surgeon. She remained in practice here for 37 years. She was the first doctor to own a car. In 1919, she became the first woman from upstate New York to be elected to the state assembly. When she retired, she did so to her Union Street home with her parrot, who was known for his "abundant vocabulary." (Efner History Research Center.)

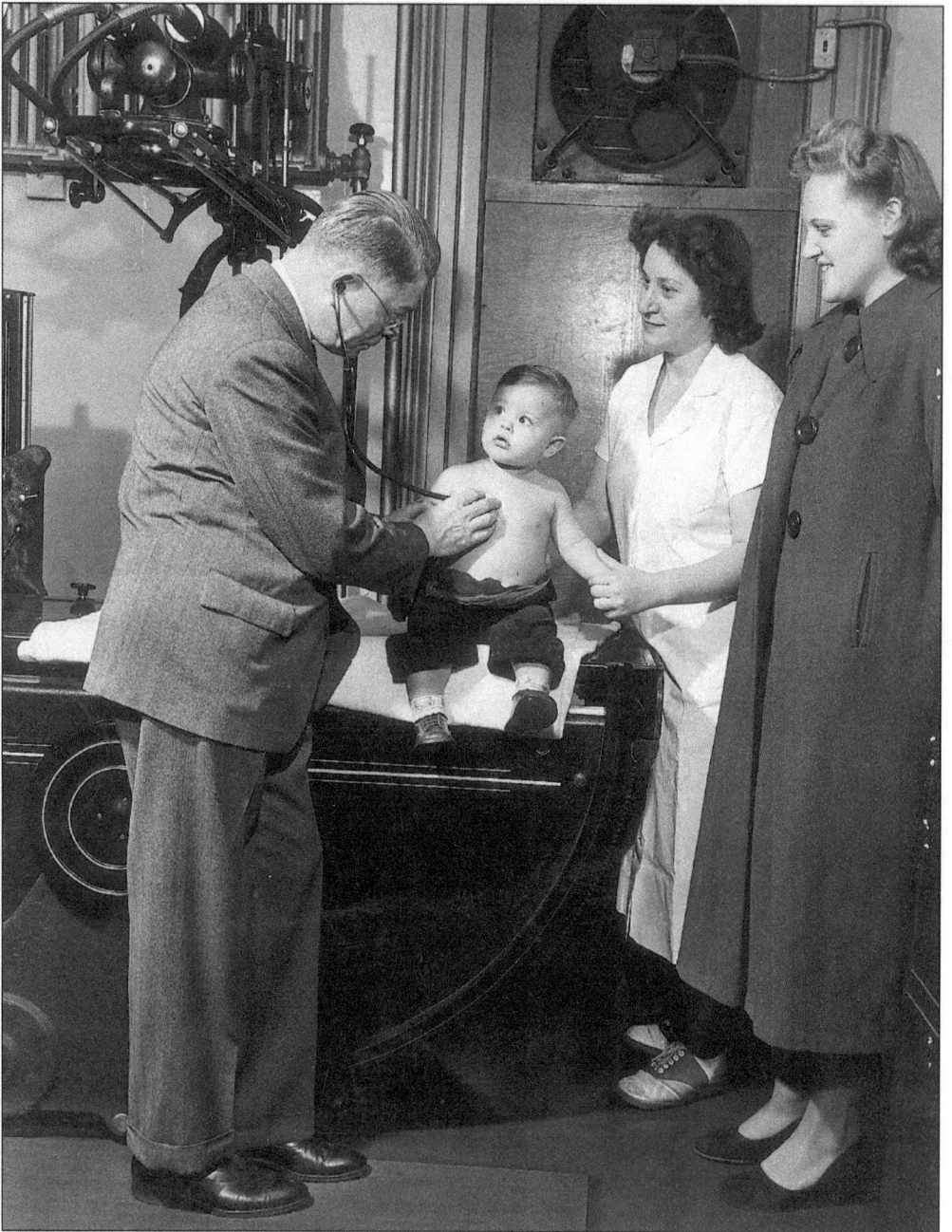

This wary baby watches the ministrations of the doctor, who was part of the city health care program of the 1940s. The Well Masters of 1679 monitored the city wells and were the first group involved with public health. Over time, the county health department took on the many of the functions of the city health department. (Jim Burns photograph/Efner History Research Center.)

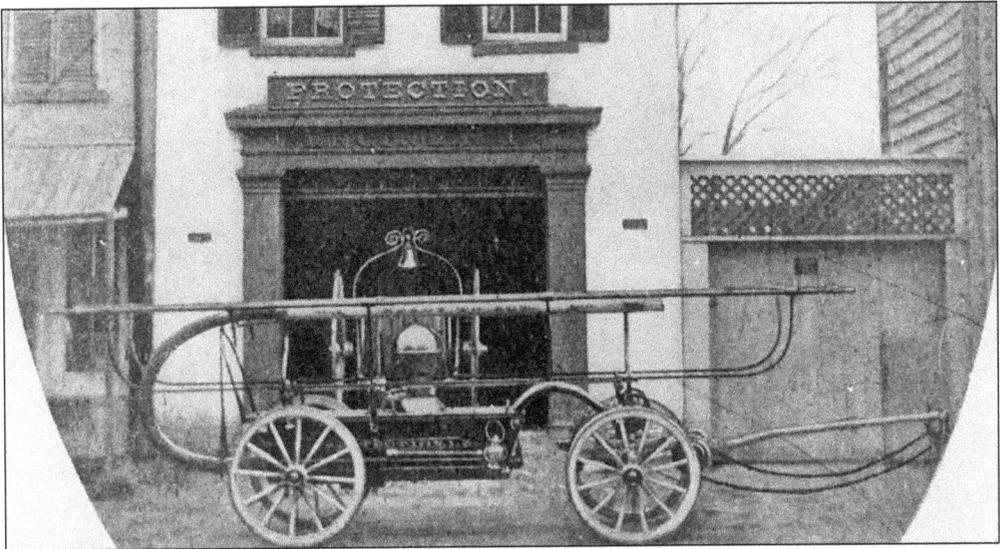

This early piece of firefighting equipment is a hand pumper. The first organized fire company in Schenectady was located at 340 State Street. Prior to that organization, the earliest force consisted of the brigades who fought fires with leather buckets. Those brigades were largely composed of volunteers who joined for the glory, the danger, and the uniforms. (Courtesy of Scott Haefner.)

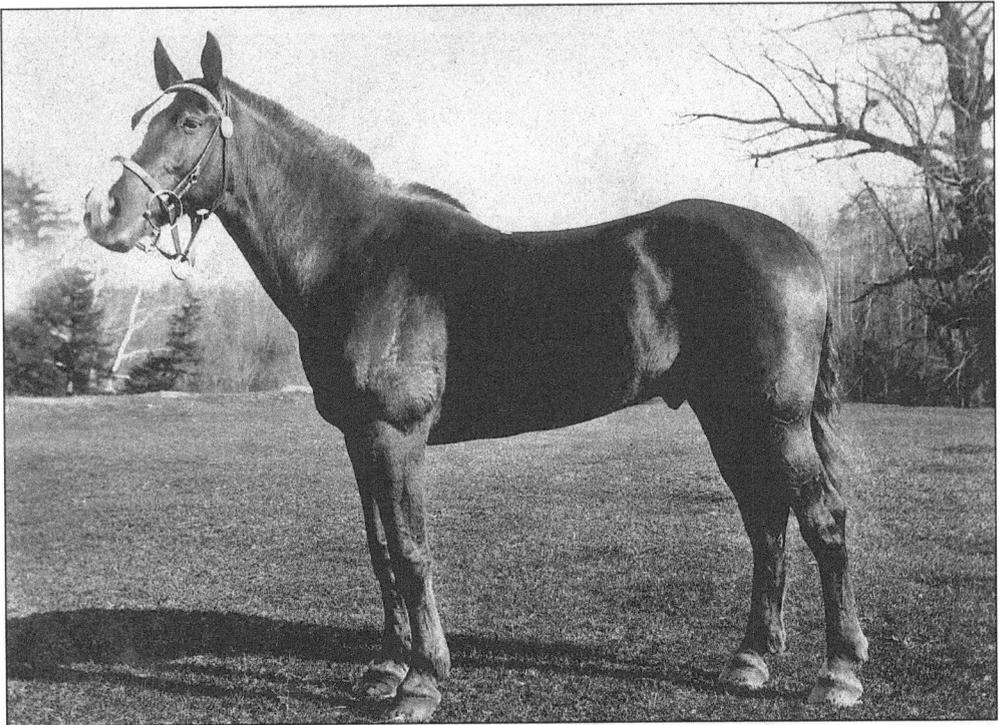

The early fire departments were equipped with their own horse. Van was purchased for $150 by the Van Vranken Hose Company No. 2 in 1896. He was a chestnut with a white face, weighing 1,212 pounds and standing 16 hands high. Van served full time for seven years and part time until 1911. (Edwin Anderson Collection/Efner History Research Center.)

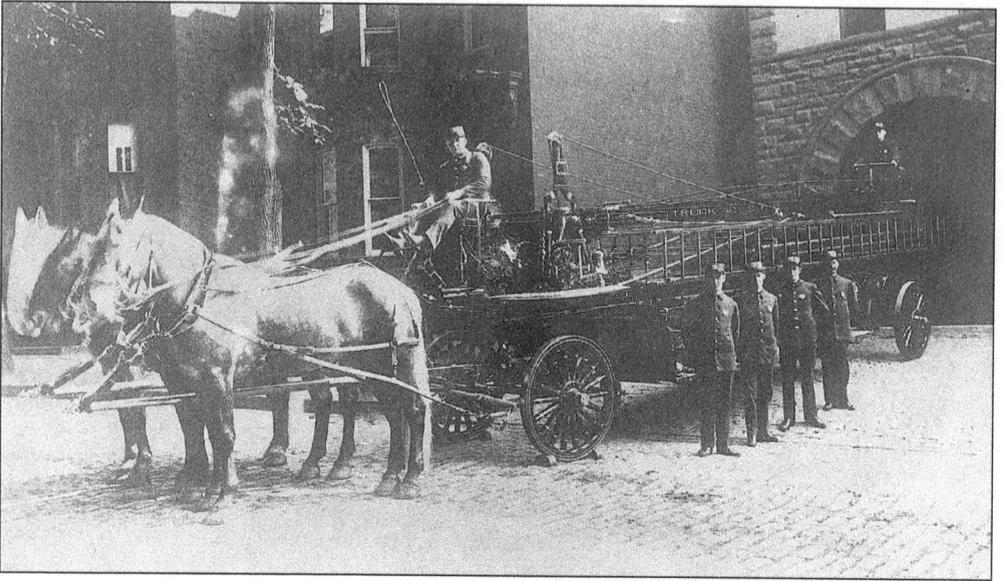

Fire equipment became more elaborate as years passed; however, the most reliable mode of power remained the horse. This undated photograph shows Central Fire Station's truck No. 2, with Augustus Pangburn, driver. Standing, from left to right, are Warren Blaser, William Dickson, Frank Falton, and Warren Hotaling. An unidentified fireman is in the back of the truck. (Edwin Anderson Collection/Efner History Research Center.)

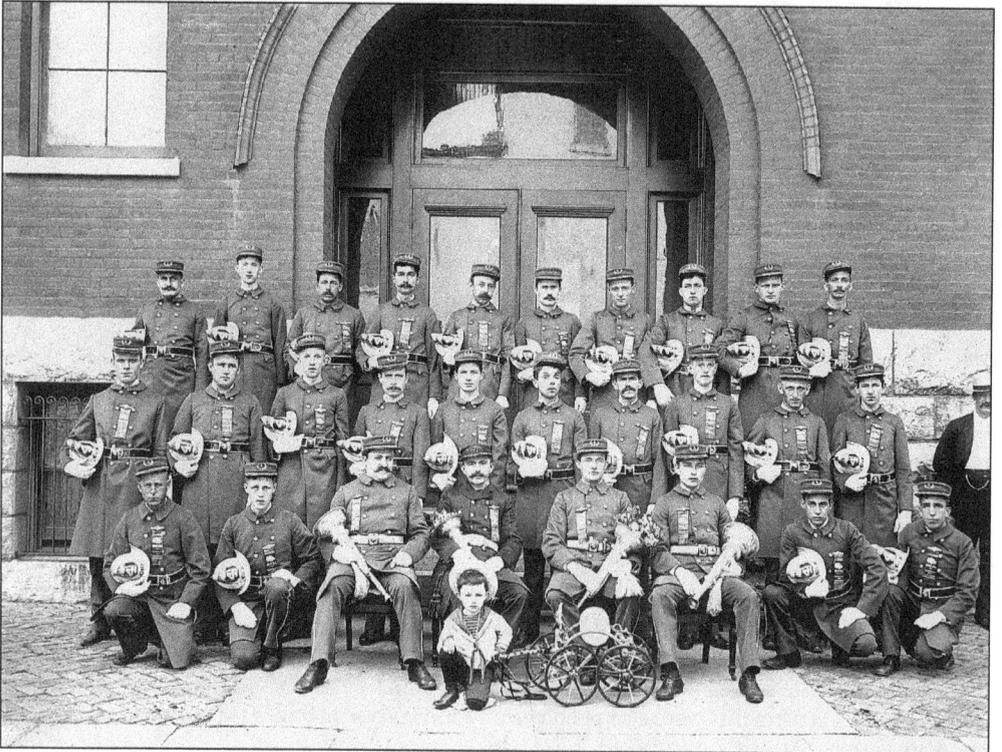

Taken at the turn of the century, this photograph shows the J.D. Campbell Hose Company No. 4 on South College Street. (Van B. Wheaton photograph/Efner History Research Center.)

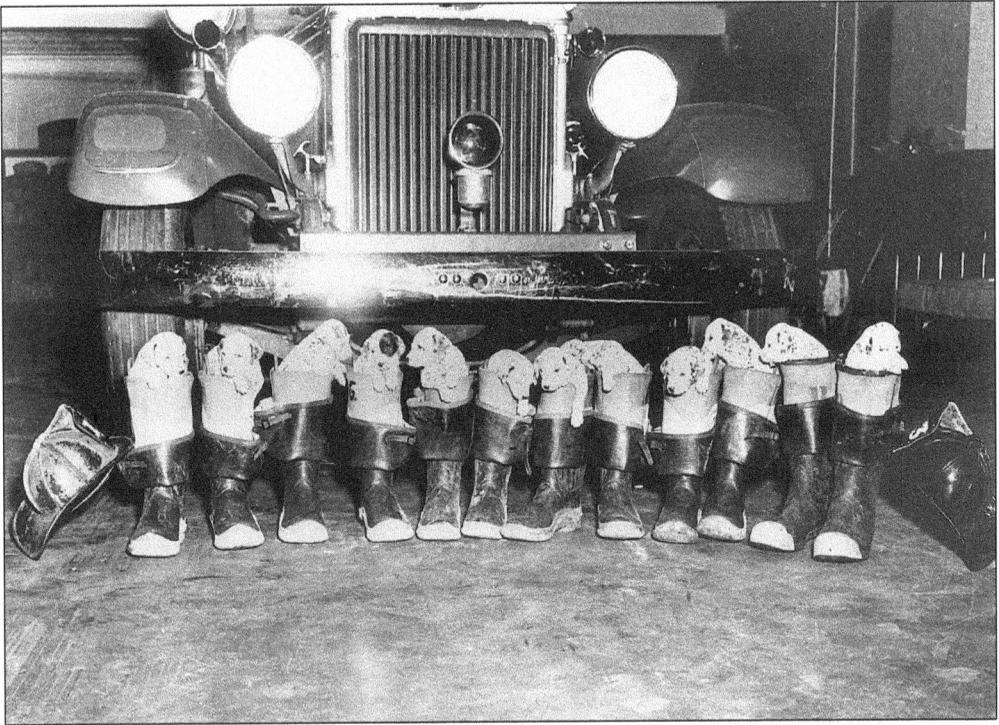

A dozen junior firefighters pose in front of a vintage fire engine dating from the 1940s or 1950s at the Brandywine Fire Station on Brandywine Avenue. (Sid Brown photograph/Efner History Research Center.)

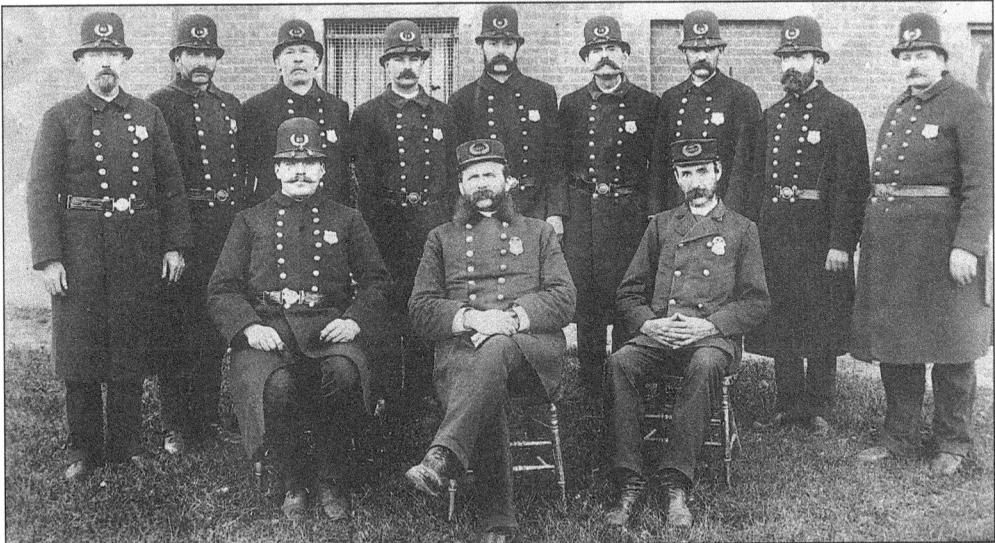

This group of men comprised "Schenectady's Finest" as they were in 1887. The photograph was taken in front of the old city hall on Jay Street. Pictured, from left to right, are the following: (front row) James Flanigan, Detective Sergeant; William L. Campbell, Police Chief; and Frank V. DeForest, Chief of Detectives; (back row) William Jones, George Trumbull, George J. Dent, James W. Rynex, Albert Gould, William F. Walsh, Aaron Waldron, P. Floyd Hallenbeck, and Job Wolfe. (Francis Platt Collection/Efner History Research Center.)

This photograph shows two unidentified officers on the front steps of the Summit Avenue Precinct in 1901. Early law enforcement officers performed many of the same tasks as those of today. (Courtesy of Larry Hart.)

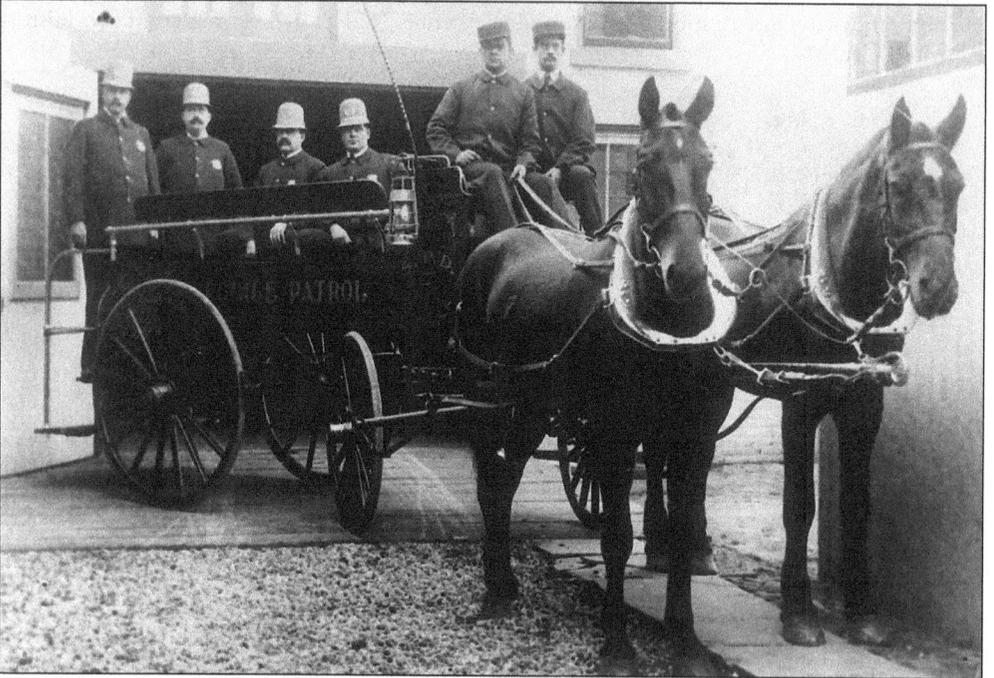

Taken *c.* 1905, this photograph depicts police aboard a patrol wagon. It was taken in front of the old police wagon house that was located to the rear of the old city hall on Jay Street. By this time, horses pulling vehicles had to contend with the noise and disruptiveness of the trolleys. (A. Gayer Collection/Efner History Research Center.)

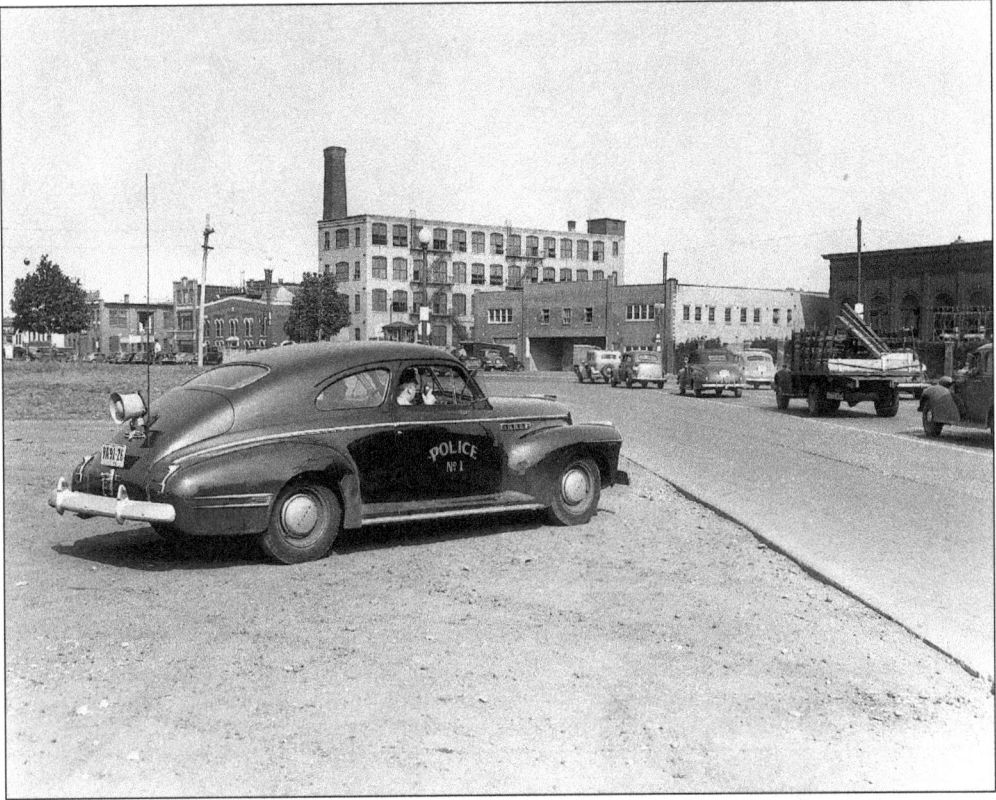

Police car No. 1, complete with siren and radio, monitors traffic on Rice Road near the junction of Erie Boulevard in the 1940s. (Doug Dales photograph/Courtesy of Scott Haefner.)

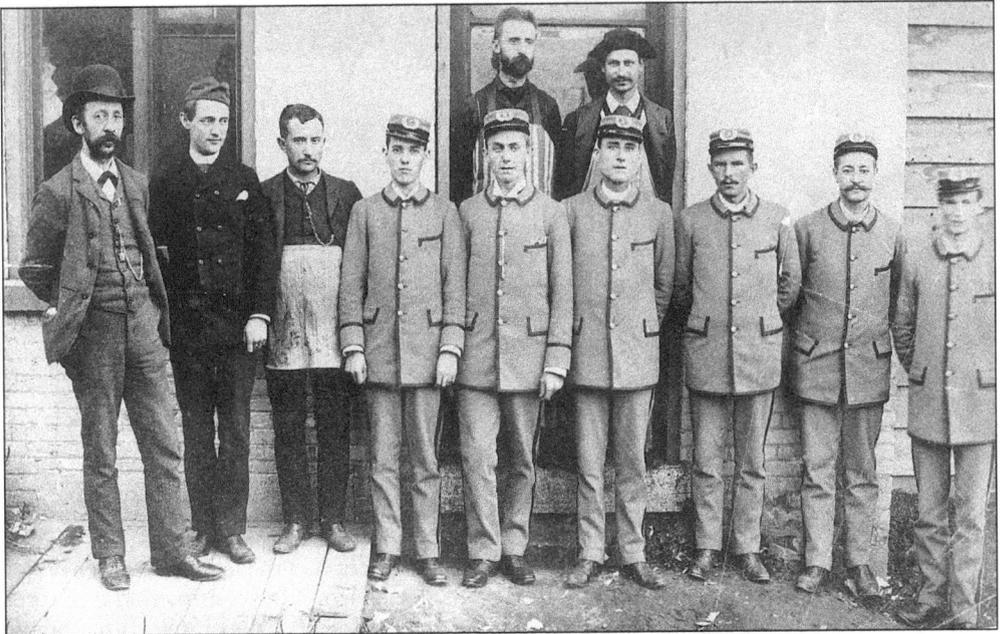

These "mail boys" pose at 132 Wall Street *c.* 1895. (Courtesy of Larry Hart.)

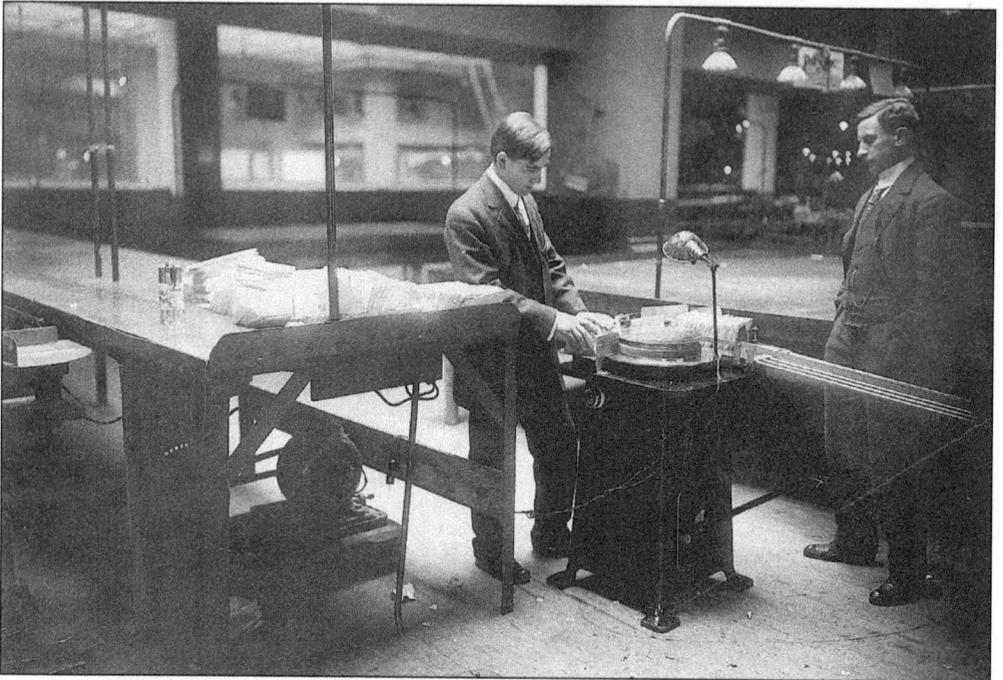

A postal employee operates a hand-fed canceling machine in this photograph of the interior of the post office in the 1920s. (Efner History Research Center.)

This photograph dated August 1, 1934, shows the reconstruction of the main post office on Jay Street. Beyond is the roof of the newly built city hall. To the left of the construction is the area that was later demolished, where the county public library was erected in 1969. (Black Studio photograph/Courtesy of Larry Hart.)

On the northwest corner of Union and North Ferry Streets sat a building that had been built by the Union College. In 1798, when the city received its charter, arrangements were made between the city's trustees and Union College to use the building as the city hall. First orders of business there were as follows: no hats are to be worn at meetings; persons wishing to speak must stand and address the chair, and all others must be quiet; and a 25¢ fine is to be levied for nonattendance. (From *Schenectady Ancient & Modern*, by Joel Monroe.)

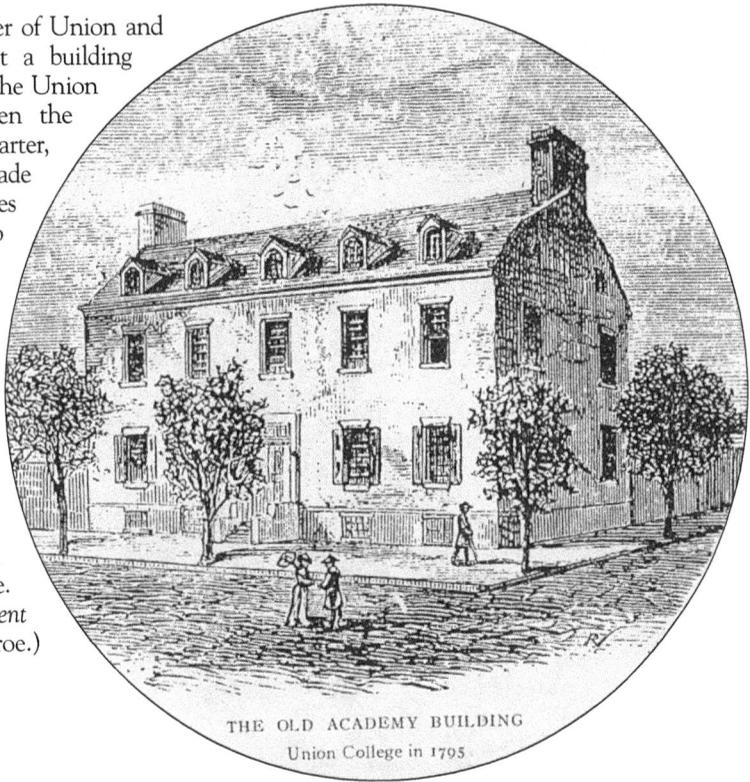

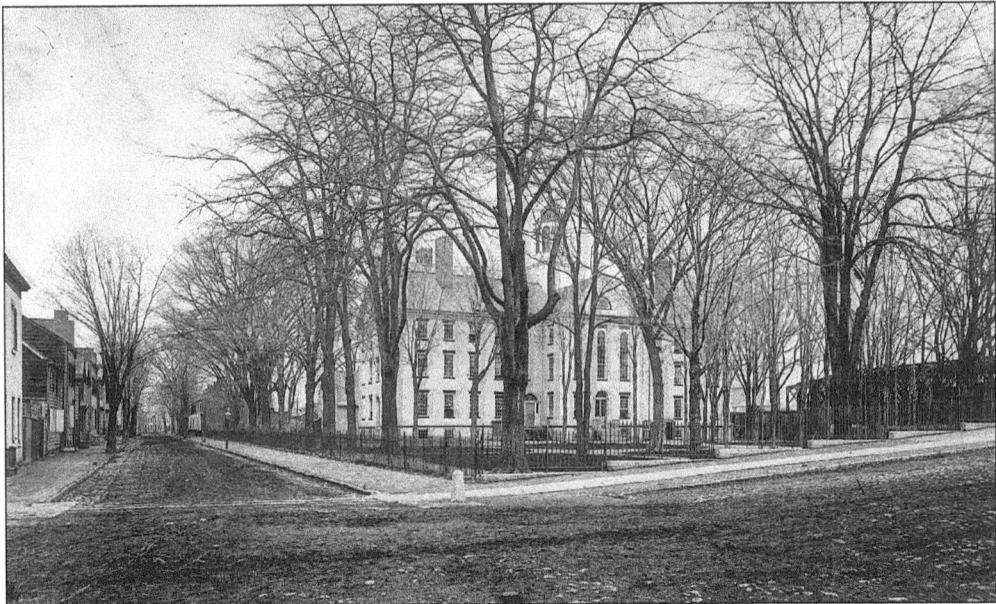

THE OLD ACADEMY BUILDING
Union College in 1795.

Situated on the corner of Union Street and what was to become the Erie Canal, this building served as the second city hall. Erected in 1804 as Union College's West College, the building was purchased in 1814 from Union College, which was expanding uptown. This photograph was taken in the 1880s; the building was razed ten years later. The site is now the Van Dyck parking lot. (Albert Gayer Collection/Efner History Research Center.)

51

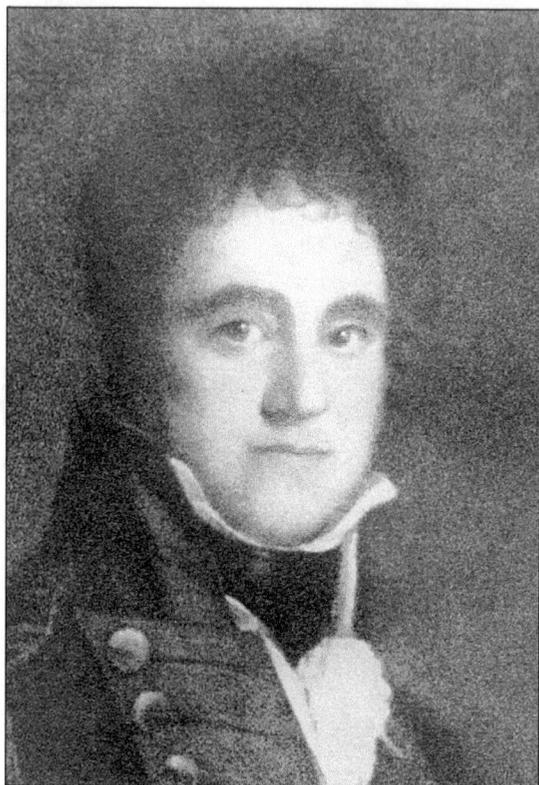

Mordecai Myer, a veteran of the War of 1812, was one of Schenectady's early mayors. After serving in the military, Myer became the city's first Jewish mayor and was in office from 1851 to 1854 at the second city hall building. (Efner History Research Center.)

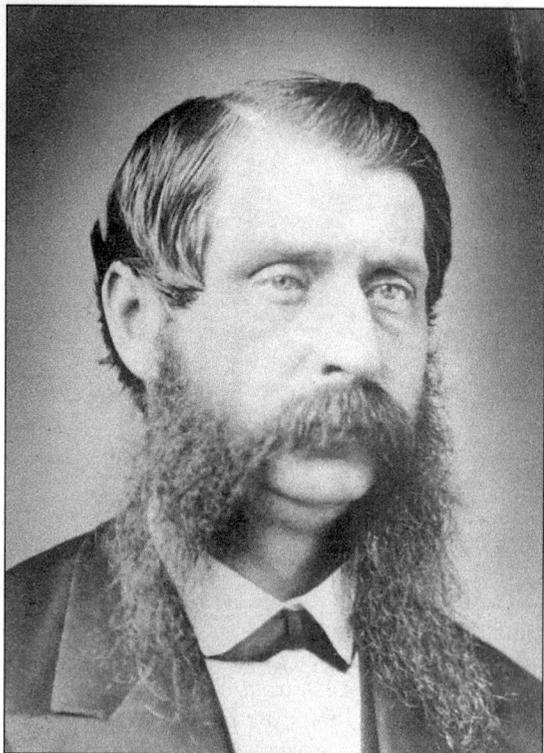

William Van Horne was an unorthodox mayor, who served only from 1871 to 1872. He dressed as a vagrant and roamed the streets to test the alertness of new law enforcement officers. One notable time he pretended to be drunk and was taken to the police station, where he revealed his identity to obtain his freedom. (Efner History Research Center.)

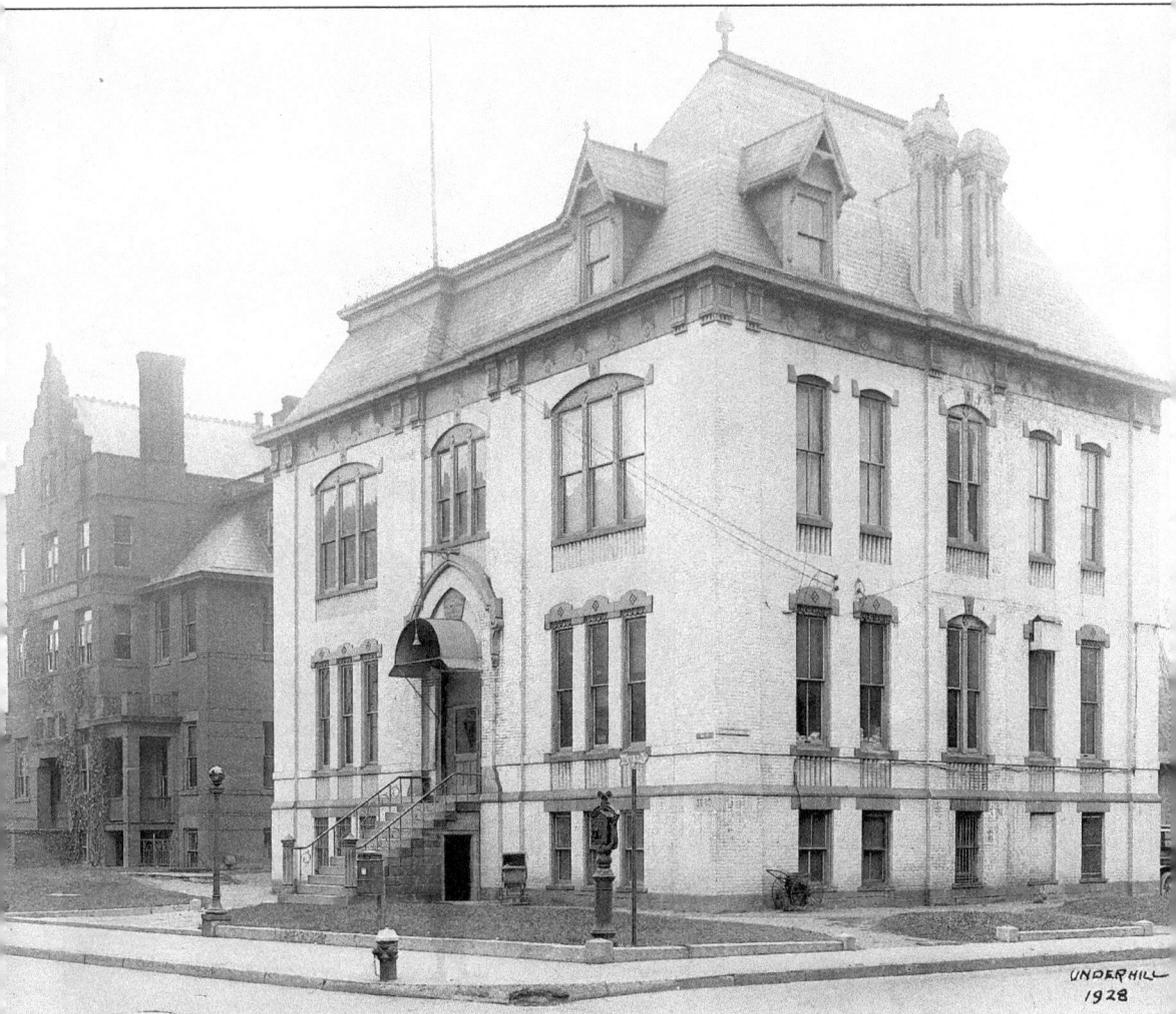

UNDERHILL
1928

In the 1880s, city hall was relocated to this Jay Street building, donated to the city by W.K. Fuller. By the 1890s, the growth of the city necessitated more space for government business; the adjacent building, the former Ellis Hospital, was annexed. This photograph was taken in 1928, one year before the building was demolished. (Underhill photograph/Courtesy of Scott Hefner.)

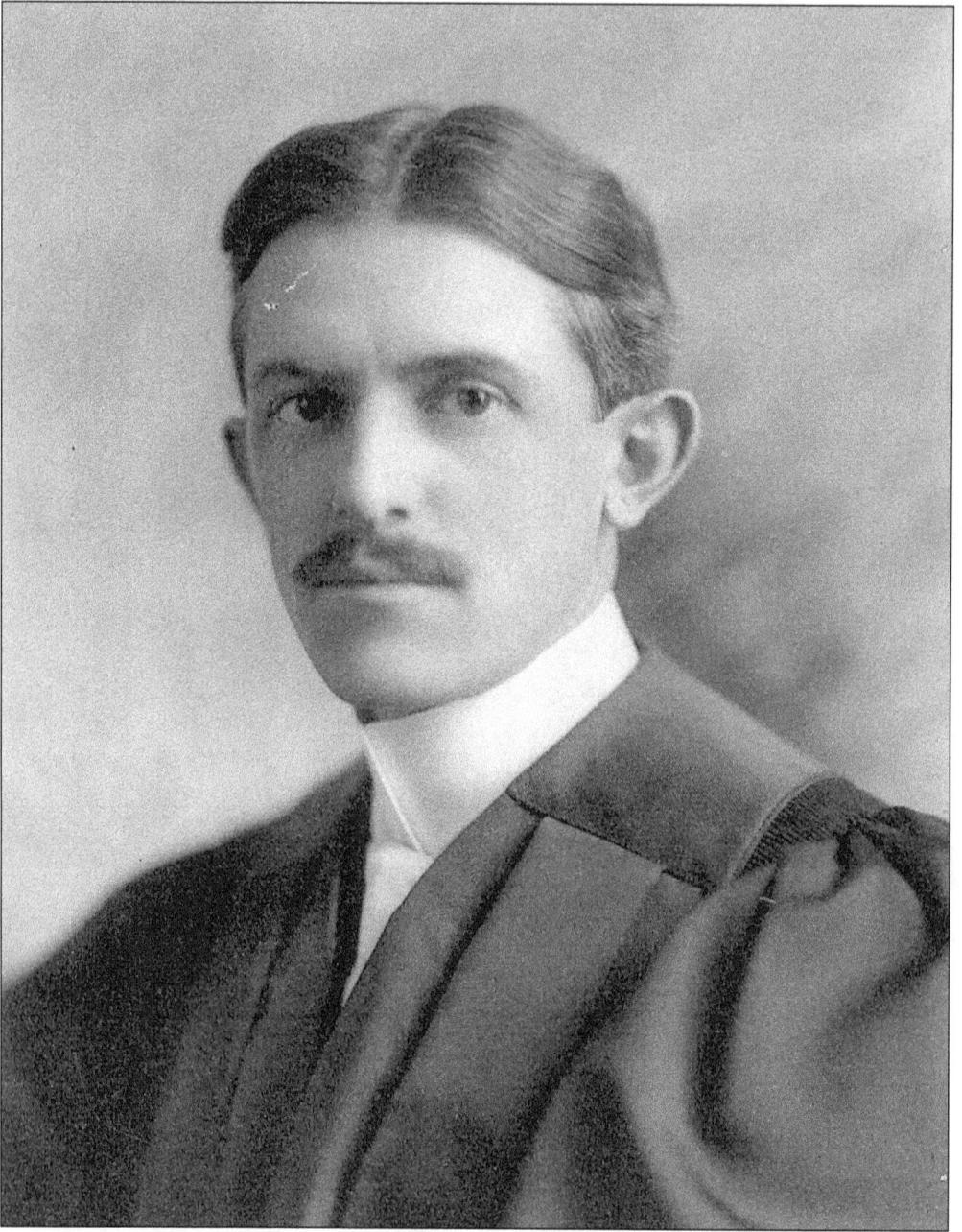

George Lunn began his career as pastor of the Dutch Reformed Church. His penchant for expressing political views prompted the church elders to suggest that he pursue a political career, his true calling. Subsequently, Lunn became Schenectady's first socialist mayor. Popular with the voters, he was elected to three separate terms: 1912–1913, 1916–1917, and 1920–1922. Under his administration, Schenectady achieved great social reforms. The public school system was expanded, streets were paved, street lights were installed, and the first municipal garbage collection service in the country was initiated. Lunn later became New York State's Lieutenant Governor. (He changed his party allegiance to Democrat in 1916.) (Ray Rowe photograph/Courtesy of the First Reformed Church.)

Henry Fagel served as mayor during Schenectady's peak in heavy manufacturing, from 1928 to 1931 and again from 1934 to 1935. He guided the city through the darkest years of the Great Depression. (Efner History Research Center.)

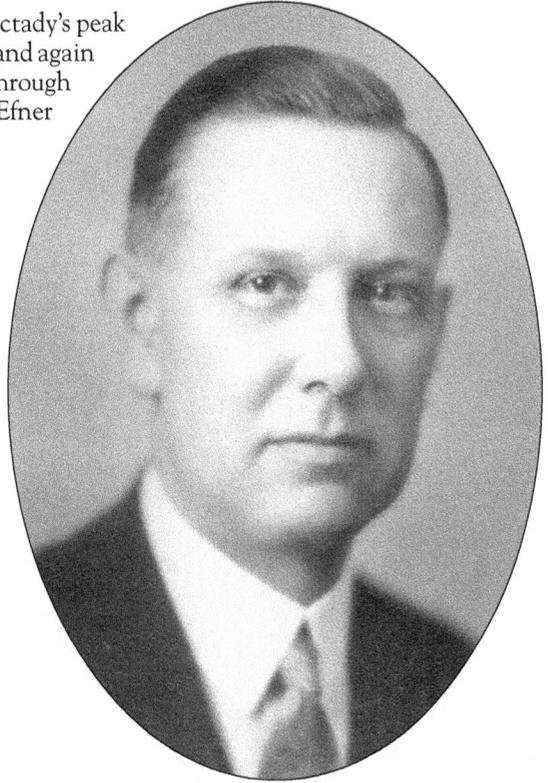

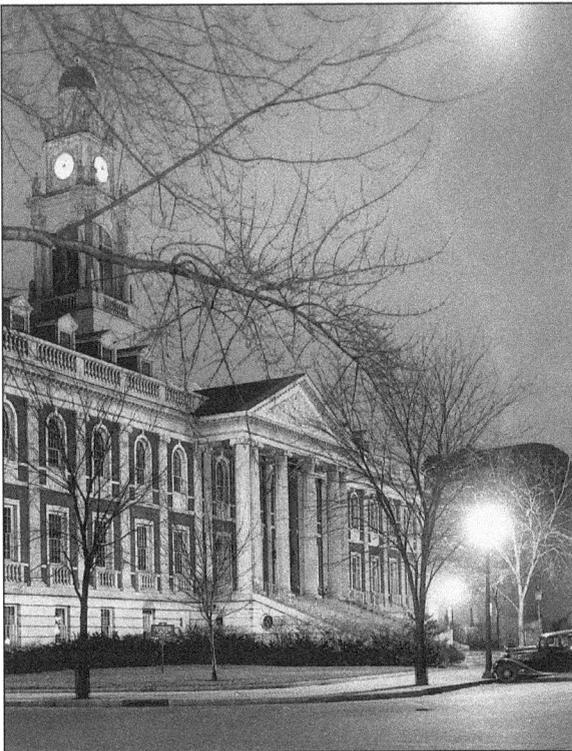

Schenectady decided to build a new city hall in the late 1920s. A national contest was held to choose the architect, and it was won by the famous firm of McKim, Mead, and White. Due to the great cost of the project during the Depression, the city hall was called "Fagel's Folly" in honor of Mayor Henry C. Fagel, who was serving at the time. Completed in 1931, the magnificent structure was later placed on the National Register of Historic Places. This photograph dates from 1940. (Courtesy of Larry Hart.)

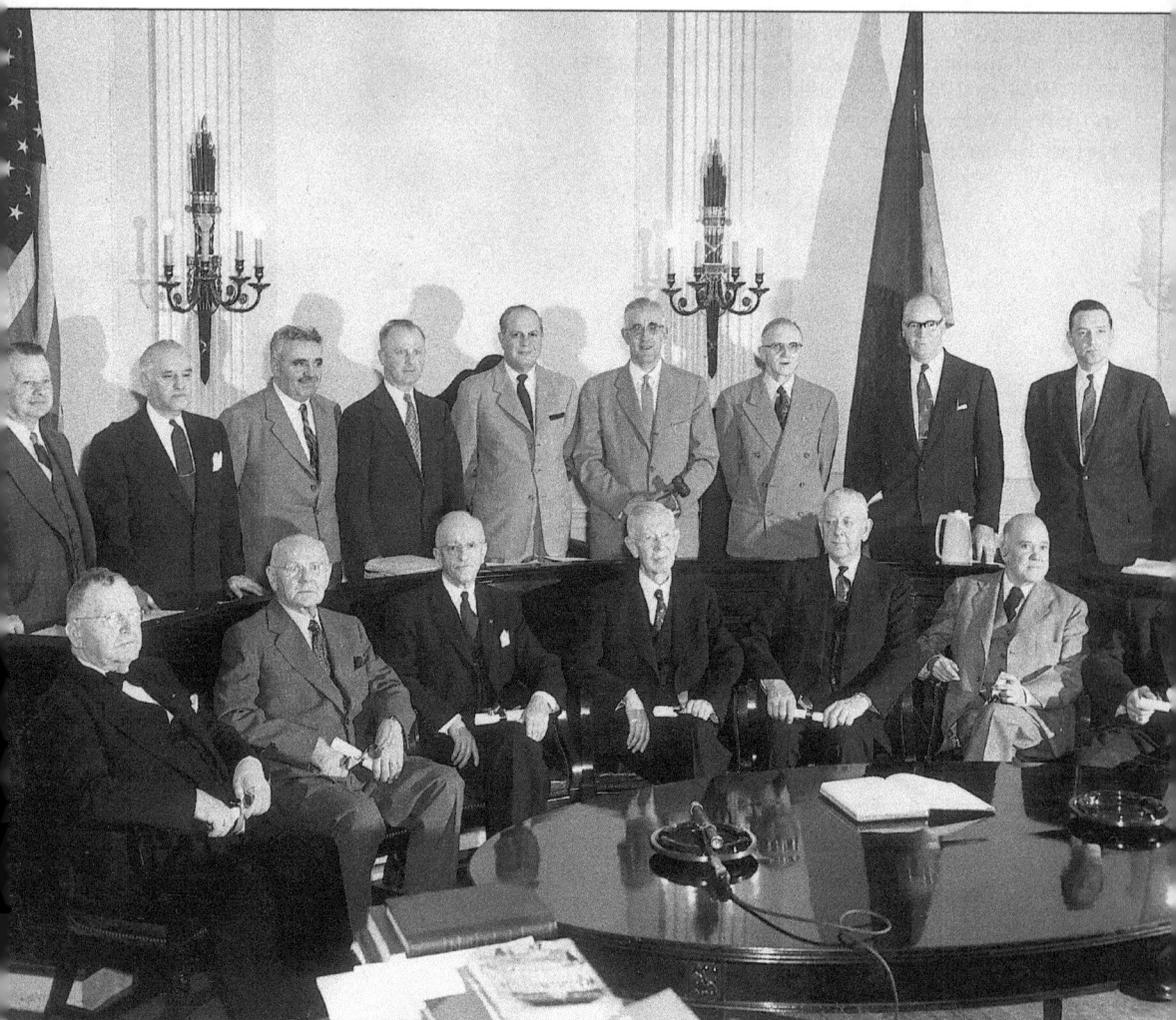

Mayor A.C. Wemple and city council members give the former mayors the city's highest honor of Schenectady Patroon on March 2, 1954. The mayors, from left to right, are as follows: (seated) Charles Simon, 1918-19; Clarence Whitmeyer, 1923; William Campbell, 1924-25; Henry Fagel, 1928-31; Robert Baxter, 1934-35; Mills Ten Eyck, 1940-49; and Owen Bagley, 1950-51; (standing) Louis Rinaldi, unidentified, Alex Grasso, Arthur Boehm, Frank DeManna, A.C. Wemple, Thomas Monihan, Ken Sheldon, and Sam Stratton. (Jim Garrett photograph/Courtesy Scott Haefner

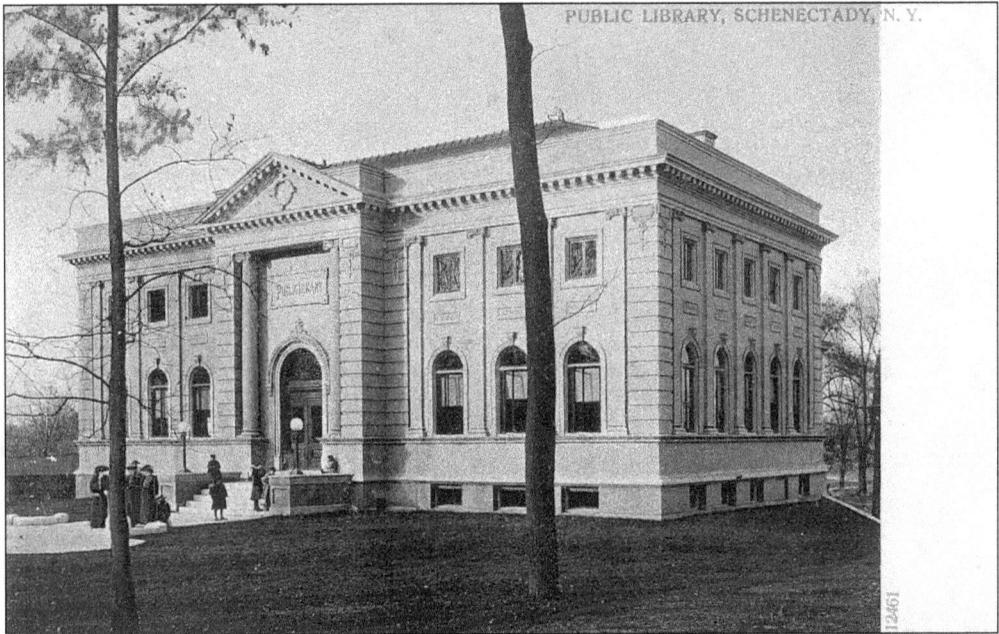

The public library opened in 1903 at the corner of Union Street and Seward Place. Built with funds from the Carnegie Foundation and a General Electric grant, the library's exterior walls are adorned with the names of literary greats. The library was the first public building in Schenectady to be wired for electricity. The building ceased to function as a library in 1969, when a new library was completed across the street from the main post office. The old library now is used by Union College as Webster Hall Dormitory. (Efner History Research Center.)

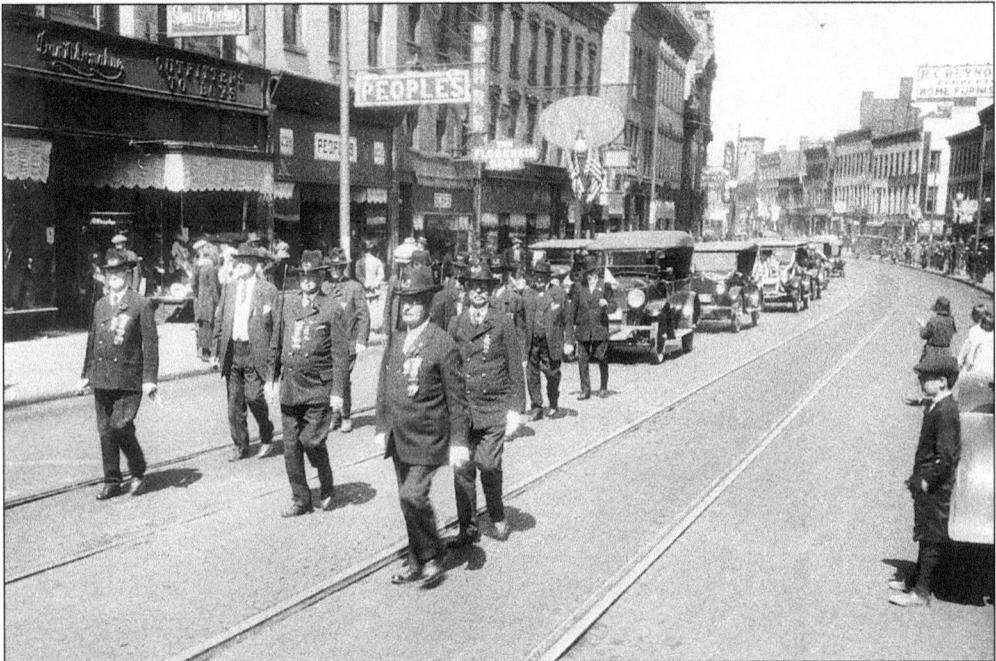

Schenectady residents answered the call to many battles. Here, Civil War veterans march proudly up State Street in the 1923 Memorial Day parade. (Courtesy of Larry Hart.)

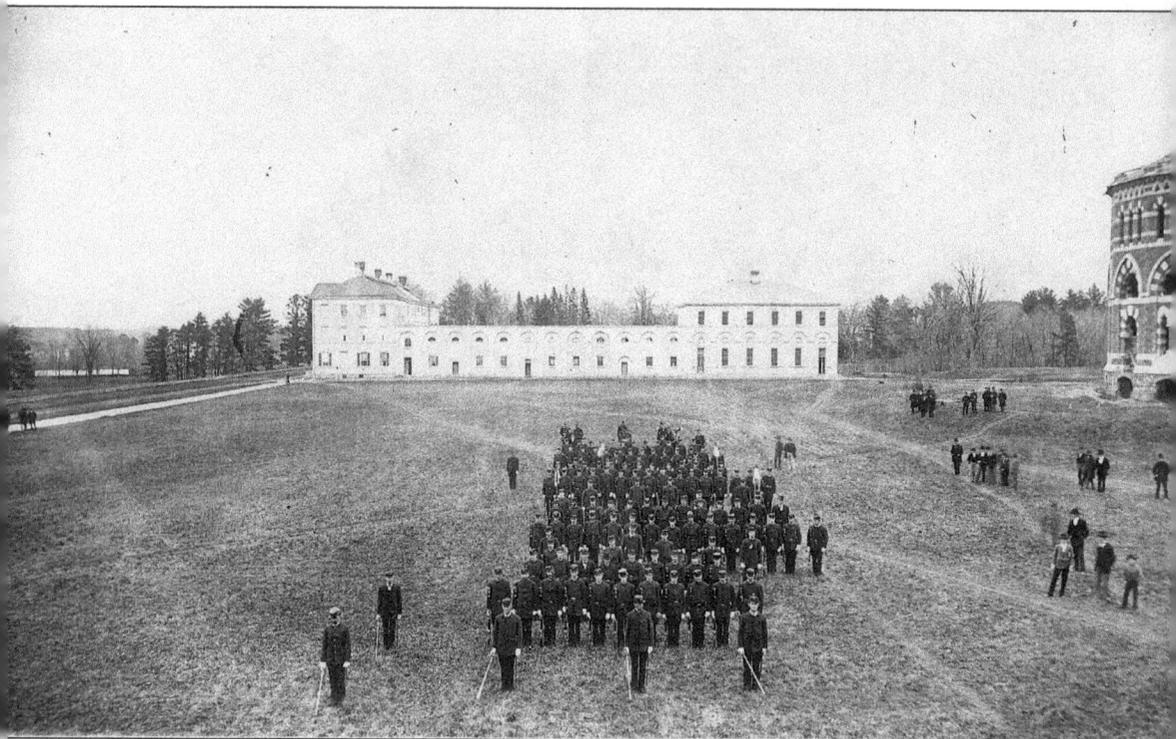

Company A of the Union College cadets join in field exercise in front of Union's newly constructed rotunda. Behind the cadets is North College. (Courtesy of Scott Haefner.)

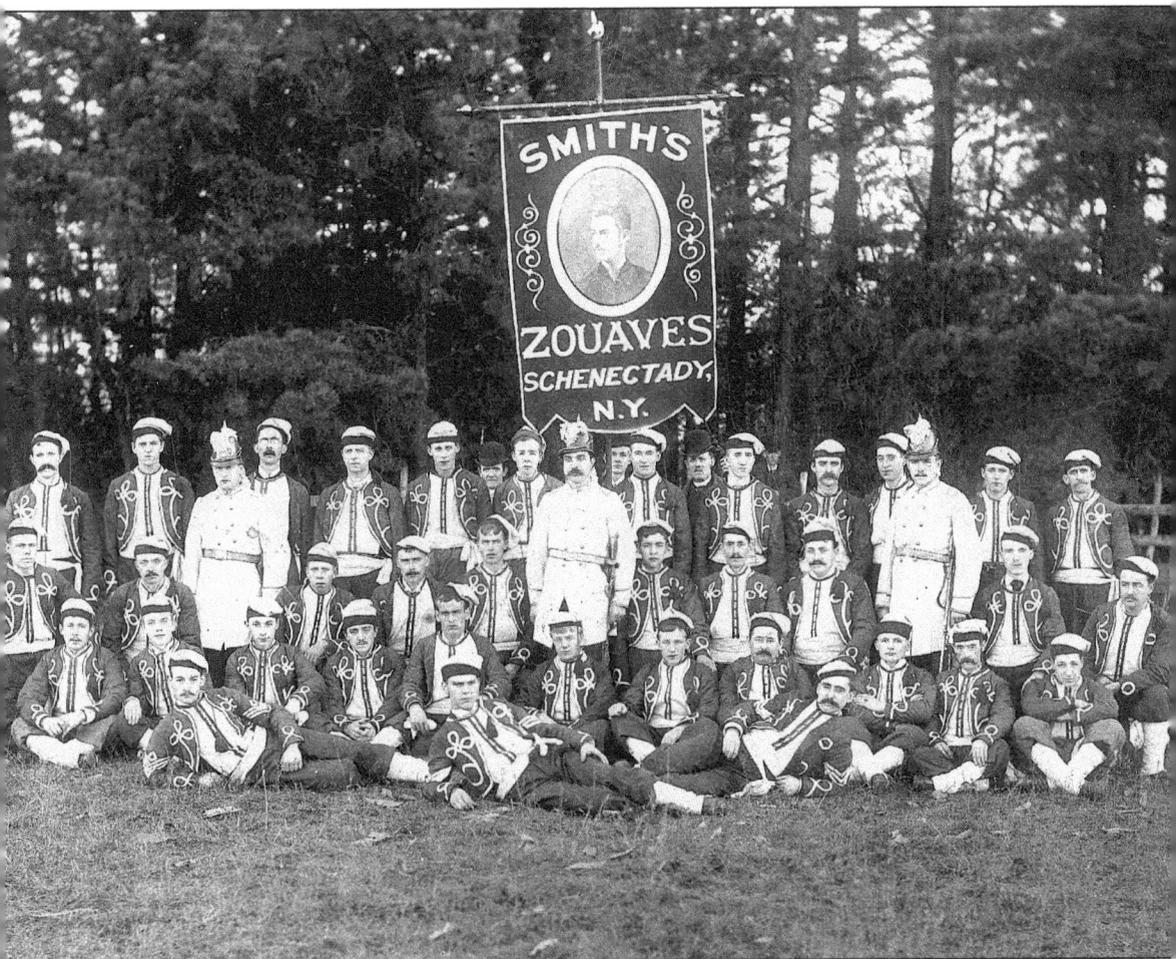

The Zouaves were a fraternal marching company dating from the American Civil War. They wore the uniform of the French Zouaves. Their red bolero jackets were easy to spot on the battlefield, so they were abandoned. Kneeling in the second row, fifth from the right, is Frank de Forest. (Jay DeForest Collection/Efner History Research Center.)

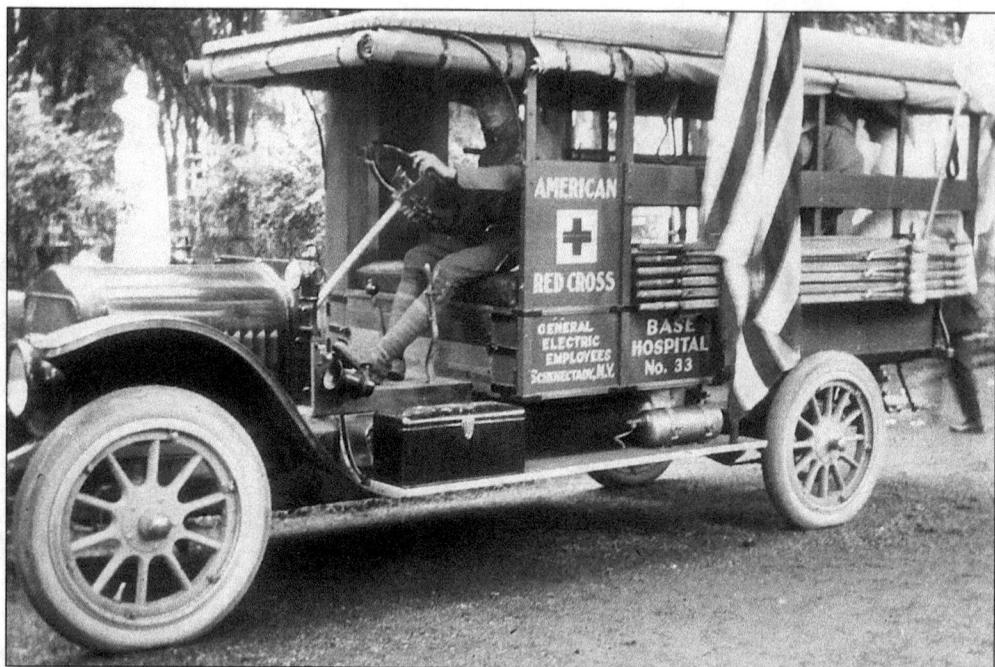

Workers at General Electric were among supporters of the war effort during World War I, the "war to end all wars." This photograph taken *c.* 1917 shows a U.S. Army medic driving an American Red Cross ambulance donated by the employees of General Electric. (Efner History Research Center.)

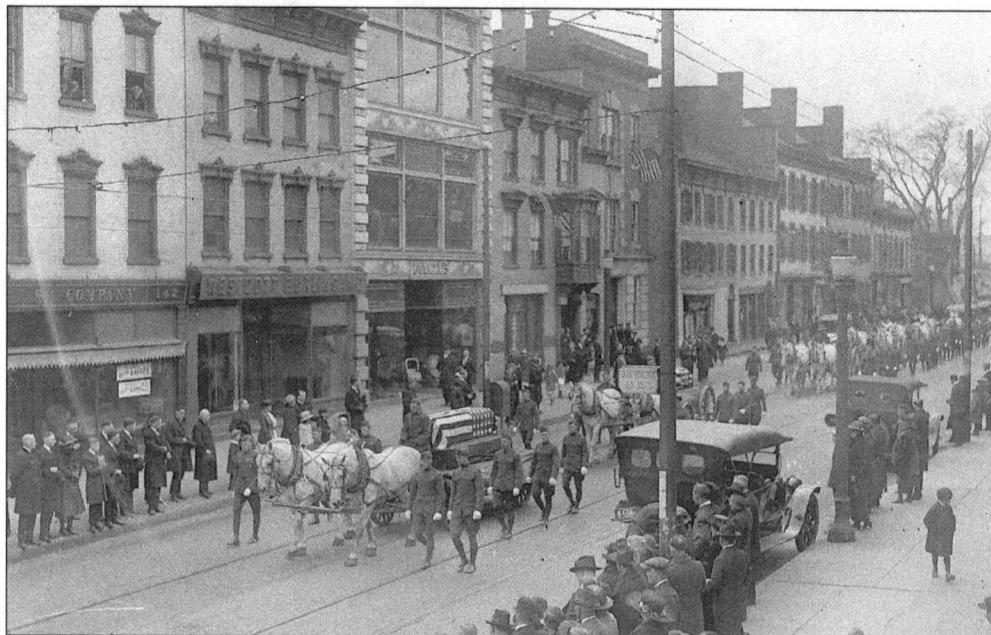

In this 1919 photograph, a cortege of Schenectady's World War I dead moves east on State Street between South Ferry and South Church Streets. Ceremonies were held at the old armory on the top of the hill, home of Schenectady's National Guard. Somber onlookers line both sides of the street. (Albert Gayer Collection/Efner History Research Center.)

Four

GETTING AROUND TOWN

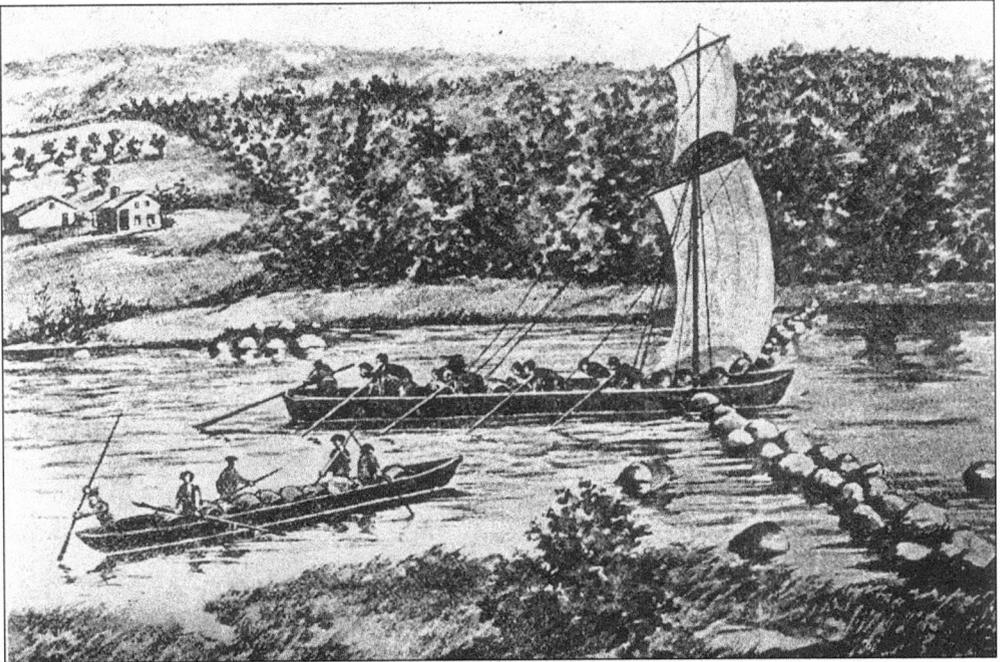

Taken from an old print, this scene depicts boating on the upper Mohawk River. The small boat is a bateau and the larger, a Schenectady Durham boat. Sails, setting poles, oars, and towropes were used to guide the boats. The shallows were deepened by rows of boulders across the river forming a V shape with an opening in the middle. Bateaux and scows navigated the river from c. 1720 to 1825. With the opening of the Erie Canal, the larger 10-ton Durham boats operated, from 1797 to 1825. (John Papp Collection/Efner Research Center.)

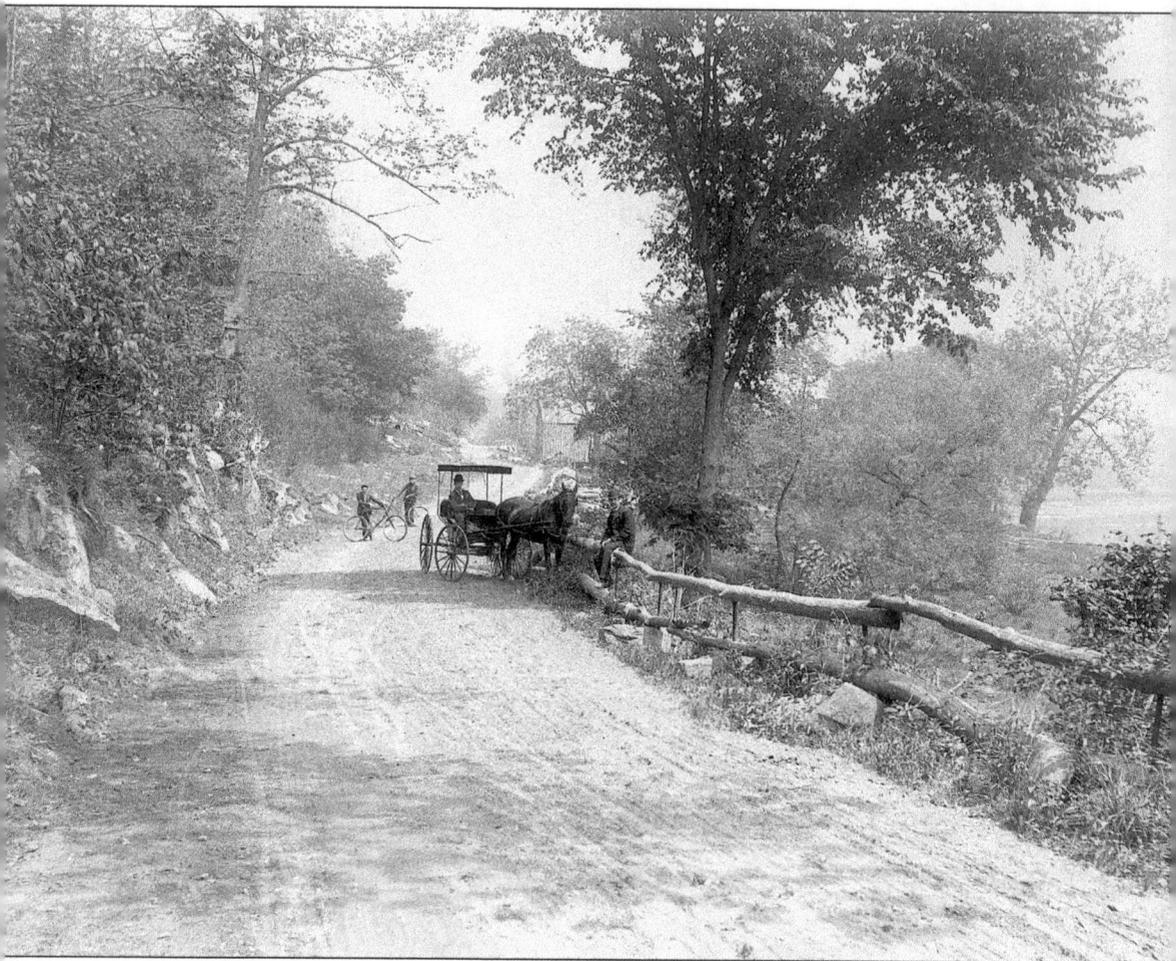

Earliest forms of transportation included the horse, with or without a carriage, and the bicycle. These men pose for the camera along Aqueduct Road just east of the city boundary. The photograph was taken looking toward Schenectady, where Aqueduct Road becomes Van Vranken Avenue. (F.F. Scoville Collection/Efner Research Center.)

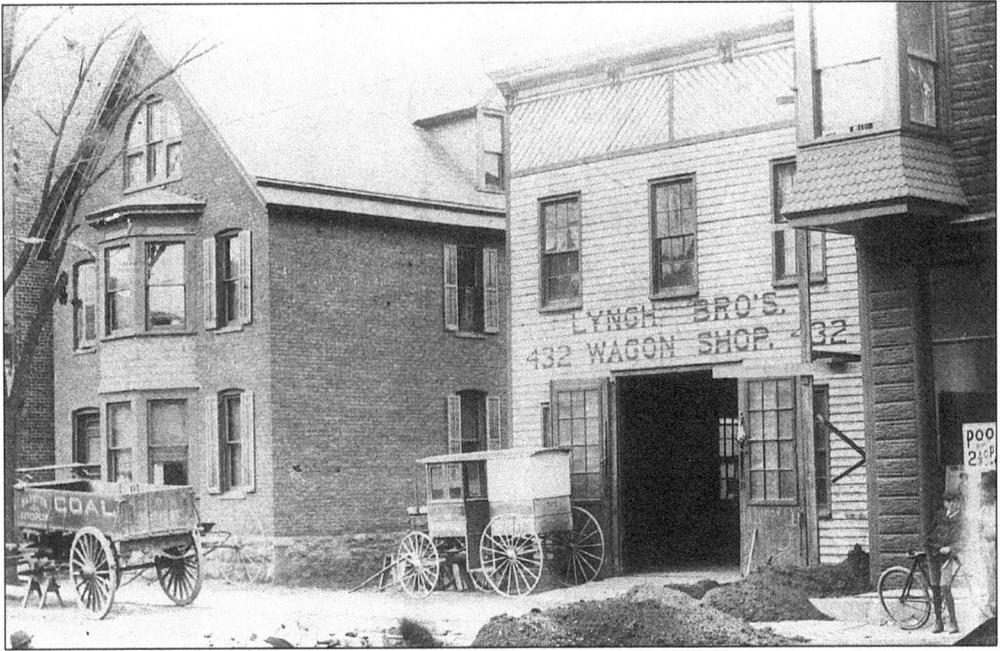

The Lynch Brothers Wagon Shop at 432 Broadway was one of a number of shops that helped keep wheels rolling in the Schenectady of the 1900s. The horse era necessitated liveries, blacksmiths, horse troughs, stepping-stones, hitching posts, and horse barns. Horses were used to pull carriages, police vans, fire trucks, delivery wagons, and sleighs, and were used by the mounted police. (Efner History Research Center.)

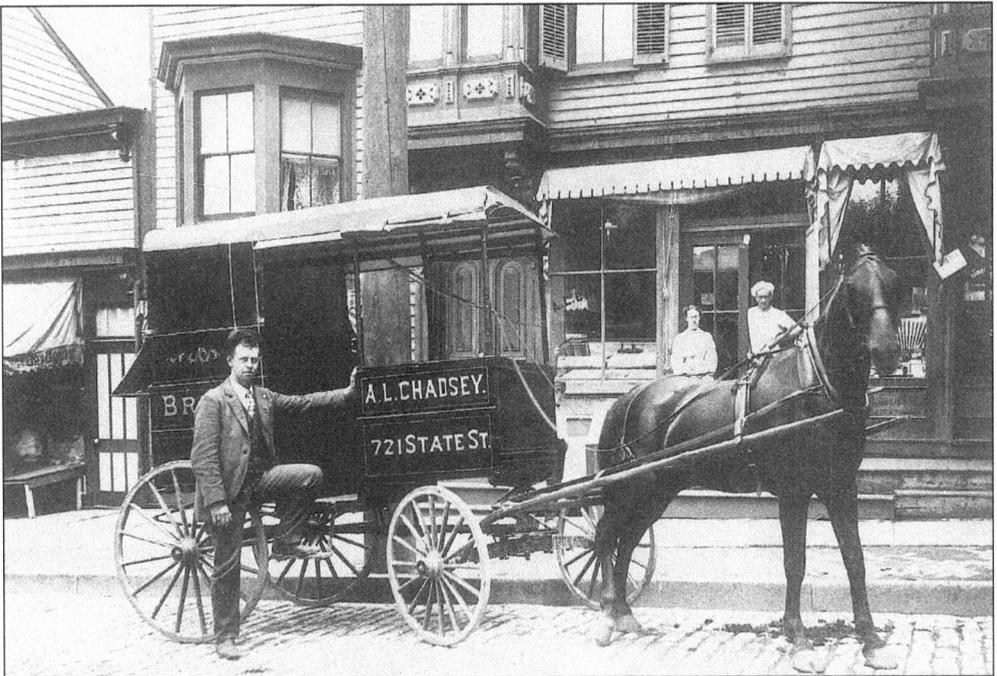

Arthur L. Chadsey poses with his horse-drawn bakery delivery wagon in front of the bakery at 721 State Street *c.* 1912. (Efner History Research Center.)

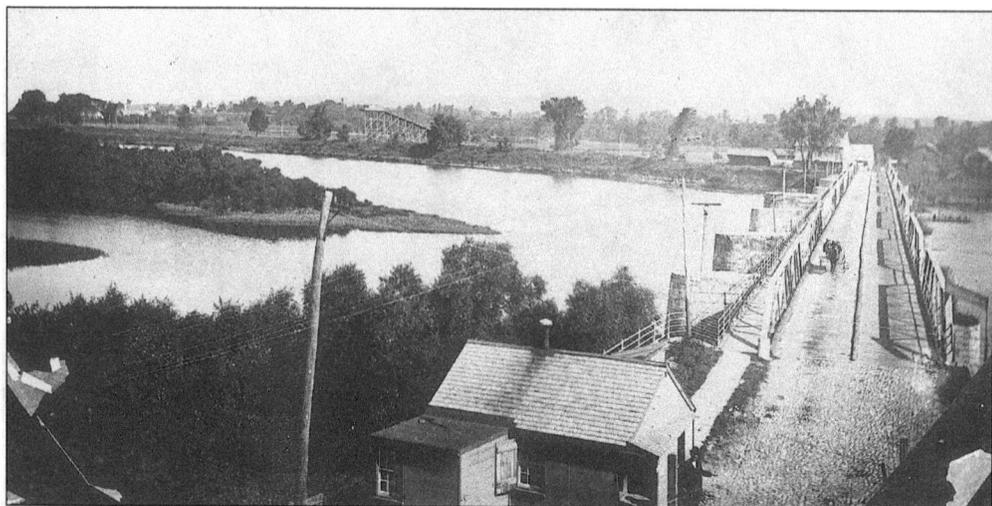

This was the second Mohawk Bridge over the Mohawk River connecting Washington Avenue in the Schenectady Stockade with Washington Avenue in Scotia. The toll building and toll collector are at the bottom right. The first bridge, called the Burr or Mohawk Bridge, was covered and became a dangerous place. It was demolished in 1874. (Efner History Research Center.)

Toll collector John Calland stands at the entry to the steel-framed bridge on October 18, 1892. Some of the stonework for this bridge can still be seen at the foot of Washington Street. The bridge was used until 1939. (W.C. Vrooman Collection/A. Gayer Collection/Efner History Research Center.)

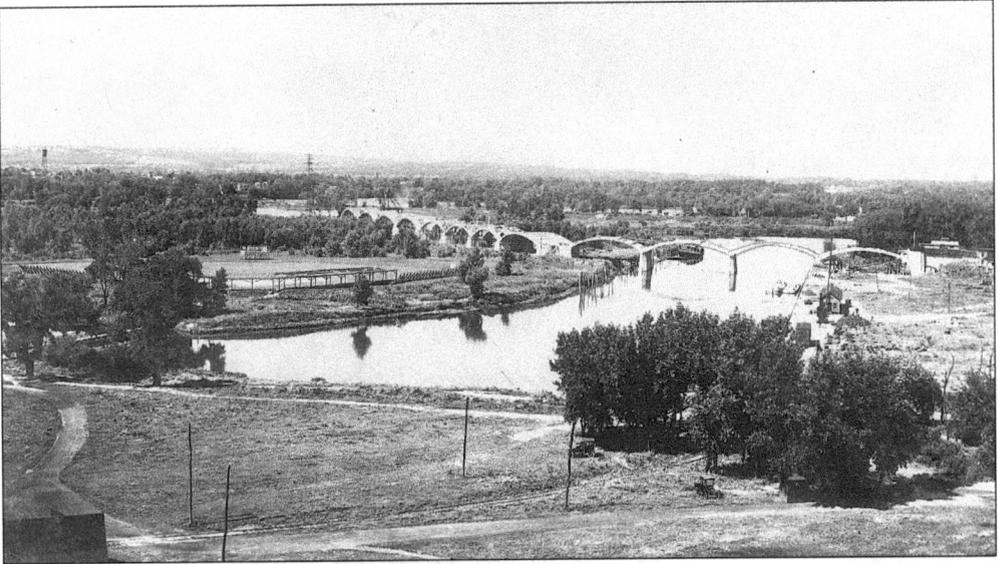

This photograph shows the Great Western Gateway Bridge under construction in 1924. Wood frames were built and then concrete was poured into them. One of these frames collapsed from the weight of the wet concrete on the Scotia side, and several workmen lost their lives. At this time, the state league baseball diamond at Island Park on Van Slyck Island was still in operation. The area became part of the mainland when the Binnekill was filled in. (Kruger Collection/Efner History Research Center.)

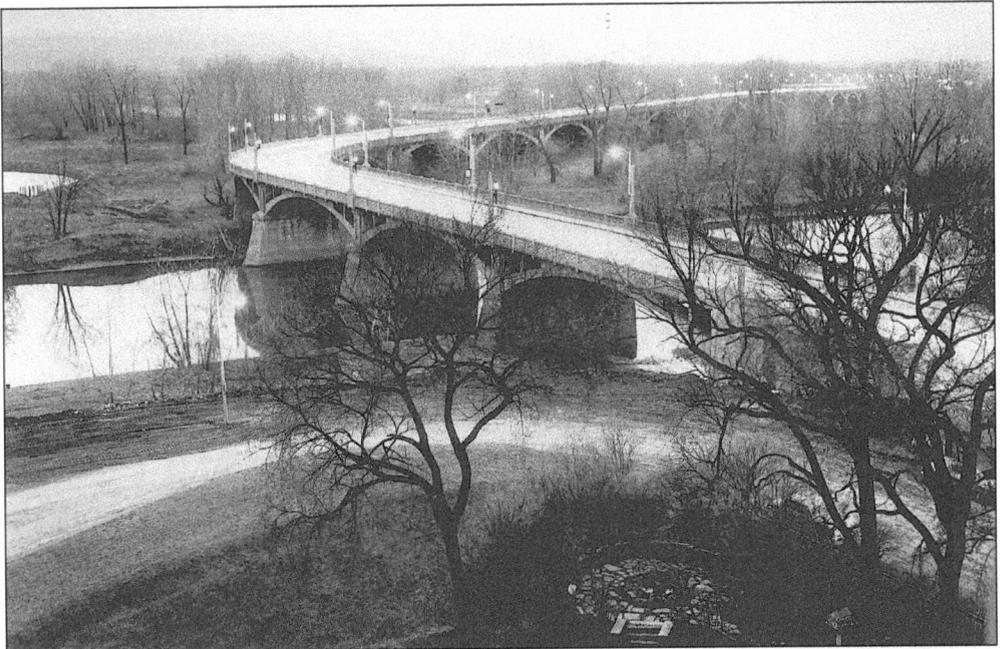

The Great Western Gateway Bridge, built in 1925, was demolished in the 1970s after a new bridge replaced it at the foot of State Street. This photograph taken from a rear upper floor of the Hotel Van Curler shows that, unlike the old Washington Avenue bridge, the new bridge possessed a considerable curve dubbed "dead man's curve." The new bridge was 4,515 feet long and cost $2.5 million. (Efner History Research Center.)

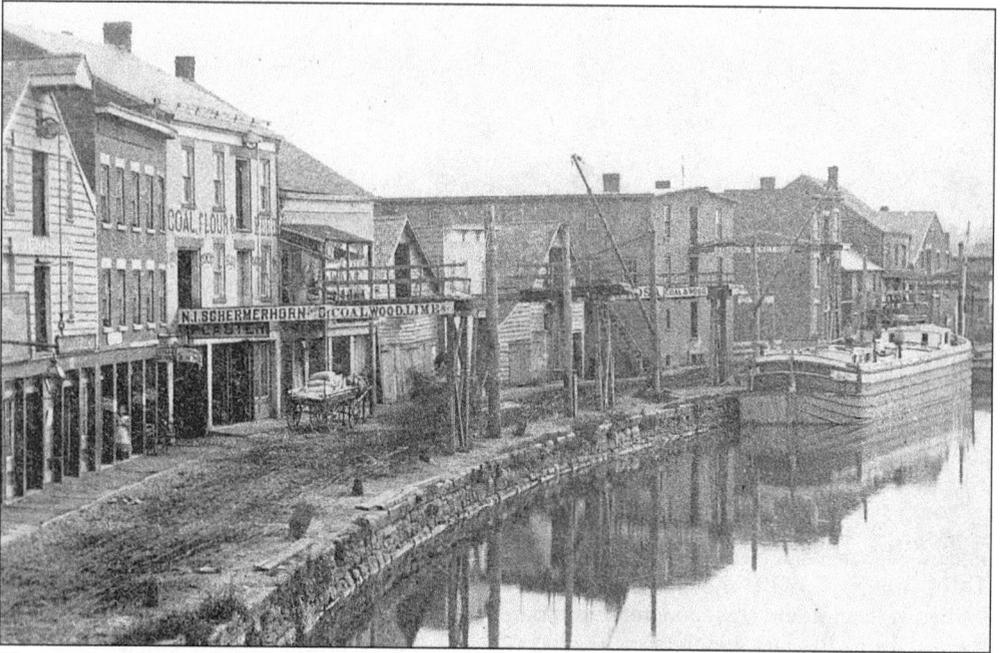

This early photograph of Dock Street shows a number of the businesses, such as Schermerhorn Coal, that lined both sides of the Erie Canal. The building of the canal was an important event because it brought boom times to the cities abutting it. (Efner History Research Center.)

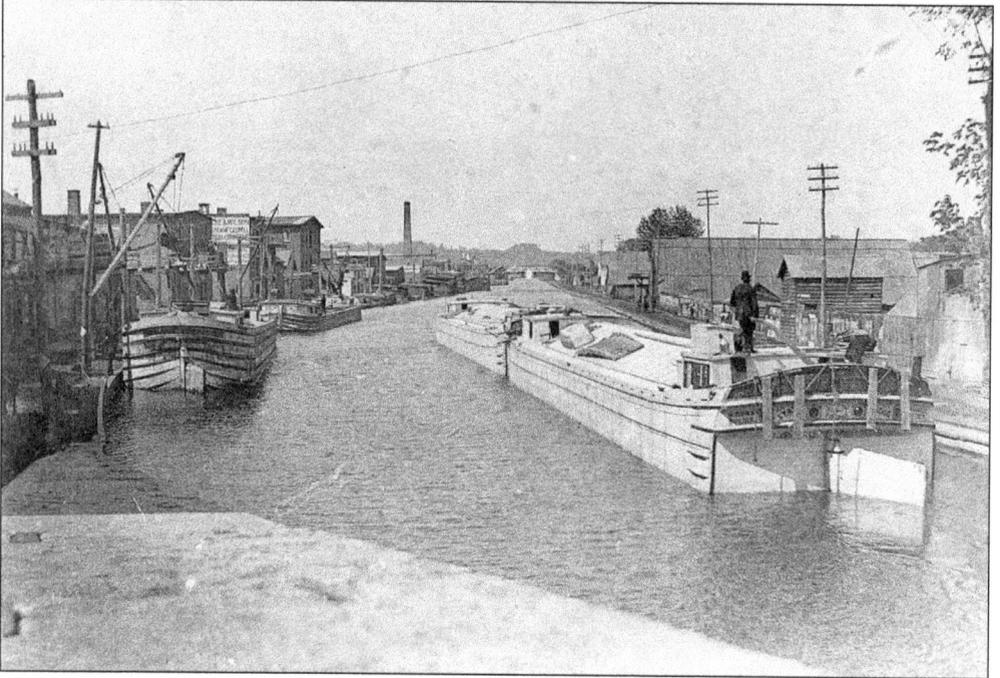

This photograph taken looking southward from State Street shows traffic on the Erie Canal in the area called the basin. The basin was wide enough to allow boats to turn around. Built largely by Irish immigrants, the Erie Canal was 40 feet wide, 4 feet deep, and 363 miles long. (Efner History Research Center.)

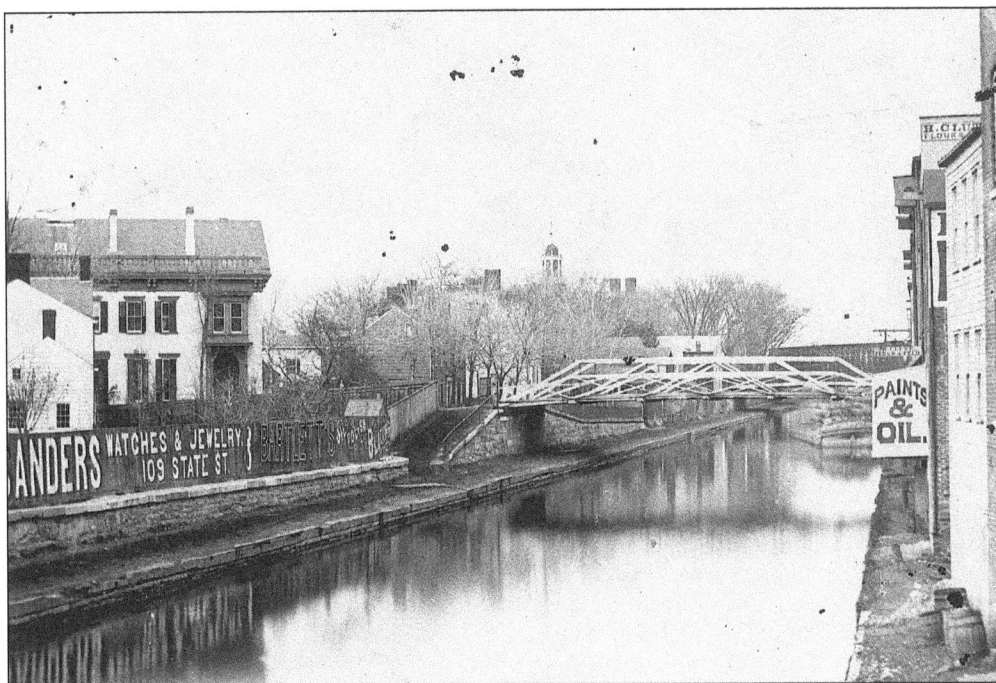

This photograph of the Erie Canal at Liberty Street was taken looking northward. The cupola rising beyond the trees sat atop the building which was the first site of Union College. The bridge is a Whipple bridge, designed by Squire Whipple, a graduate of Union College. The house to the left was the second residence of electrical engineer Charles Steinmetz. (Efner History Research Center.)

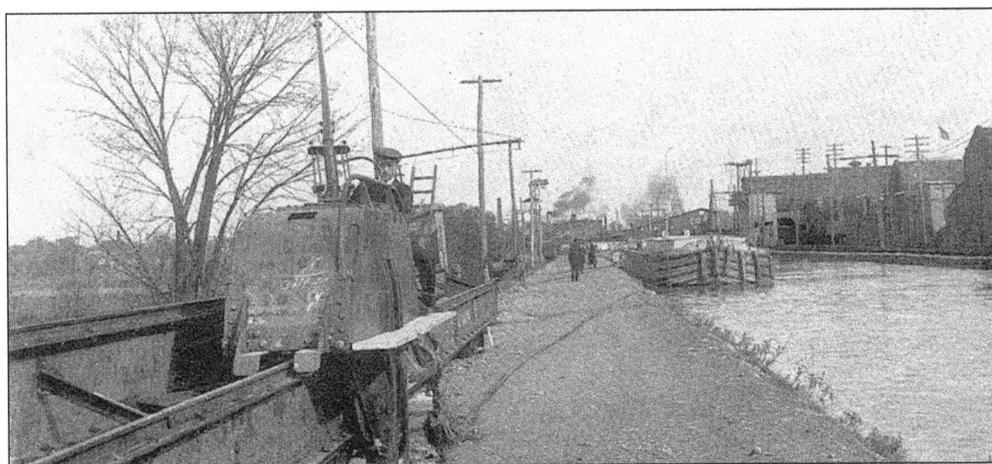

The Erie Canal was in operation from 1822 to 1915. Here, an electric mule designed by General Electric pulls a canal boat on the test track which ran along General Electric's property. (Robson & Adee photograph/Efner History Research Center.)

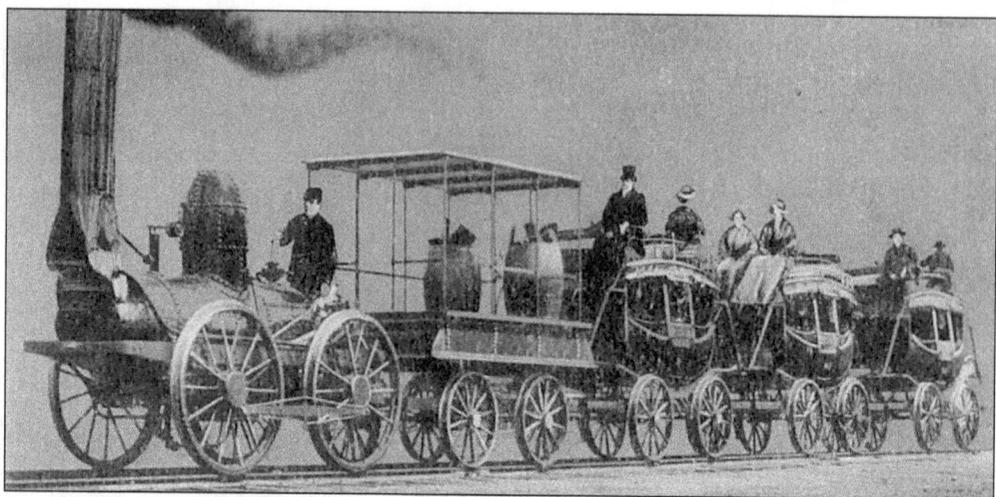

This representational drawing depicts how the DeWitt Clinton might have looked on its first run between Albany and Schenectady on September 24, 1831. The Mohawk and Hudson Railway was granted a charter on March 27, 1826 and ground was broken in 1830 for the railroad. This was the first railroad in New York State. It represented the beginning of the end for canal traffic. (Efner History Research Center.)

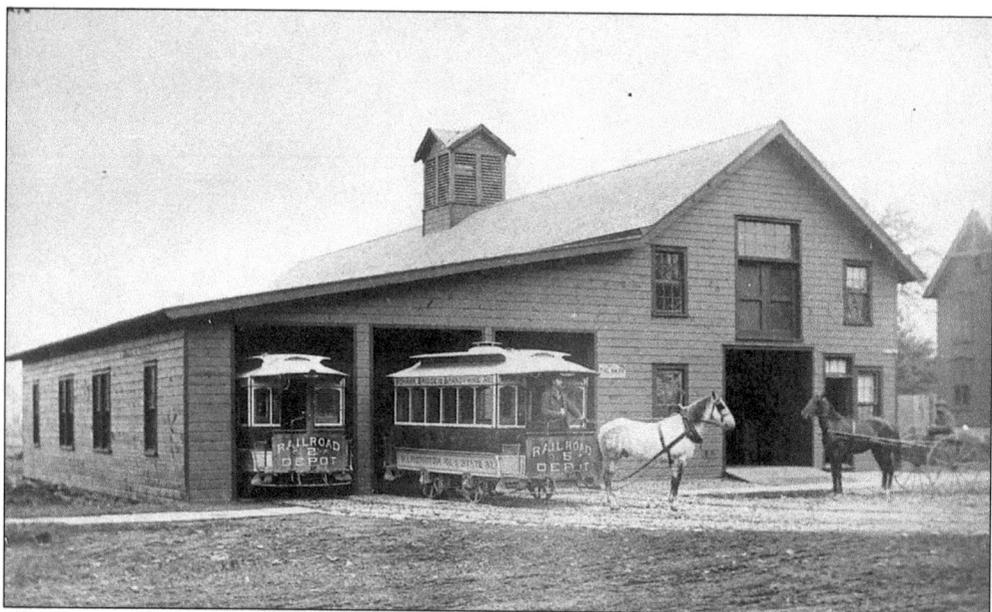

Streetcar No. 5 of the Schenectady Street Railway Company pulls out of the streetcar barn on Brandywine Avenue at Eastern Avenue in 1885. The horsecar vehicles operated from here down to Washington Avenue for 5 cents a ride. (Efner History Research Center.)

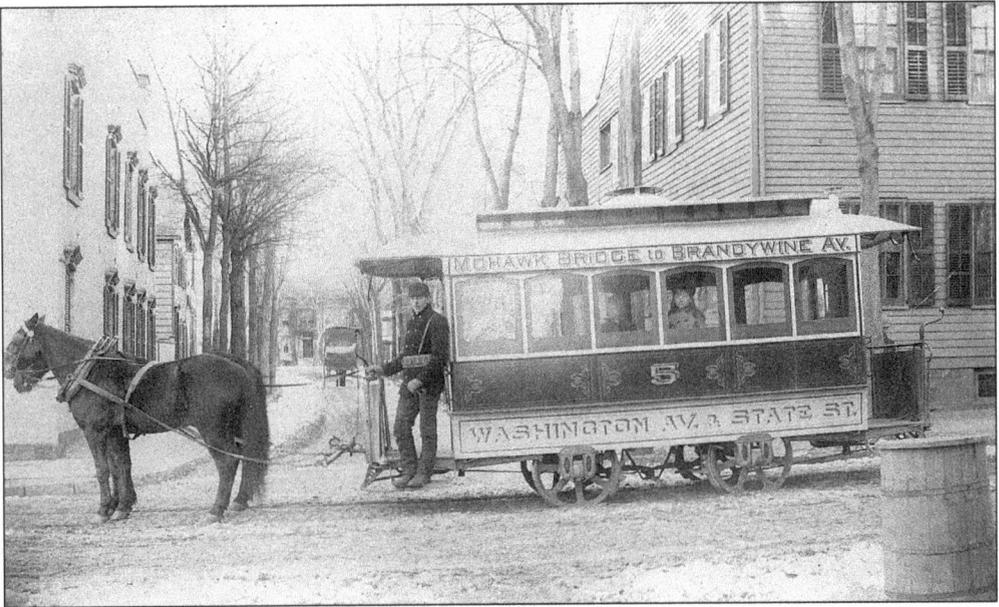

Driver Daniel McCollom pauses at the corner of Washington Avenue and Front Street in October 1888. The lines were electrified in 1891. Visible at the end of the road is the John Yates House on North Church Street. (Efner History Research Center.)

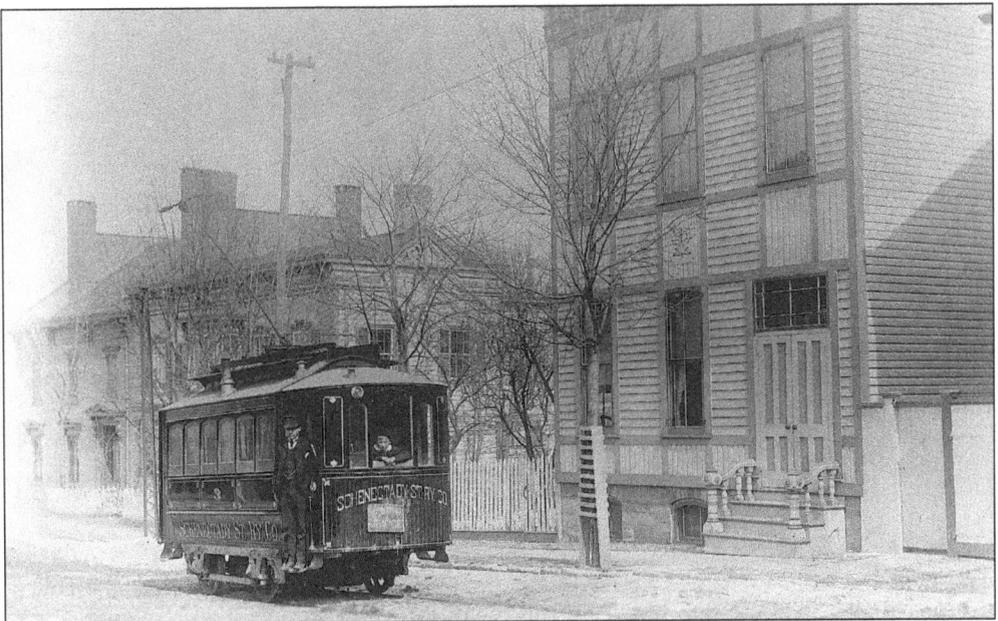

The newly electrified car of the Schenectady Street Railway Company travels its Mohawk Bridge route up Washington Avenue toward State Street in March 1892. (A. Gayer print/Courtesy of Scott Haefner.)

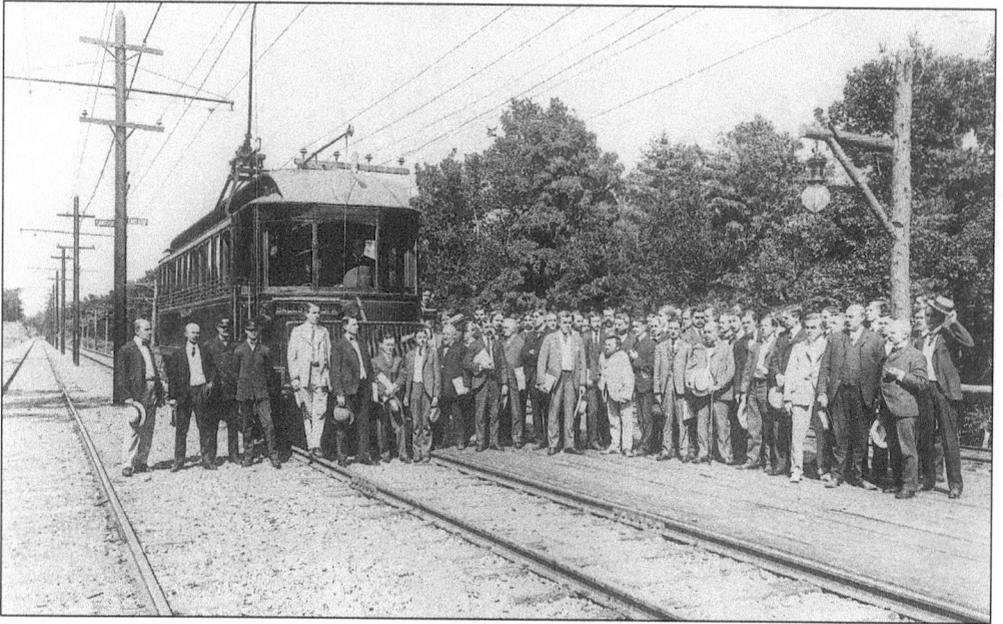

This photograph shows an exhibition run of the alternating current-propelled car on August 19, 1904. Charles Steinmetz, the theoretical mathematician responsible for the car's development, is in the front row, wearing a light-colored suit. W.B. Efner, who in 1940 became the first city historian, is on the far right by the pole. G.E. Emmons, president of General Electric, is at the front far right, and just behind Emmons with hand on hat is Hinsdill Parson, vice president of General Electric. (Schenectady Museum/Hall of Electrical History.)

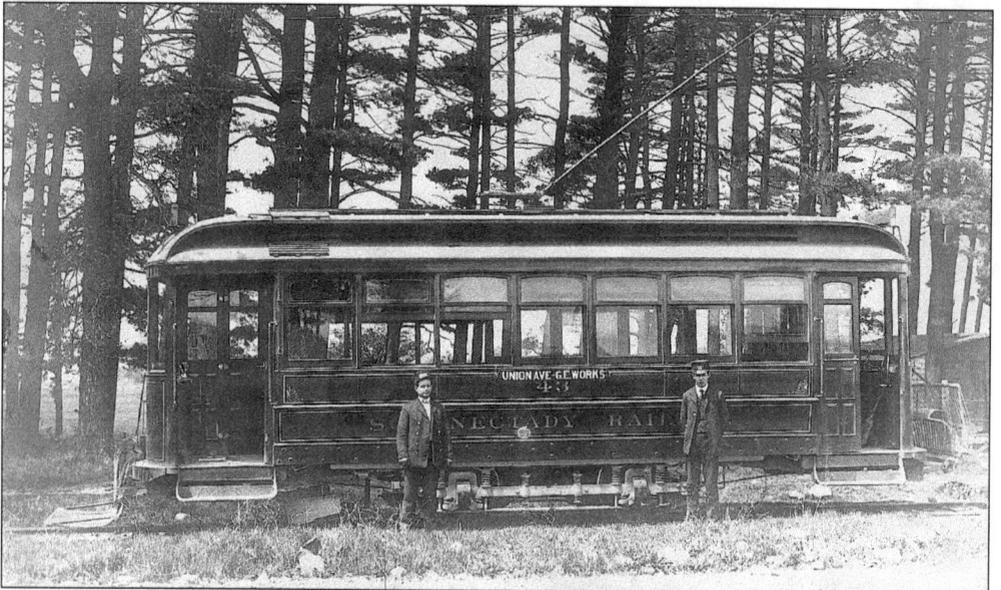

The Union Avenue-General Electric Works trolley and conductors pause near the college woods. Charles Steinmetz probably used this car to get to the GE plant. Alternating current allowed the interurban streetcars to reach outlying areas, which triggered the development of suburban neighborhoods. Woodlawn, Mount Pleasant, Bellevue, and Eastholm are examples of this development. (Courtesy of Scott Haefner.)

70

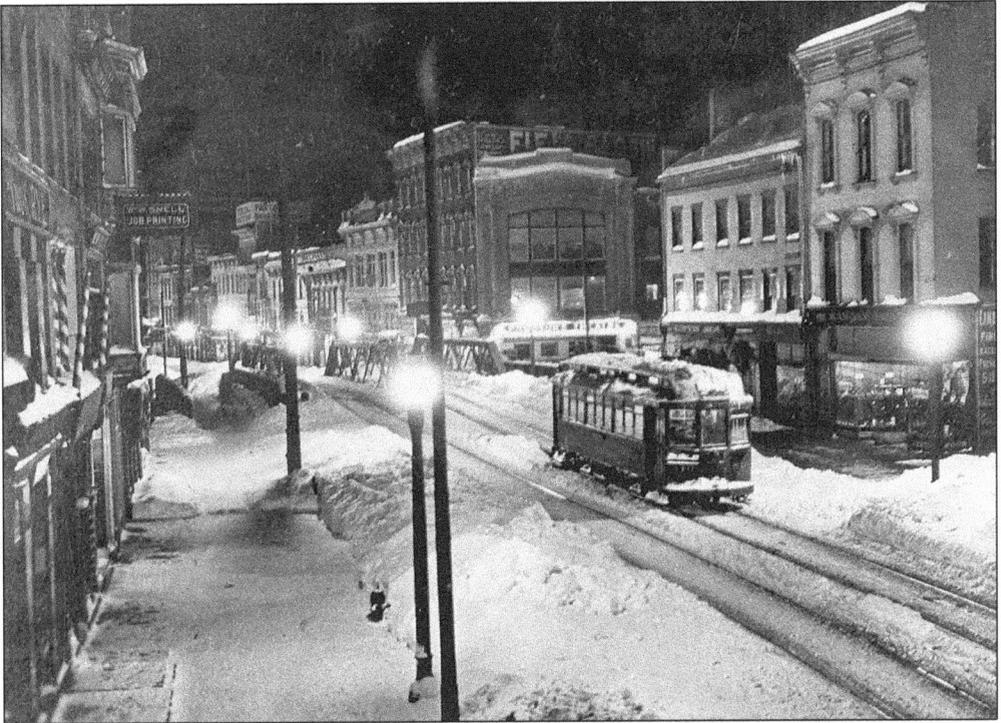

This photograph of State Street in winter was taken looking westward from the trolley bridge c. 1912. Proctor's Theater is in the rear center; Wall Street is at the right center. The Erie Canal Bridge at State Street was used by the east and west trolley lines. (Albert Gayer Collection/Efner History Research Center.)

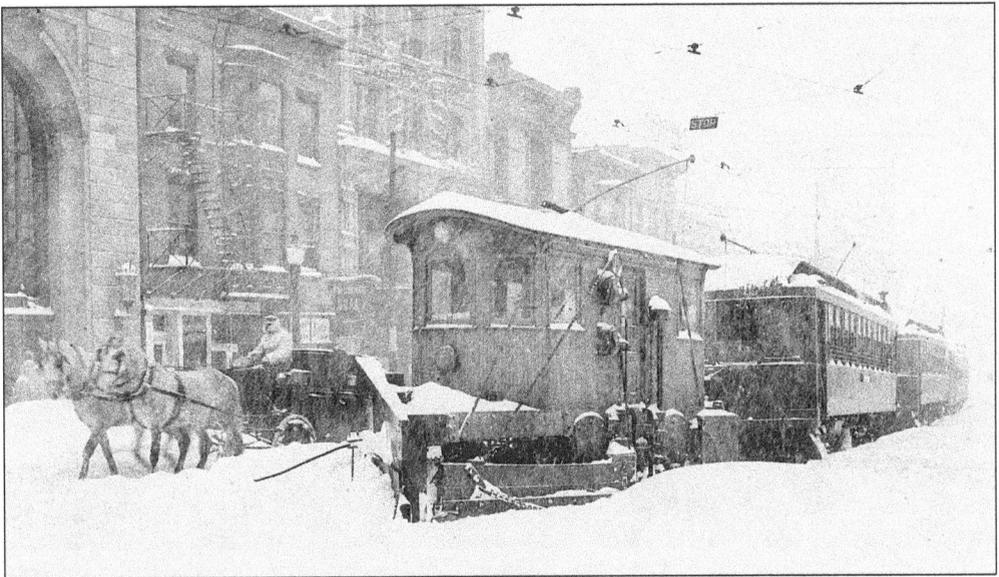

In 1914, electrified snowplows were used to clear the tracks for the trolleys. This plow is approaching Lafayette Street near the Schenectady Railway Terminal, visible at the far left. Snow already decorates the fancywork on the facade of the Foster Building. (Courtesy of Scott Haefner.)

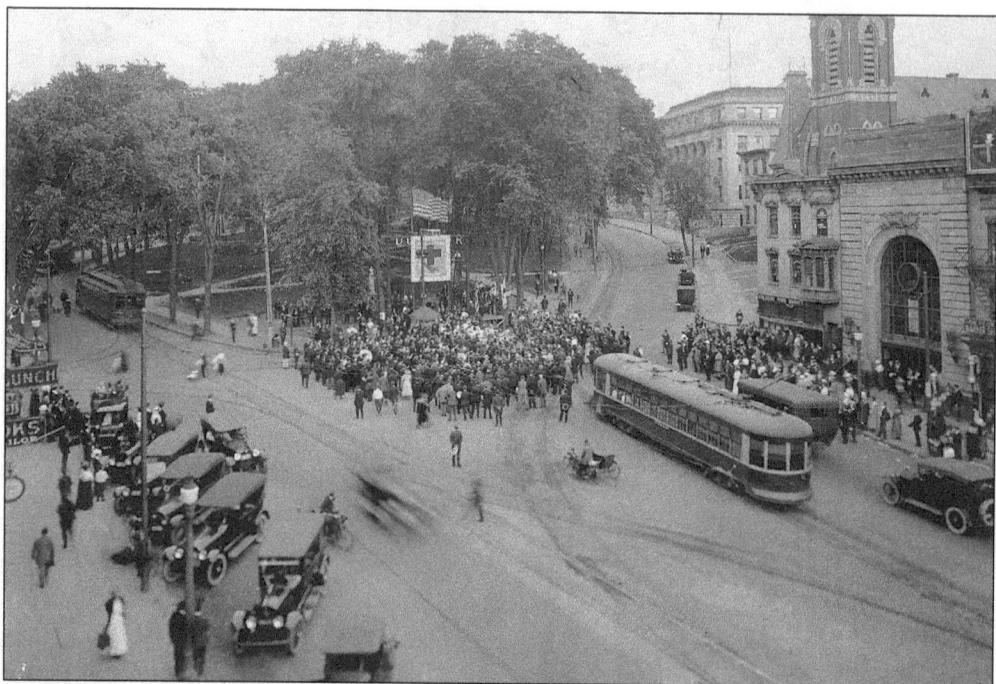

This 1918 photograph captures the activity at the intersection of State and Lafayette Streets at the foot of Crescent Park, later Veterans Park. The public is gathered to hear the Red Cross announce the successful completion of its campaign. On the right are the Schenectady Railway Company waiting room and administrative offices, opened in 1913; the Crescent Park Market; St. Joseph's Roman Catholic Church, at the beginning of Albany Street; and the county courthouse. (Efner History Research Center.)

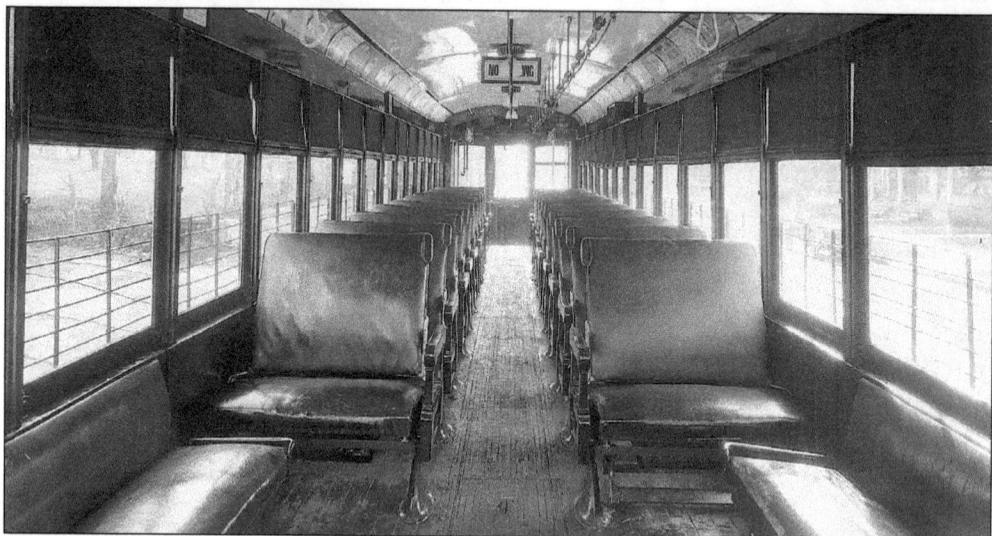

This April 1929 photograph shows the interior of an interurban Schenectady Railway car. Advertisements for national and local companies and products line the side panels above the windows. Riders are reminded to not smoke by the sign above the center aisle, which is partially obscured by the hanging light fixtures. (Roland Tinning photograph/Efner History Research Center.)

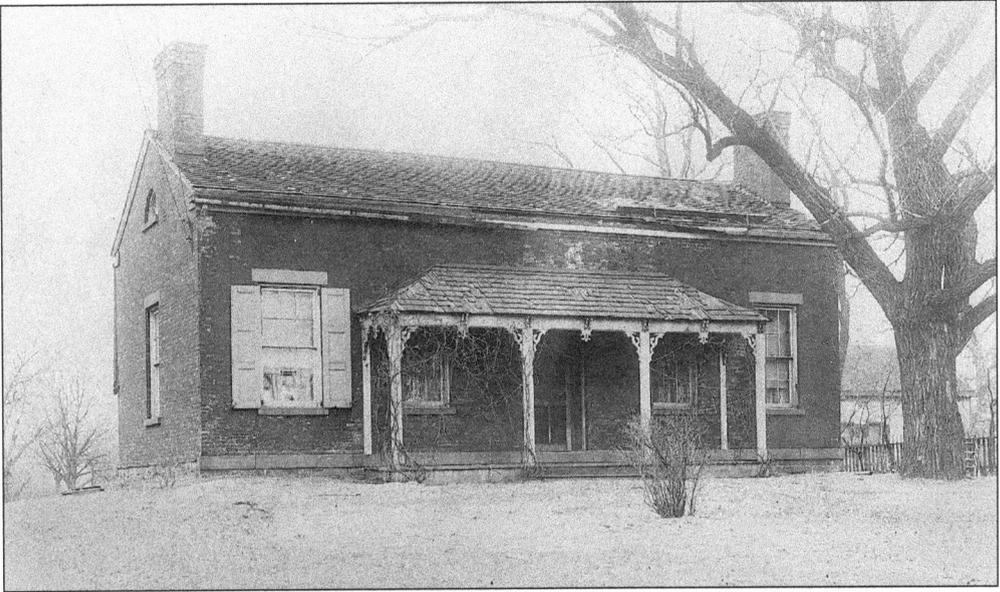

This structure was the first train terminal in Schenectady. It was located at the western terminus of the Mohawk and Hudson Railway and served the community from 1831 to 1841. A historic marker now stands at the site on Crane Street. (Efner History Research Center.)

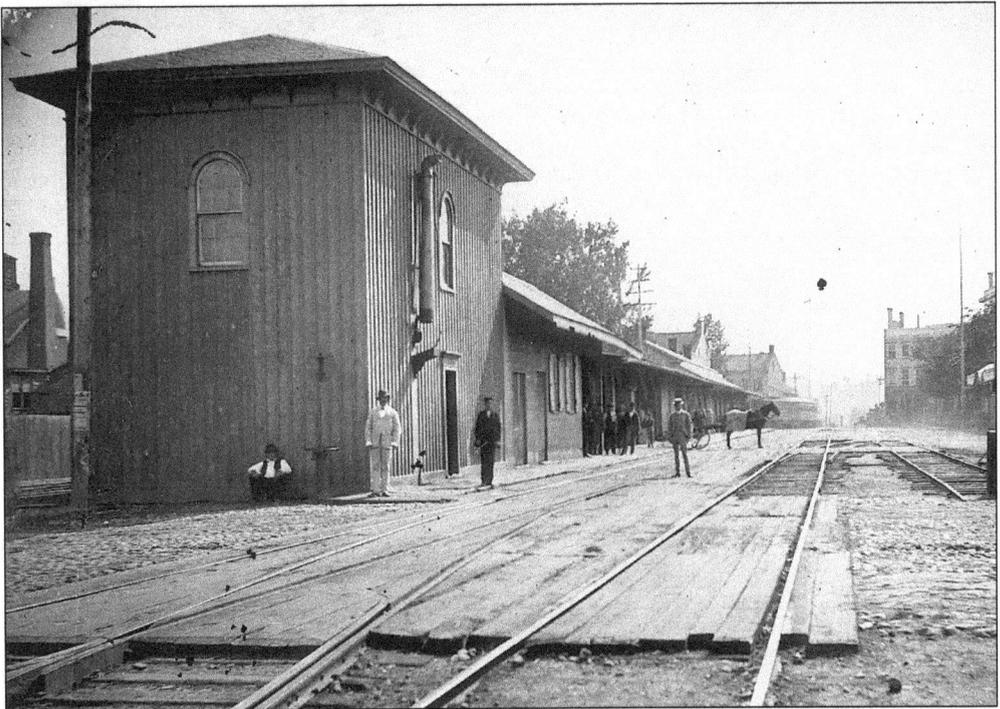

Schenectady's second railway station was located on the corner of Liberty Street and the Erie Canal. Built in 1843, the station was used until 1880. The view was taken looking south with the train station on the left. Out of sight on the right is the Givens Hotel, where Abraham Lincoln's train stopped during the presidential campaign of 1860. (John Papp Collection/Efner History Research Center.)

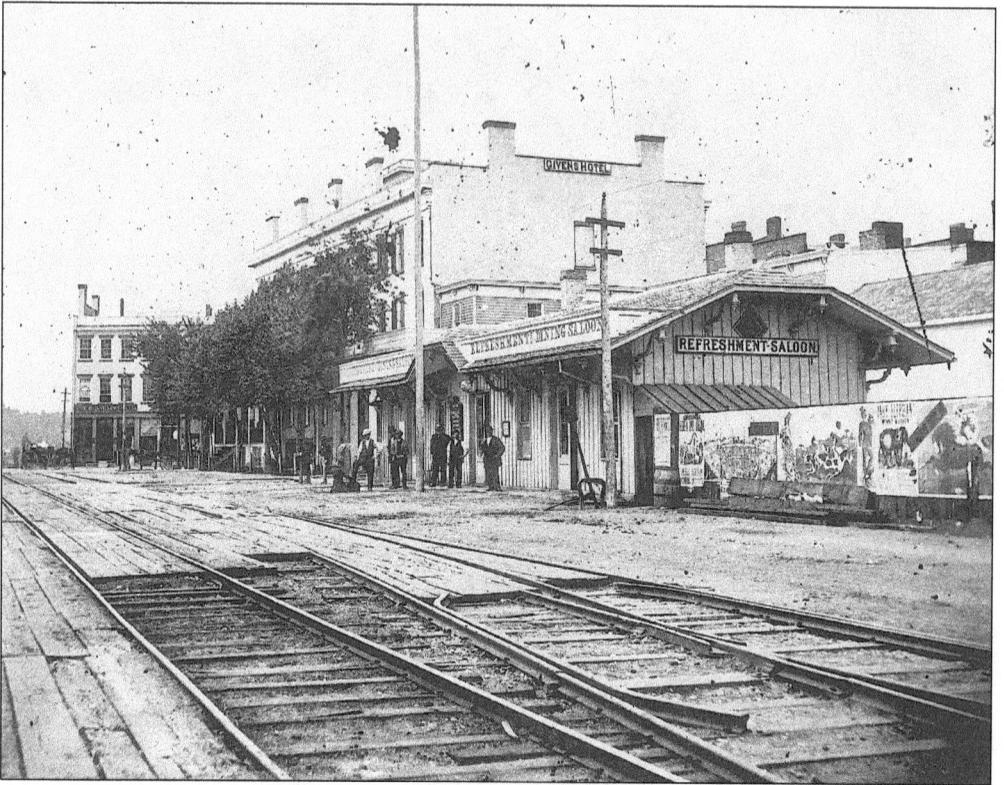

This view of the other side of Liberty Street shows the Givens Hotel with the railroad restaurant in the foreground. Abraham Lincoln stopped here and spoke to the crowd during his 1860 campaign. His funeral train passed the same spot five years later. (Courtesy of Scott Haefner.)

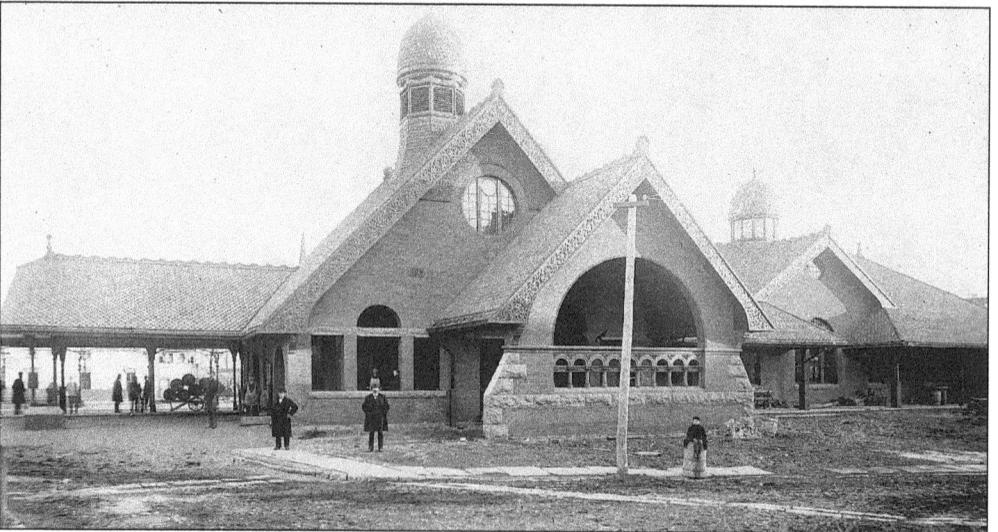

In 1883, the Schenectady Railway Station No. 3 had a Moorish flavor to its design. From 1885 to 1906, this structure stood on the site of the current station, straddling Liberty Street. (A. Gayer print/Courtesy of Scott Haefner.)

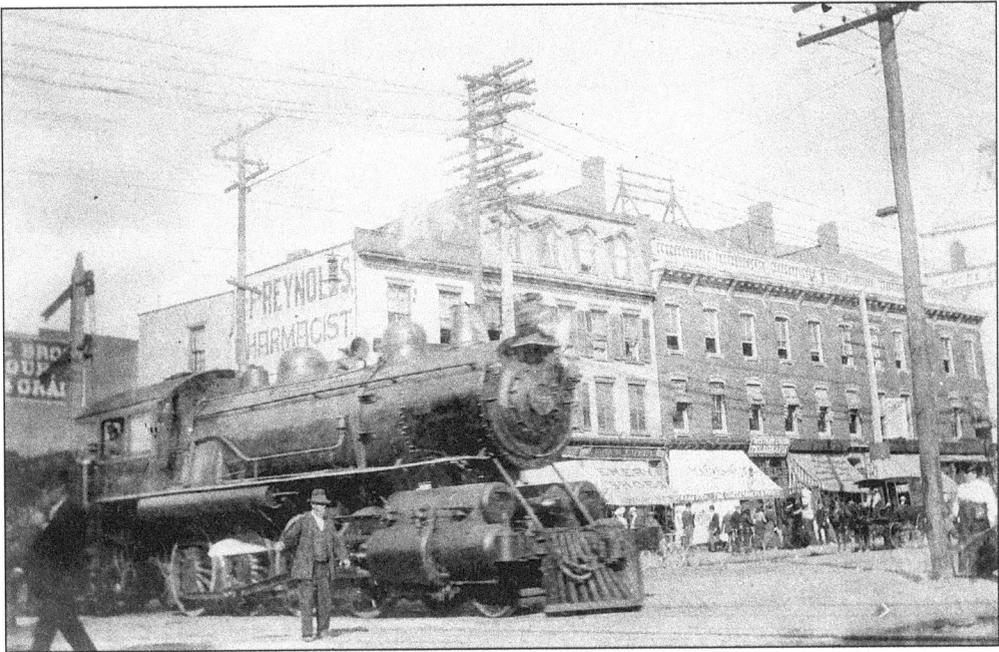

A flagman signals for pedestrians and traffic to stop for the train approaching the railroad crossing at grade level on State Street *c.* 1902. After a number of tragic accidents got the public's attention, the train tracks were raised. A total of 13 bridges to carry the train tracks over the local streets were built over a period of seven years. (Theodore Bodde photograph/Courtesy of Larry Hart.)

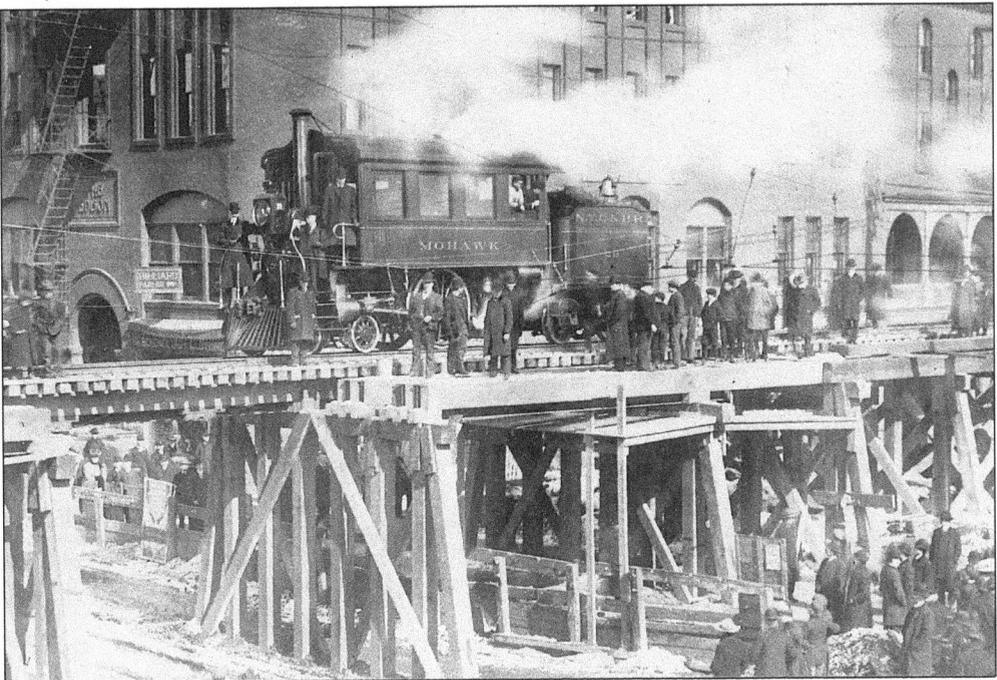

The first engine crosses the overhead bridge at State Street at 10:00 a.m. on March 18, 1906. (Courtesy of Scott Haefner.)

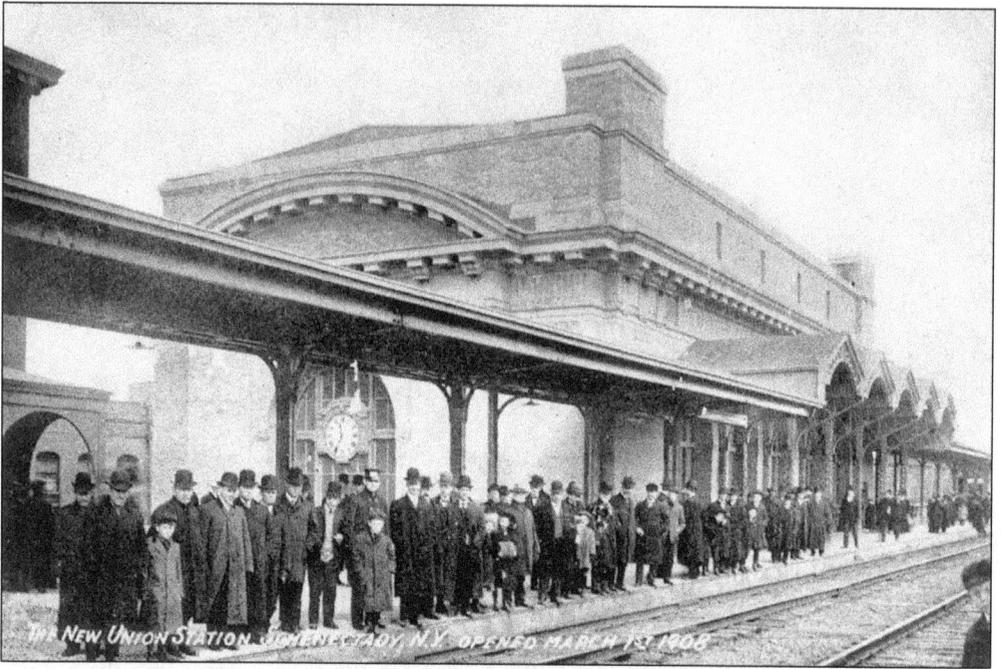

Derbies and caps adorn the heads of those congregated along the railway platform, as the new Union Station opens on March 1, 1908. Situated on the corner of Wall and Liberty Streets, this was Schenectady's fourth station. (Courtesy of Larry Hart.)

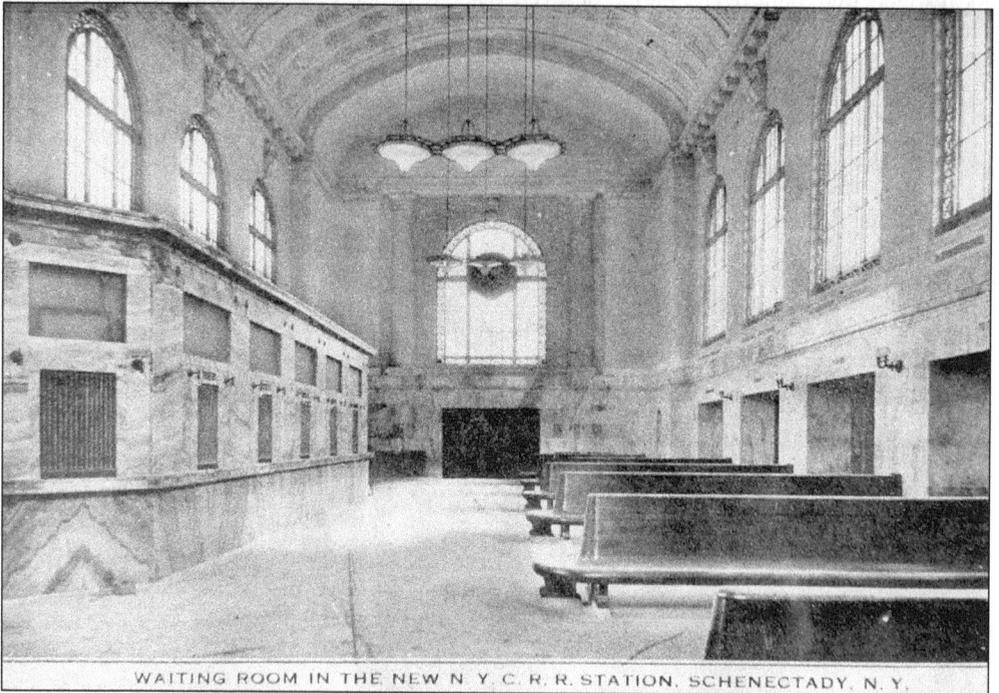

The cavernous waiting room at Union Station was the scene of many comings and goings, many meetings both happy and sad, before it was demolished in 1972. (Spoonogle Collection/Efner History Research Center.)

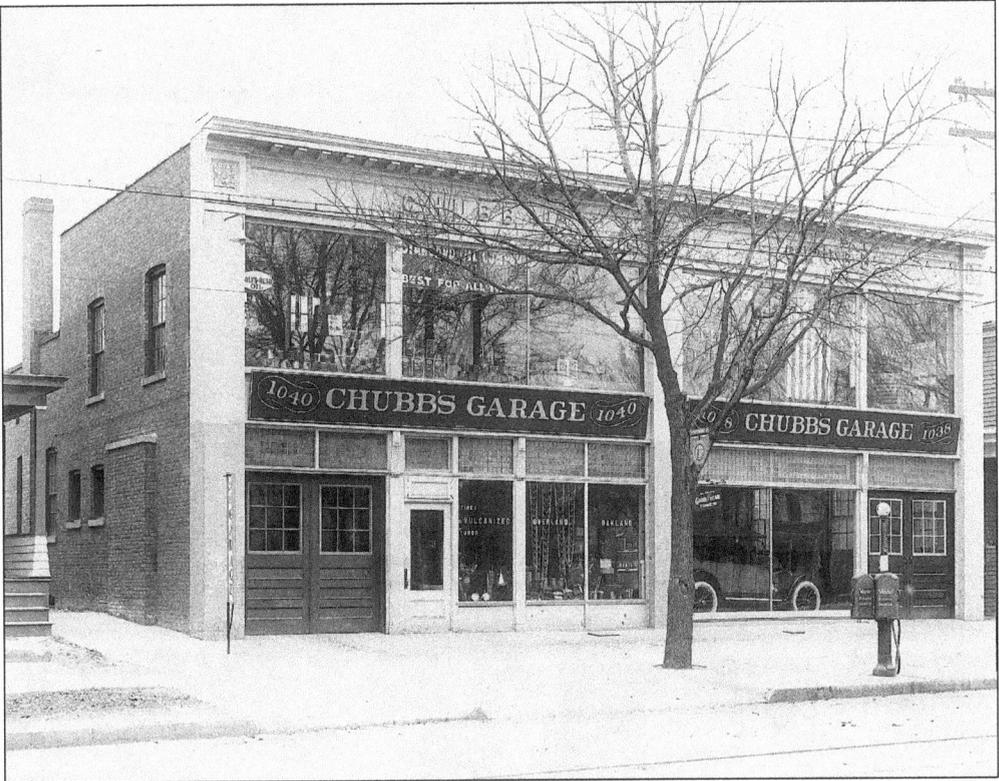

Chubb's Garage at 1038-1040 State Street offered Overland and Oakland cars for sale. In addition, the garage filled most of the motorists' needs, including new tires, vulcanized tires (retreads), and filtered gasoline. (Efner History Research Center.)

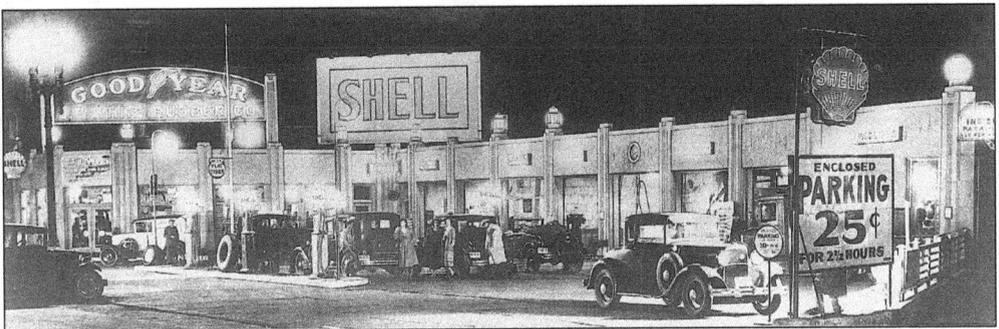

This artist's depiction of J.B. White's gas station on Erie Boulevard illustrates the growing influence of the automobile in 1930. This is the current site of Kem's Cleaners. (Efner History Research Center.)

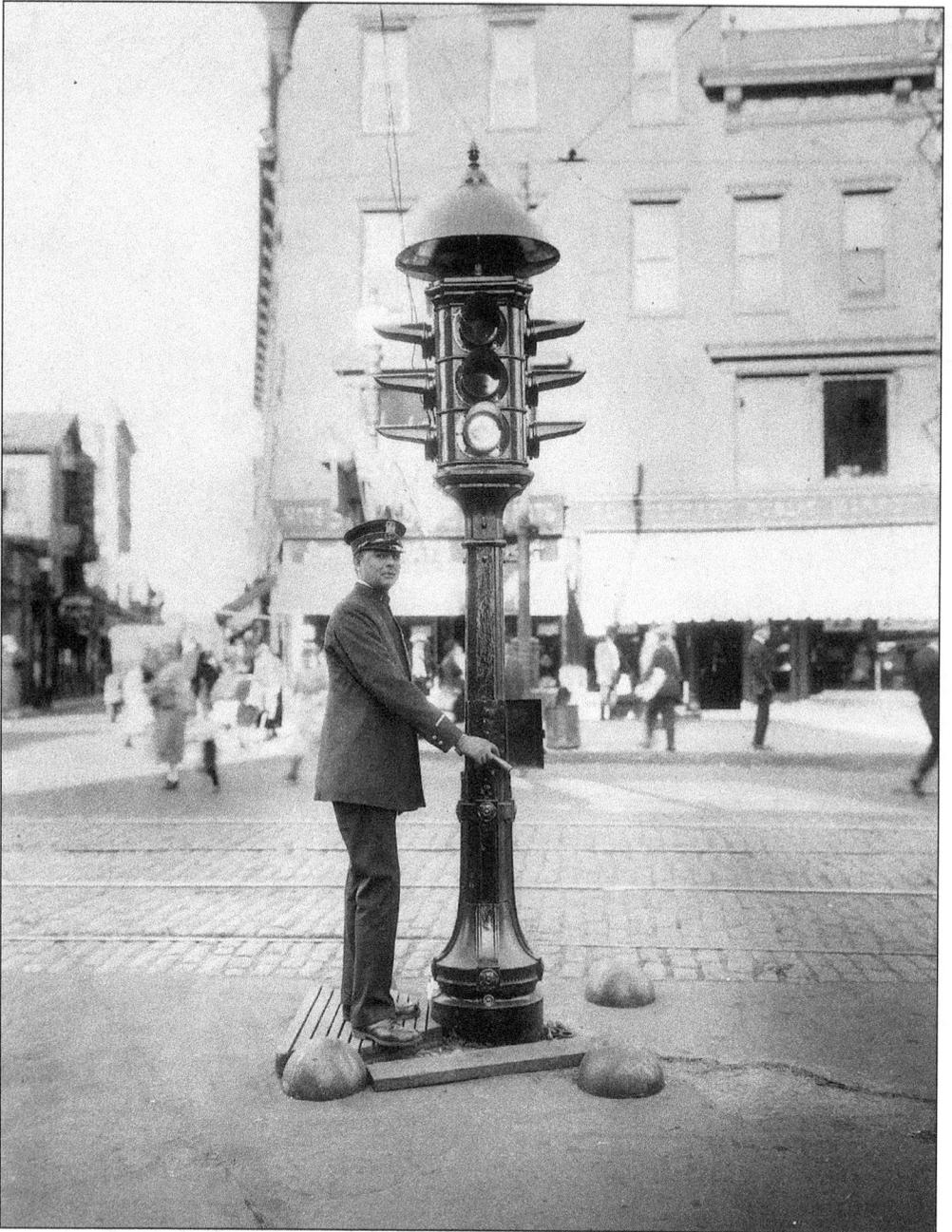

By 1924, the flagman had given way to the traffic patrolman and the traffic signal. In October 1924, Patrolman Karl Peters stands on his small island operating the control box of this first traffic signal in Schenectady at State Street and Broadway. (Efner History Research Center.)

Five

BUSINESS AND INDUSTRY LARGE AND SMALL

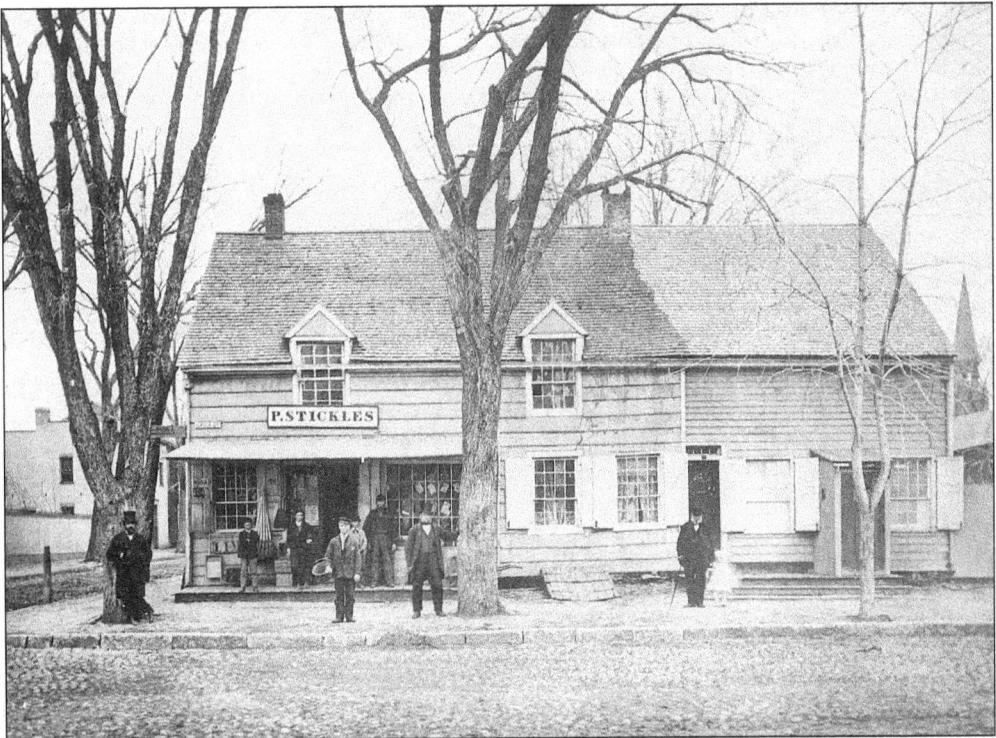

P. Stickles of 37 Union Street was said to have been in business as early as 1862. A notation on this 1870s photograph claims that this site had also been the 18th-century home of Phym and Ellice, fur traders. (Carmichael Collection/Efner History Research Center.)

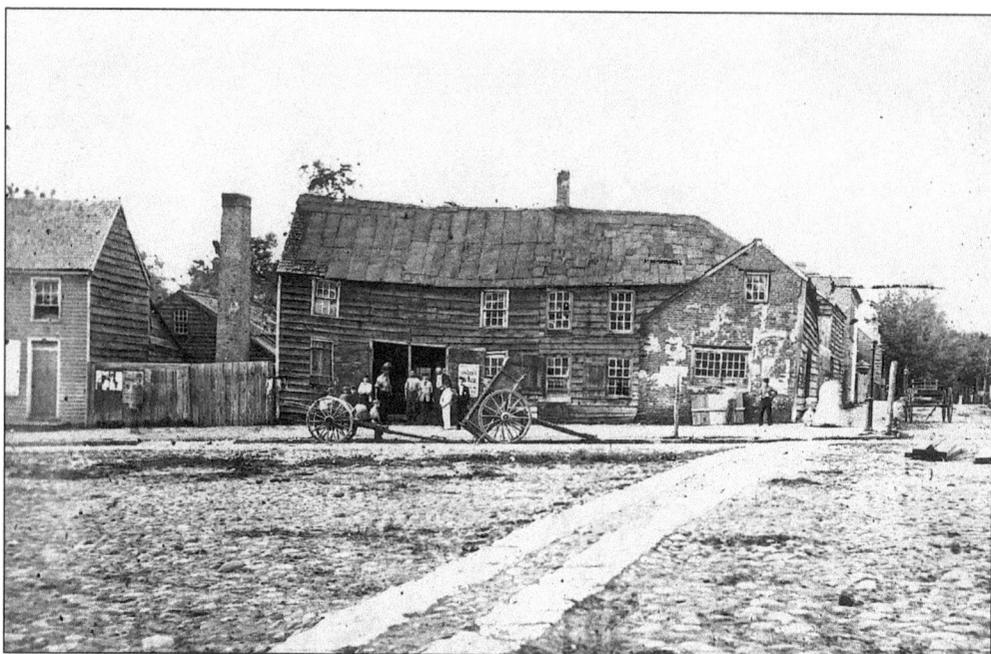

The first big industry in Schenectady was the foundry of Peter I. Clute, established c. 1820 on the corner of State and Lafayette Streets. This photograph shows Clute and Reagles Blacksmith business c. 1868 in a new location on the edge of town, where it moved after a fire at the original foundry. It was the first business to locate on the far eastern reaches of the town. In the winter months, Barnum and Bailey Circus rented space there. (Courtesy of Scott Haefner.)

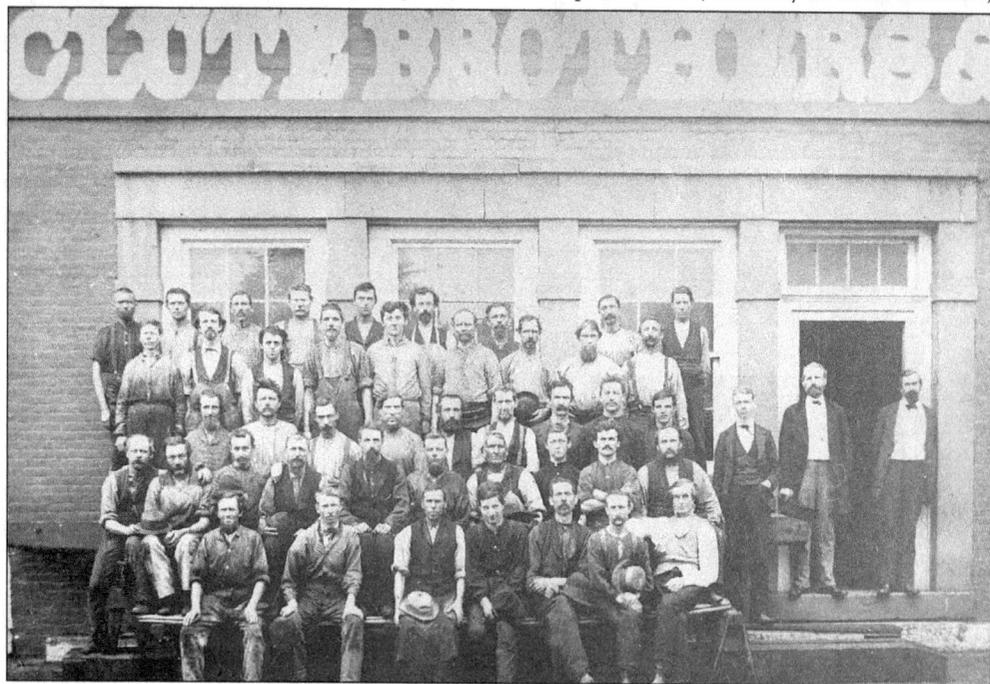

The workers of Clute Brothers pose in front of the shop at Liberty Street and the Erie Canal in the 1870s. (Spoonogle Collection/Efner History Research Center.)

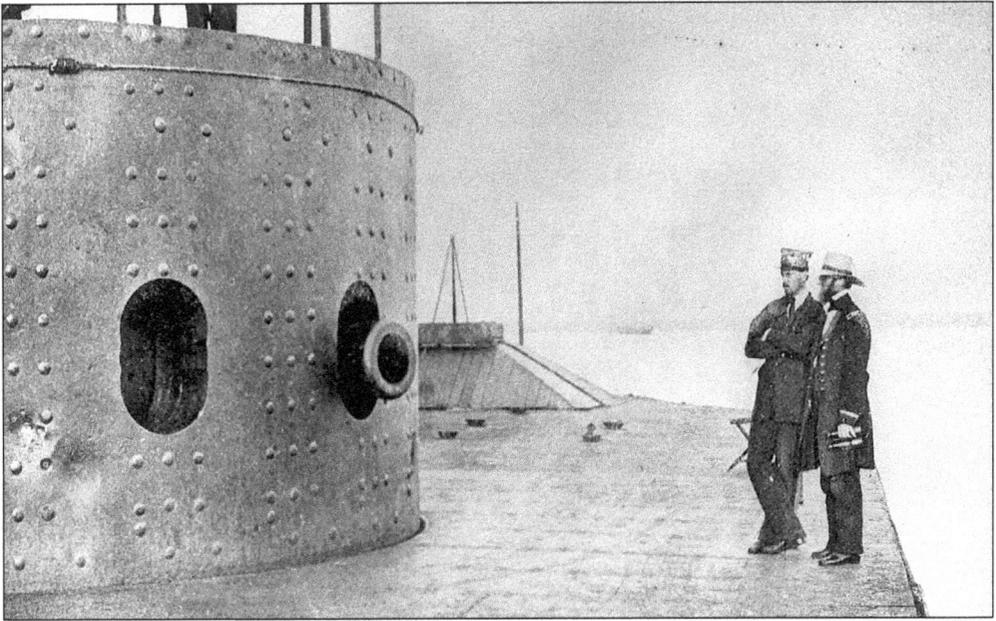

This 1862 photograph shows the deck of the ironclad vessel *Monitor* of Civil War fame. On the left is the revolving turret that was built at the Clute Iron Works in Schenectady. The turret was made of 8-inch-thick armor and had two smooth, 11-inch bore guns. The sides were of 3- to 5-inch iron plates, and its one-inch armor deck was only 18 to 27 inches above the waterline. (Efner History Research Center.)

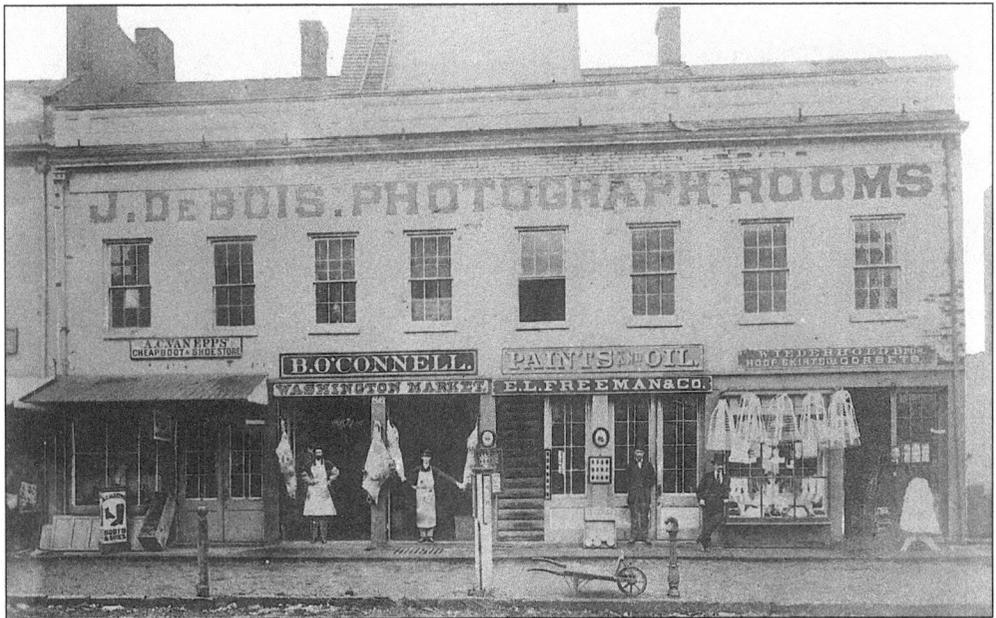

Brothers John and George Wiederhold pose in front of their ladies' garment shop on the corner of State and Ferry Streets in 1874. John Wiederhold built a brick factory with Charles Washburn in 1882 on Hamilton Street at South Center Street, now Broadway. The factory manufactured muslin underwear for some 35 years. The building still stands. (Efner History Research Center.)

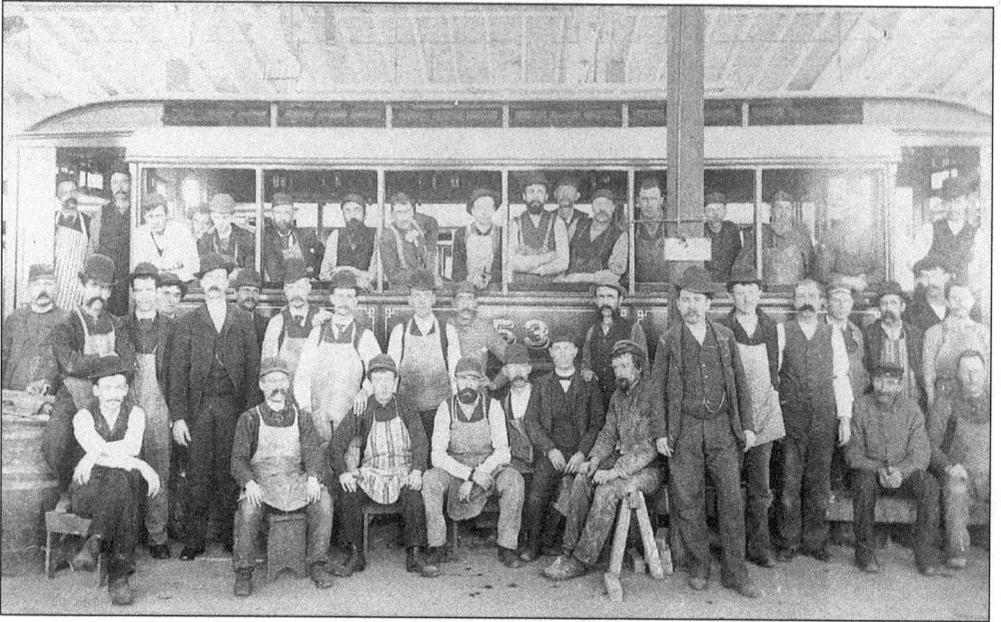

Joseph Davignon, foreman, leans against a post at Jones Car Works in Rotterdam. The company produced drawing room cars in the late 1880s. The business lasted ten years before being absorbed by an expanding General Electric Company. (Spoonogle Collection/Efner History Research Center.)

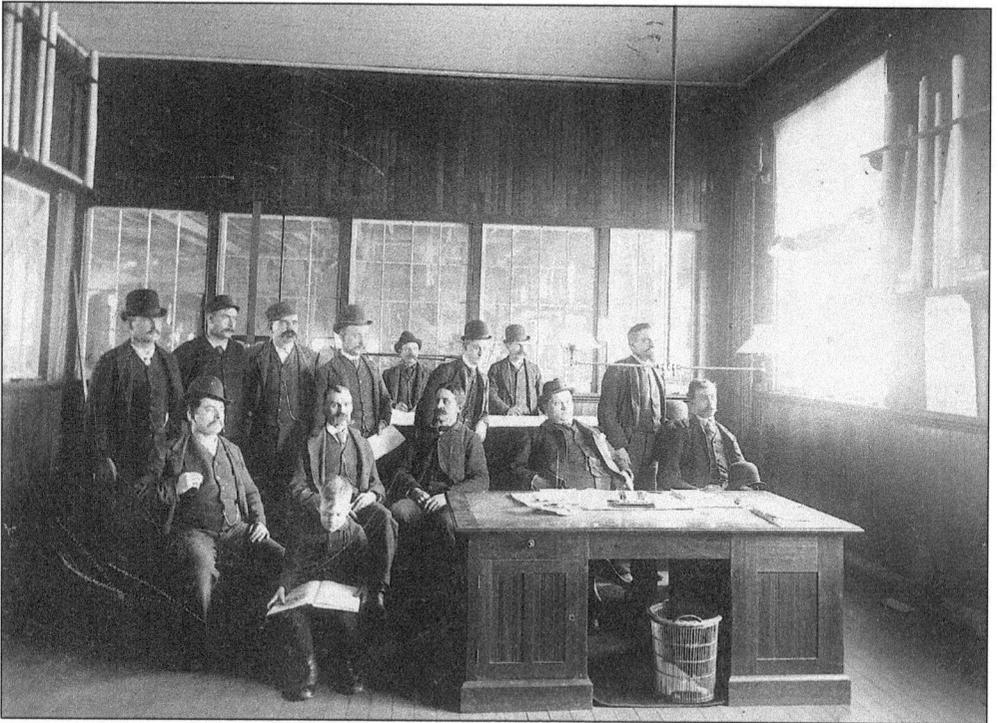

This photograph shows the management in the office of the Jones Car works. This building was torn down in 1908. (Courtesy of Scott Haefner.)

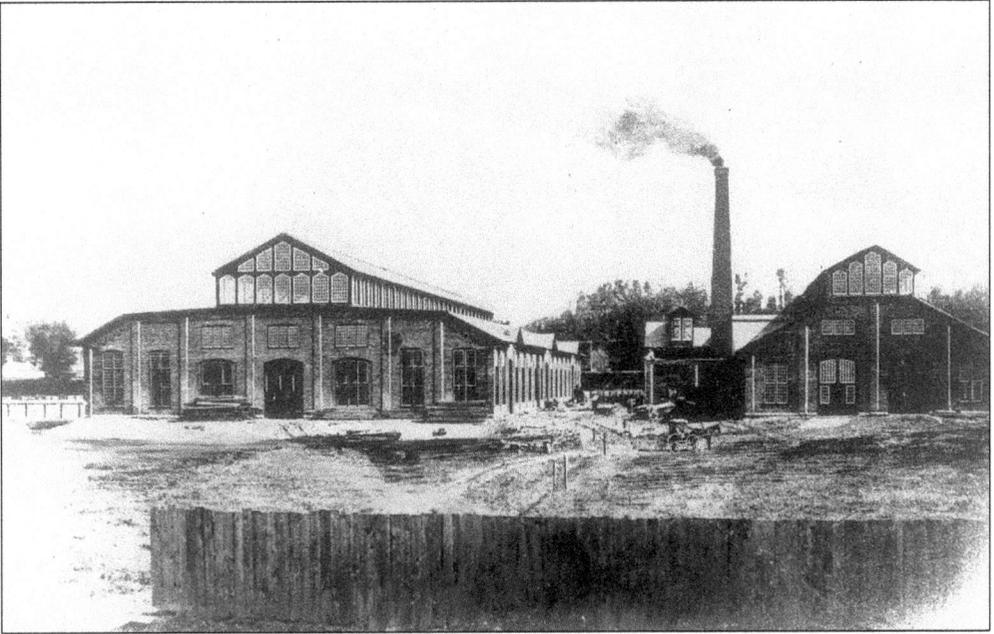

This view of the Schenectady Works of the General Electric Company dates from 1886, when inventor Thomas A. Edison founded his Edison Machine Works here. These two original buildings, the former home of the McQueen Locomotive Company, were purchased by Edison and formed the nucleus of the present-day Schenectady plant. (General Electric Collection/Efner History Research Center.)

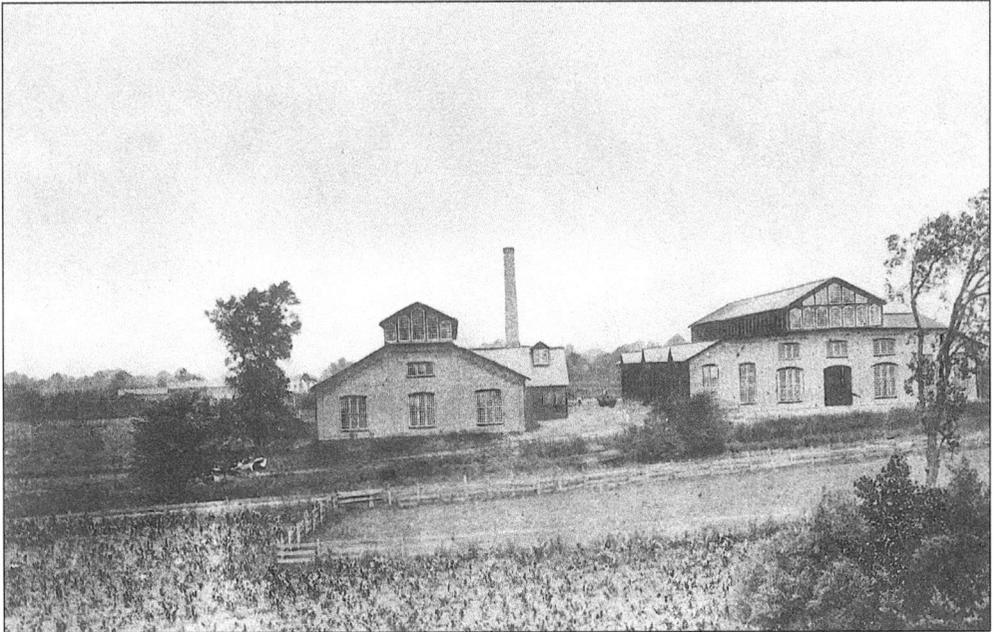

The McQueen Locomotive Company's asking price for these two buildings, shown here from the back, was $45,000. Thomas Edison's bidding price was $37,500. Neither side would budge; so, 82 Schenectady citizens and businesspeople raised $7,500 to make up the difference, and the deal was done. (General Electric Collection/Efner History Research Center.)

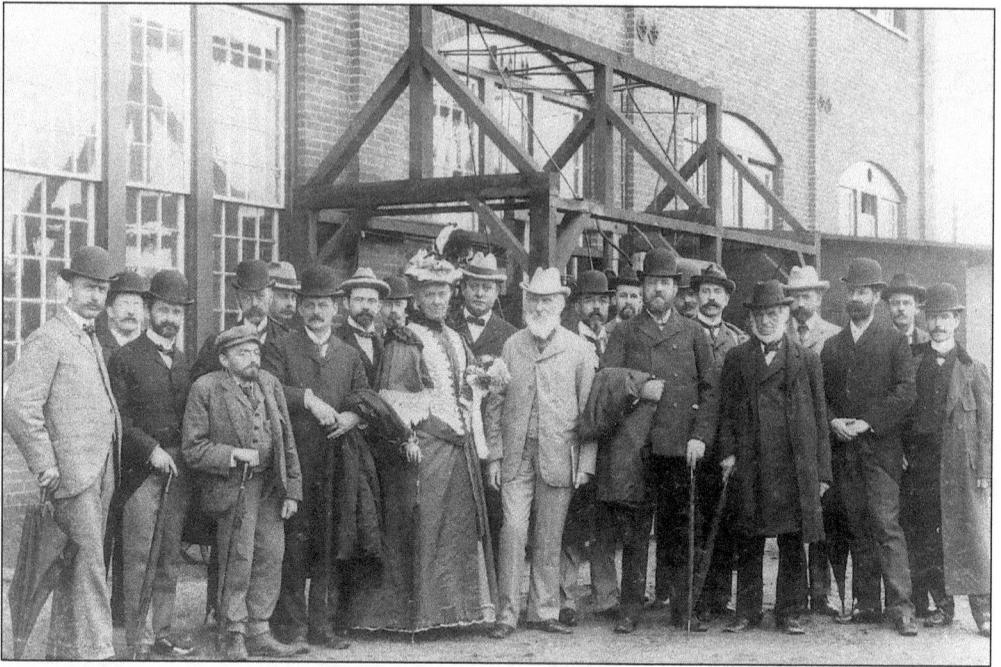

Famous figures from history gather for a photo opportunity on the occasion of Lord Kelvin's visit to General Electric in 1897. Charles Steinmetz, third from left, and Lord and Lady Kelvin, in the center of the group, are joined on their right by Spencer Trask Jr. and Sr., financiers and builders of Yaddo in Saratoga. (Schenectady Museum/Hall of Electrical History.)

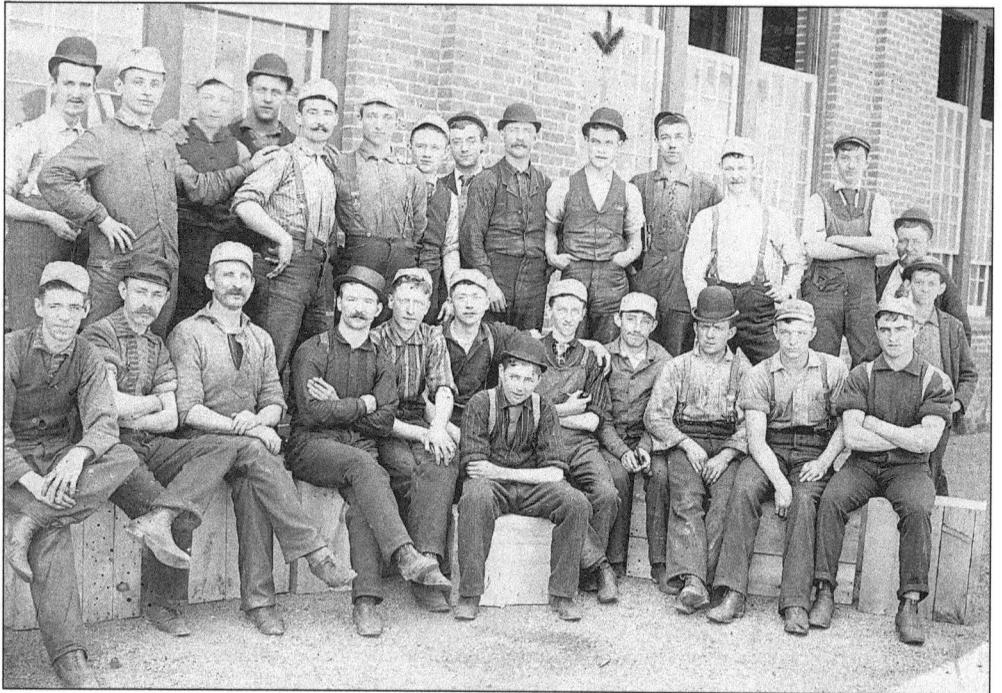

Here are members of the punch press department at General Electric in the early 1900s. The arrow points to Wilfred Sherman, foreman. (Efner History Research Center.)

84

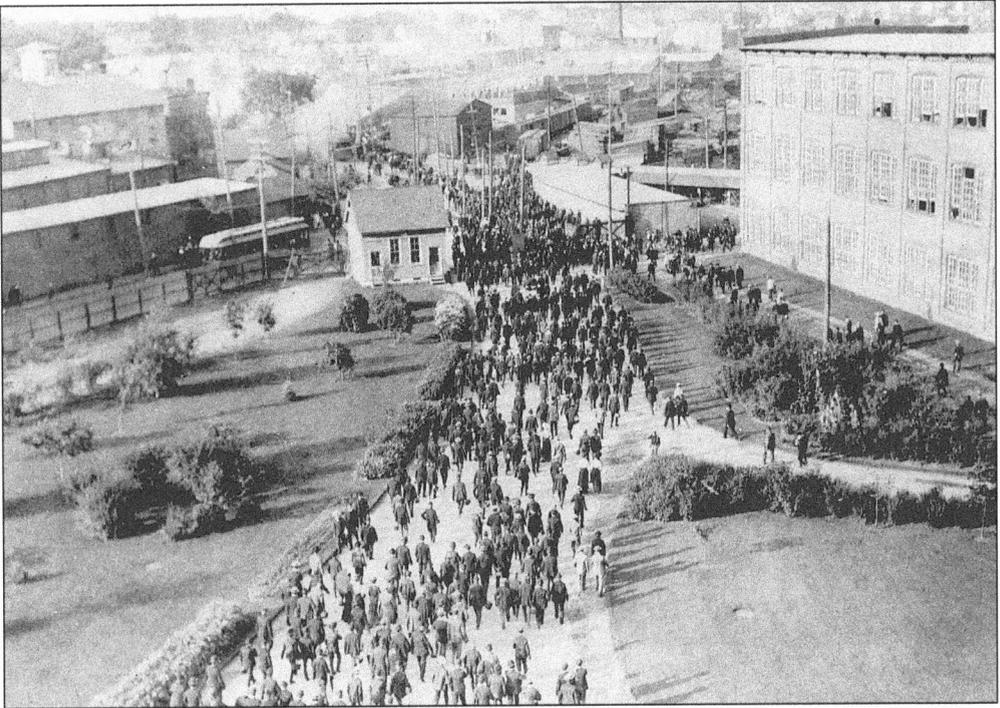

The General Electric Company of the 1890s, unlike most companies of the time, had many social programs. This photograph shows the landscaping in the front of the plant in contrast to the Westinghouse Farm Machinery Company at Dock and Washington Streets across the way. (General Electric Collection/Efner History Research Center.)

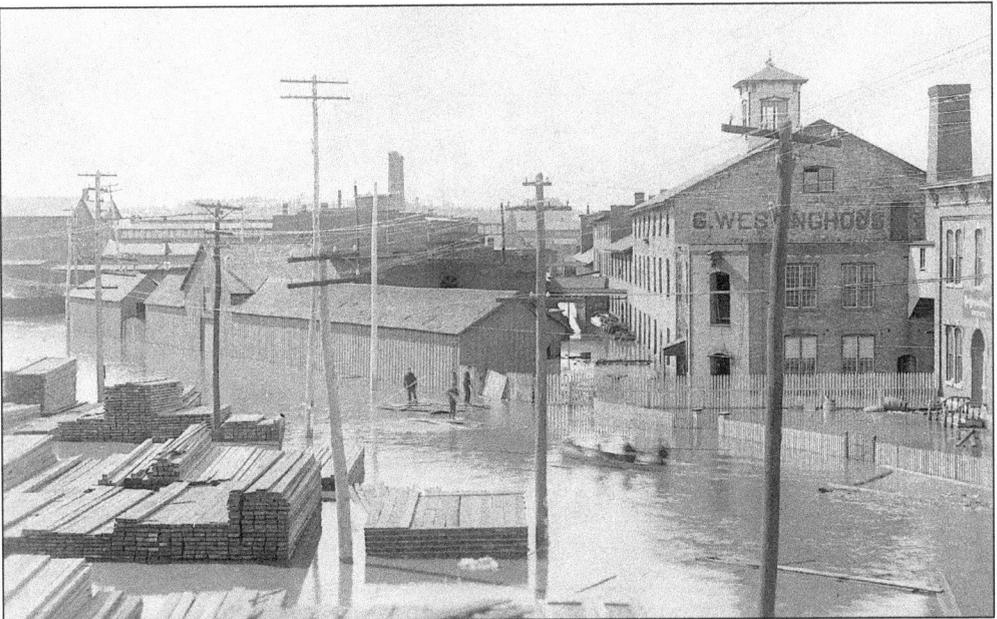

The Westinghouse Company, founded by George Westinghouse Sr., is shown here during the flood season of 1914. The company was gone by 1922 since the need for farm equipment lessened and no new products were being developed. (Courtesy of Scott Haefner.)

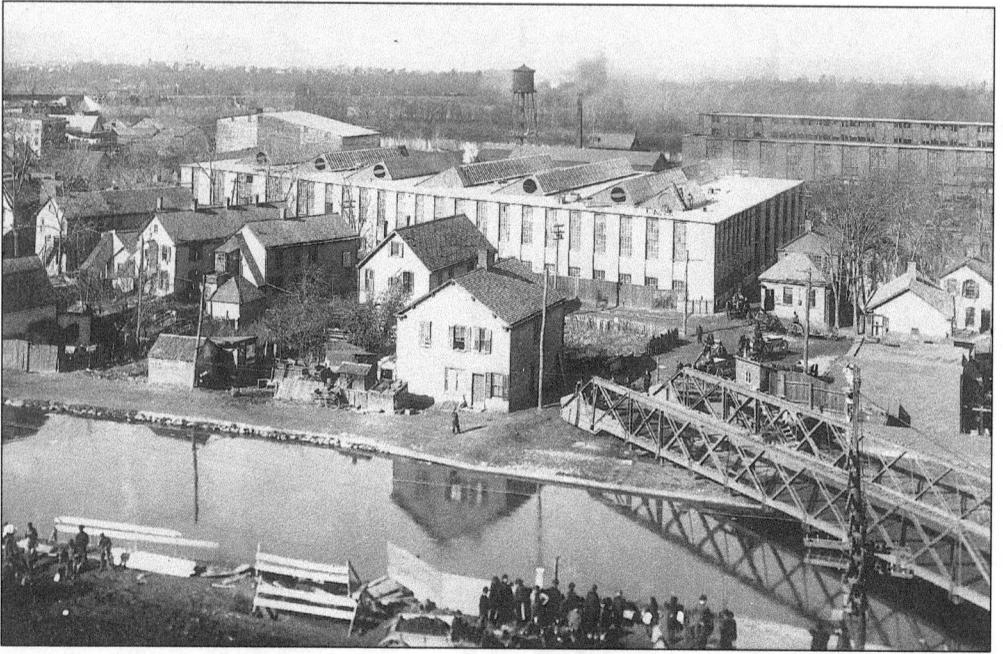

A crowd of pedestrians and horse-drawn vehicles wait on both sides of the canal for the swing bridge to move into position so that they can cross to the other side. Beyond the ALCO plant are the railroad bridge, the Mohawk River, and the town of Scotia. The photograph dates from c. 1906. (Efner History Research Center.)

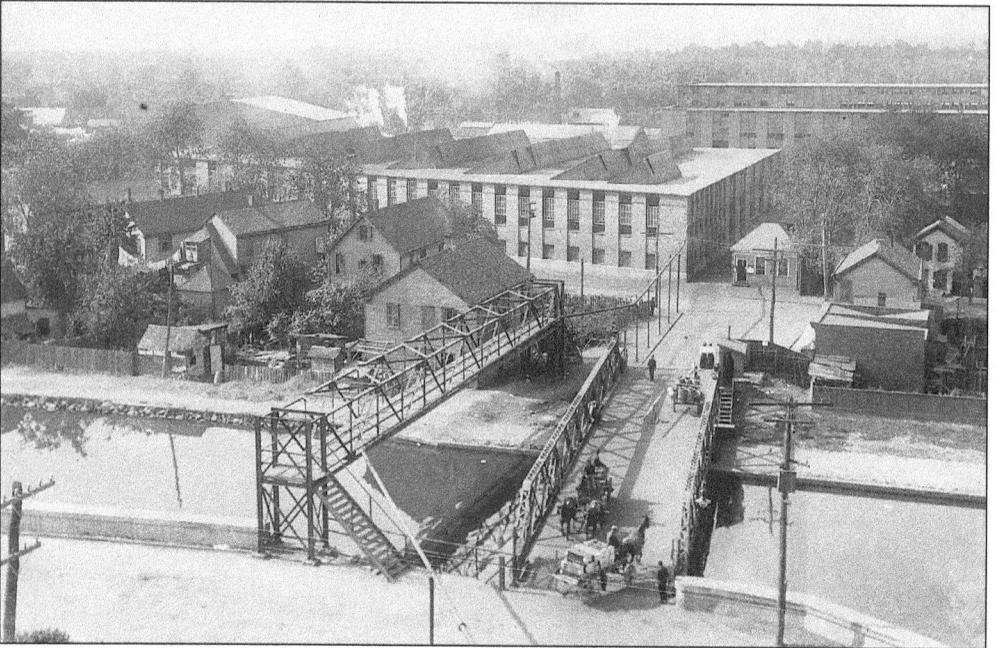

This photograph shows the swing bridge in place with a new pedestrian walkway alongside. The Schenectady Locomotive Works became part of the American Locomotive Works in 1901. The factory building to the left of the plant entrance was erected c. 1905. It is now part of the Schenectady Industrial Park.

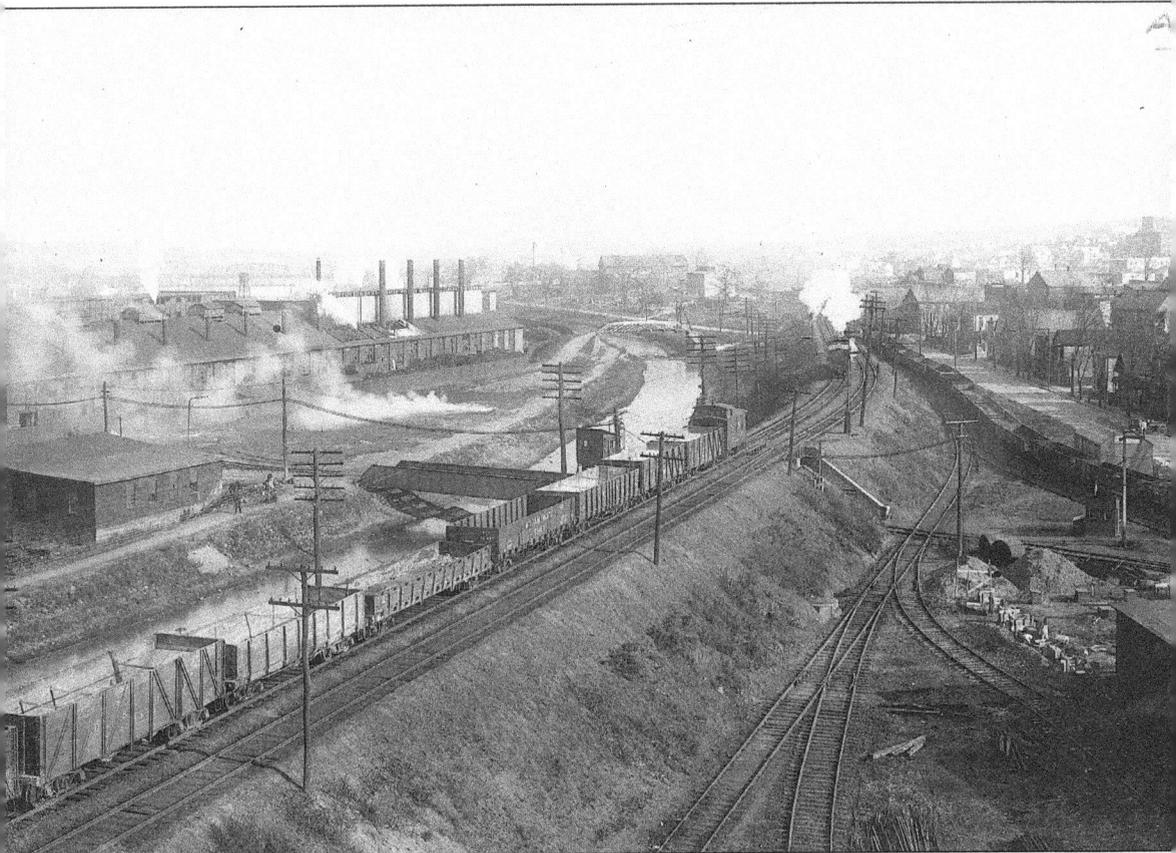

Here is the American Locomotive Works during its heyday c. 1910, with all furnaces belching smoke into the sky. The canal runs between the railroad tracks and the ALCO plant. Freeman's Bridge to Scotia and the Mohawk River are barely visible on the left in the distance. The Mohawk Brewery of 1890, which later became United Plating, is on the upper right. The remains of that building were removed in 1999. (ALCO Collection/Efner History Research Center.)

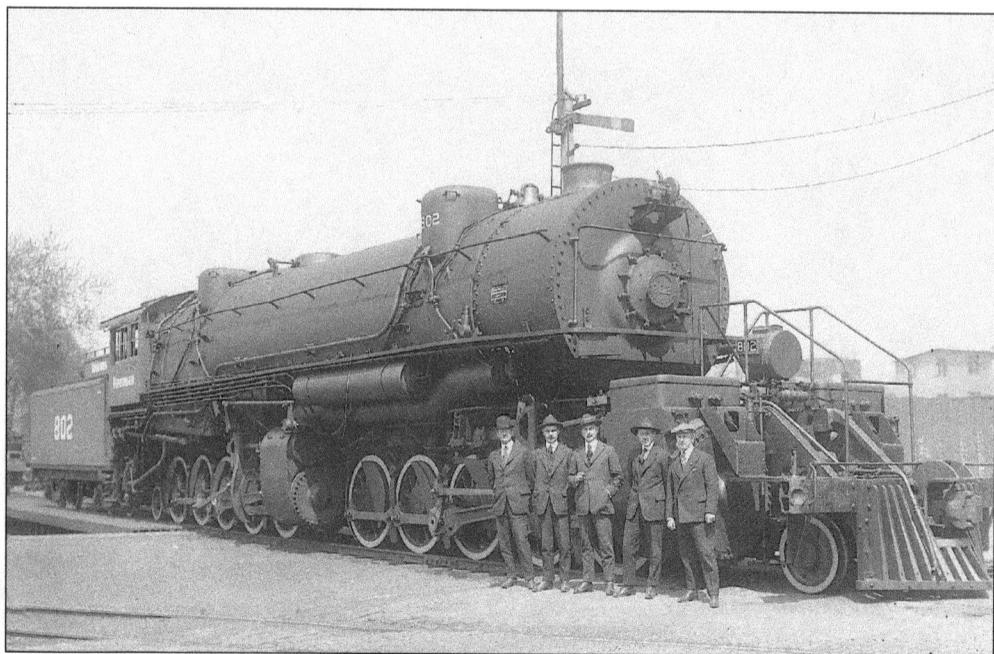

This 1918 photograph shows Virginia Engine No. 802, built by the American Locomotive Works, and some dapper-looking railroad officials. (ALCO Historic Photos/Efner History Research Center.)

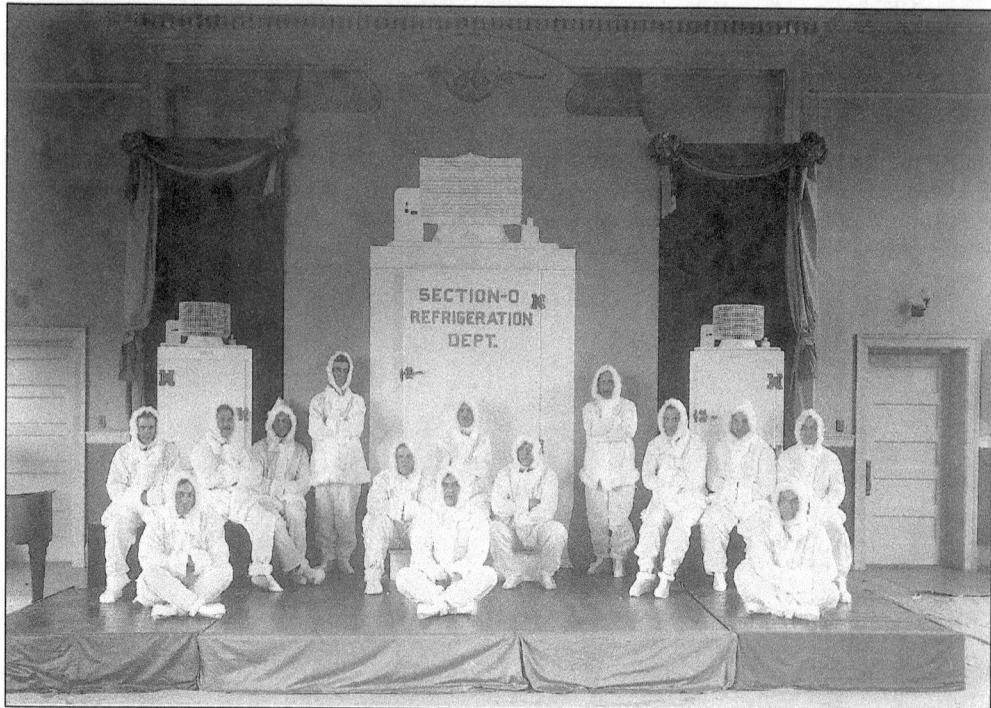

This promotional picture from the late 1920s was for the General Electric Monitor-Top Refrigerator. The only person identified is Charles Juno, machinist, standing fifth from the left. (General Electric Collection/Efner History Research Center.)

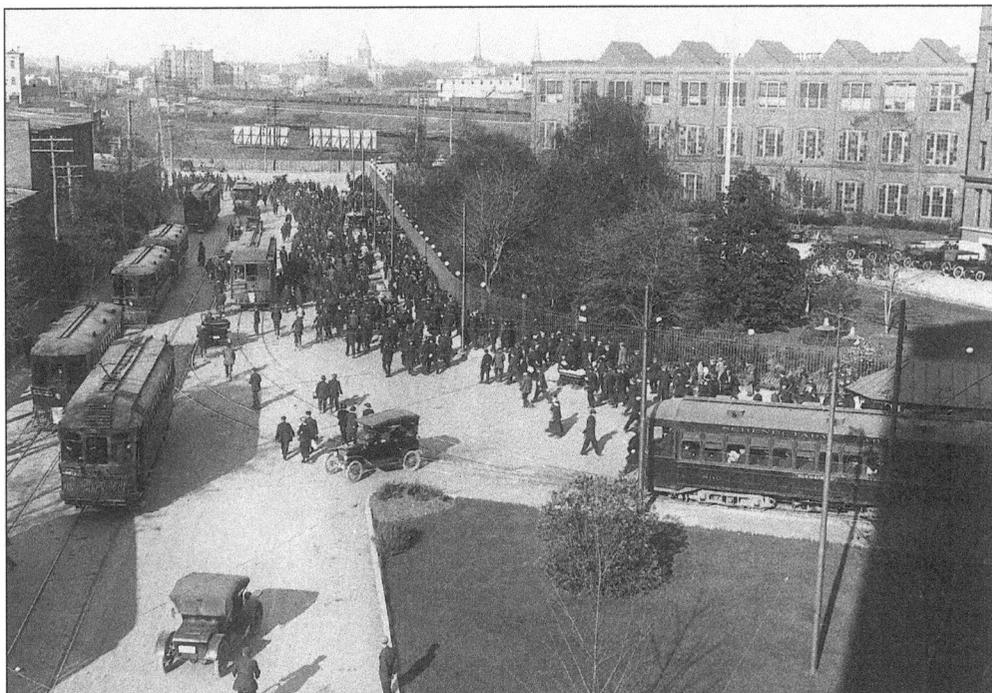

Model T Fords, bicycles, and streetcars of the Schenectady Railway Company bring workers to the General Electric Plant. The dome of St. John the Evangelist Church, dedicated at its completion in 1904, is visible on the horizon. (Efner History Research Center.)

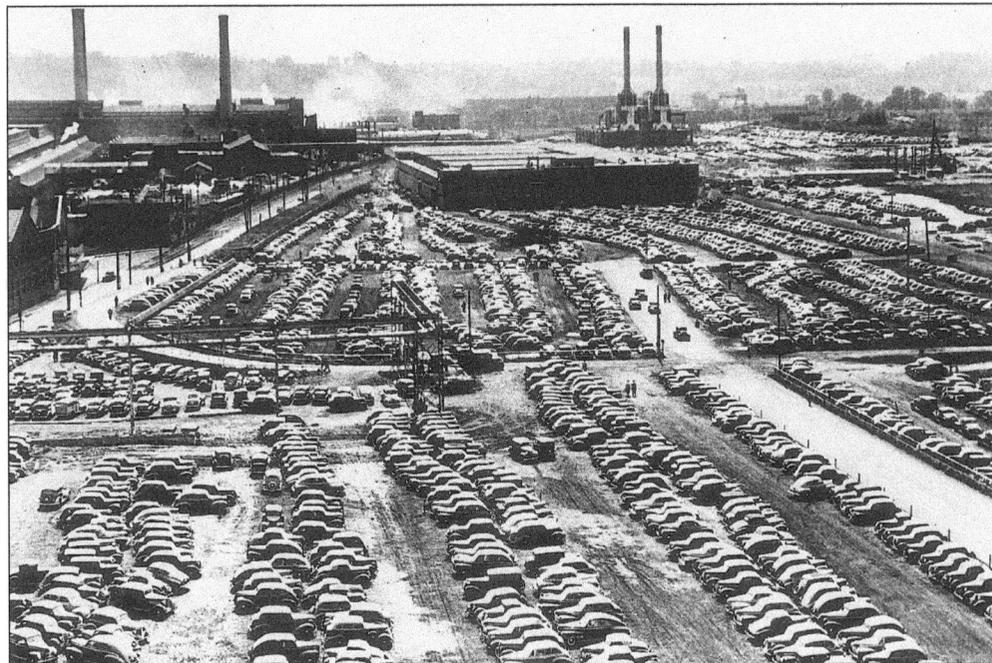

Snow-covered cars fill the parking lot in the early 1940s. General Electric was going full tilt during the war effort. At its peak, the company employed 54,000 people. (Efner Collection/Efner History Research Center.)

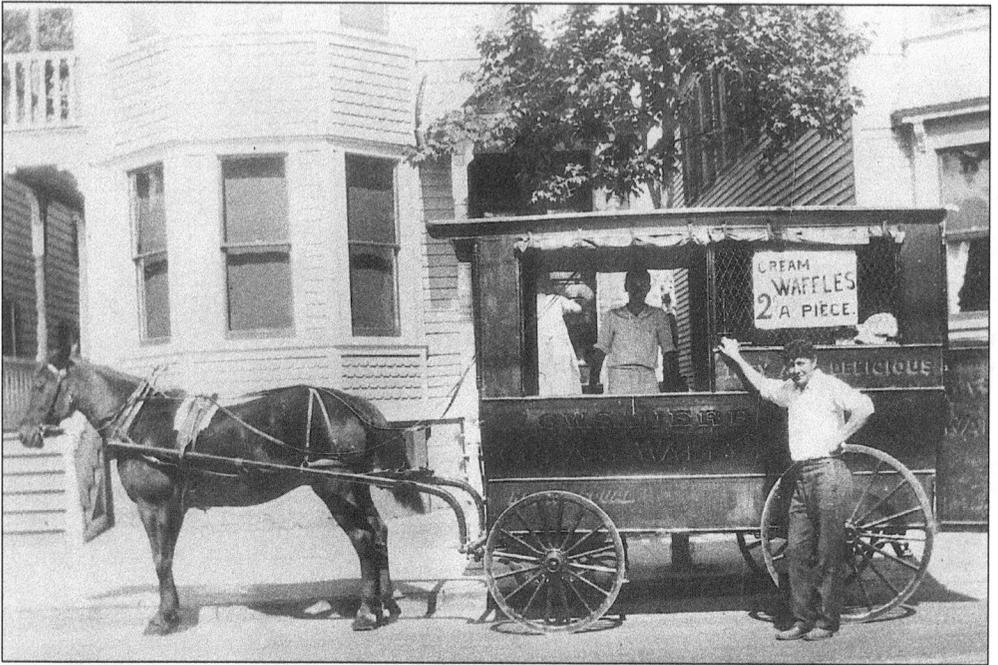

George W. Sauerborn of 315 Hulett Street, a small entrepreneur, sells cream waffles from his horse-propelled waffle wagon in 1914. (Efner History Research Center.)

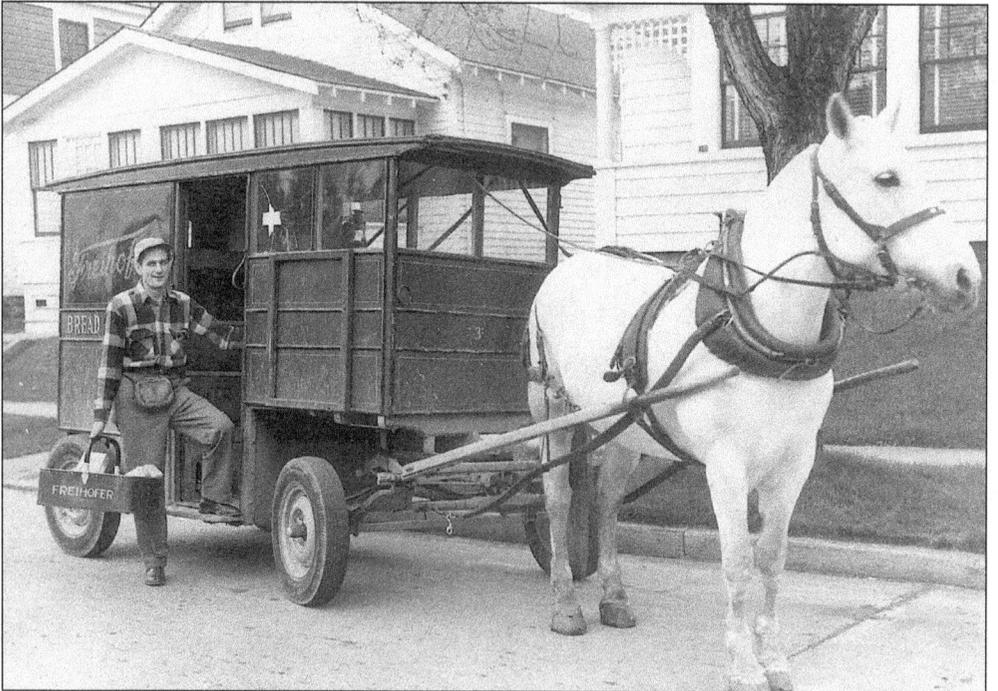

Forty years later a larger company called Freihoffers still employed the same delivery method. Here, George "Eddie" Neals and his horse Peaches stop on their way back to the Albany Street horse barn to have their picture taken by a young boy with a Brownie camera. (Courtesy of Jacqueline Karwowski.)

This 1920s photograph shows the home of the International Brotherhood of Electric Workers, one of a number of unions that found a home in Schenectady. Note the men in the upper left windows. The building was located at 105 Clinton Street, across from city hall. In 1937, the present-day Greek Orthodox Church was built to the right of the union building. (Roland Tinning photograph/Efner History Research Center.)

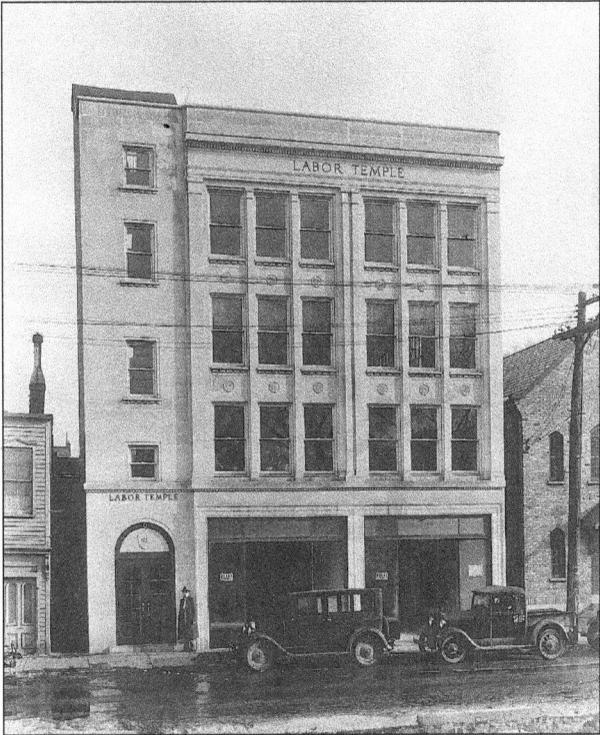

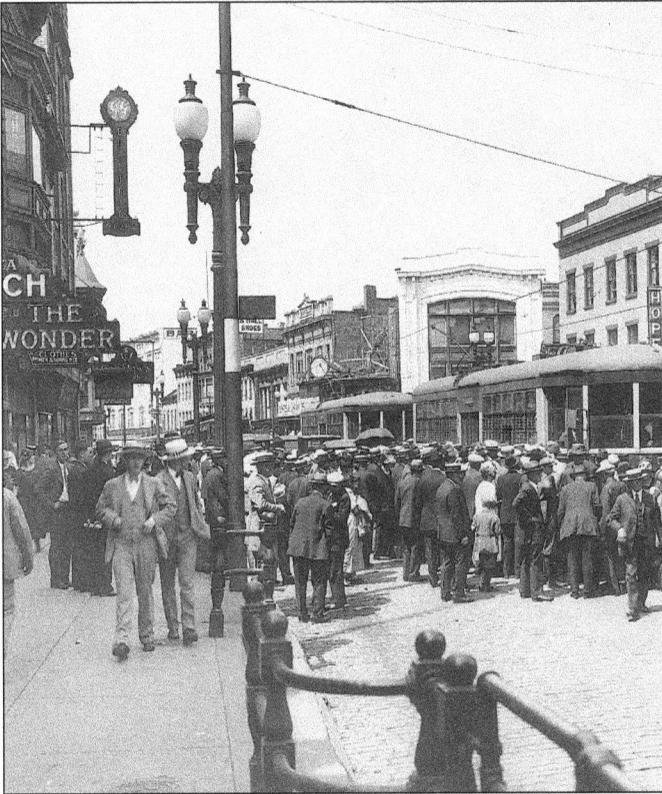

A throng of commuters wait to board trolleys in a 1925 rush hour on State Street in front of the current location of Trustco Bank and Rudnicks. (Courtesy of Scott Haefner.)

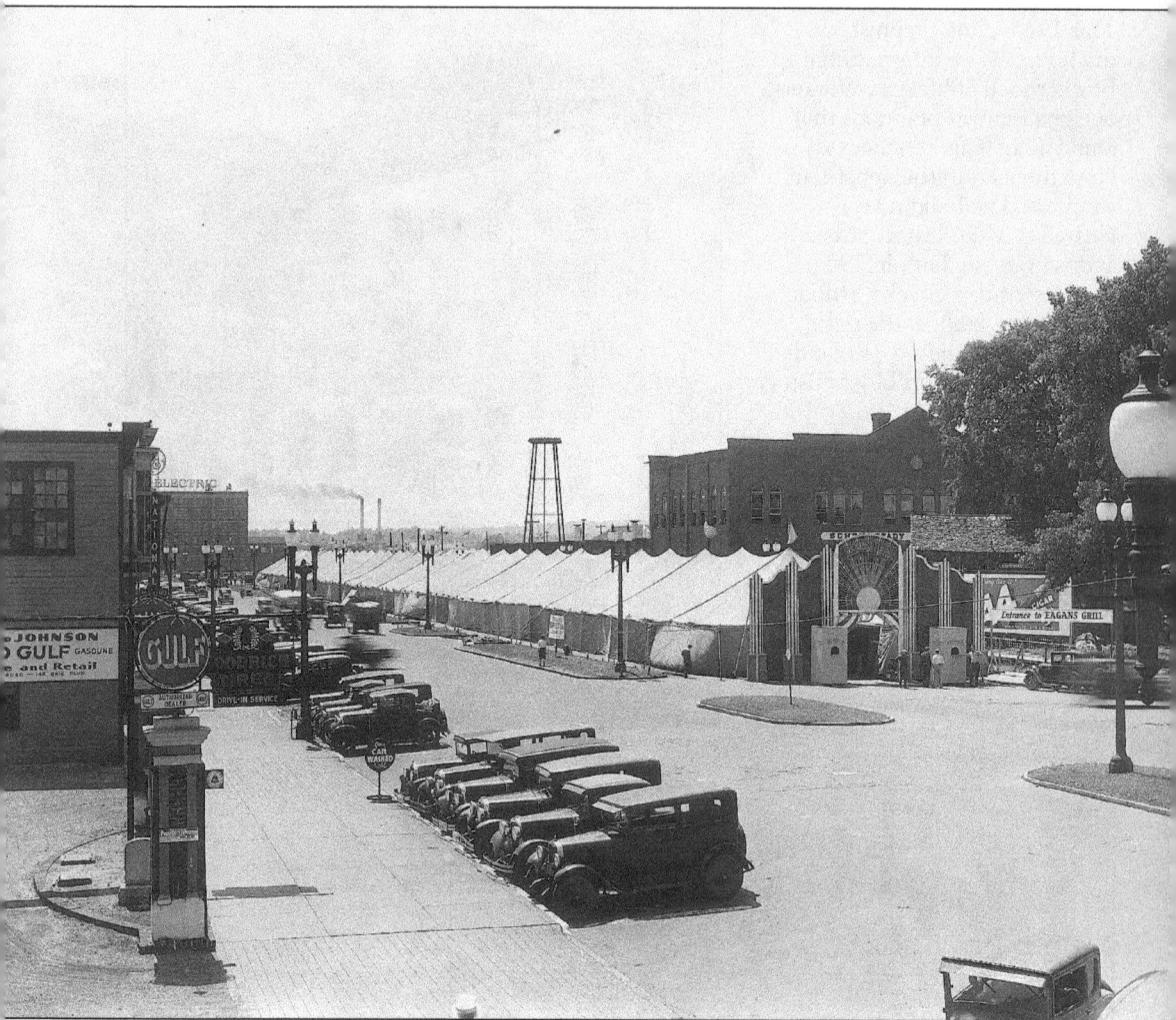

This early 1930s photograph shows the Schenectady Chamber of Commerce's Prosperity Exposition of August. Held on Erie Boulevard, the exposition featured booths showcasing the latest advancements—all for 25¢ admission. Olney Redman's gas station is on the front left, and the car barn for the Schenectady Railway Company is behind the tents. (Schenectady Chamber of Commerce.)

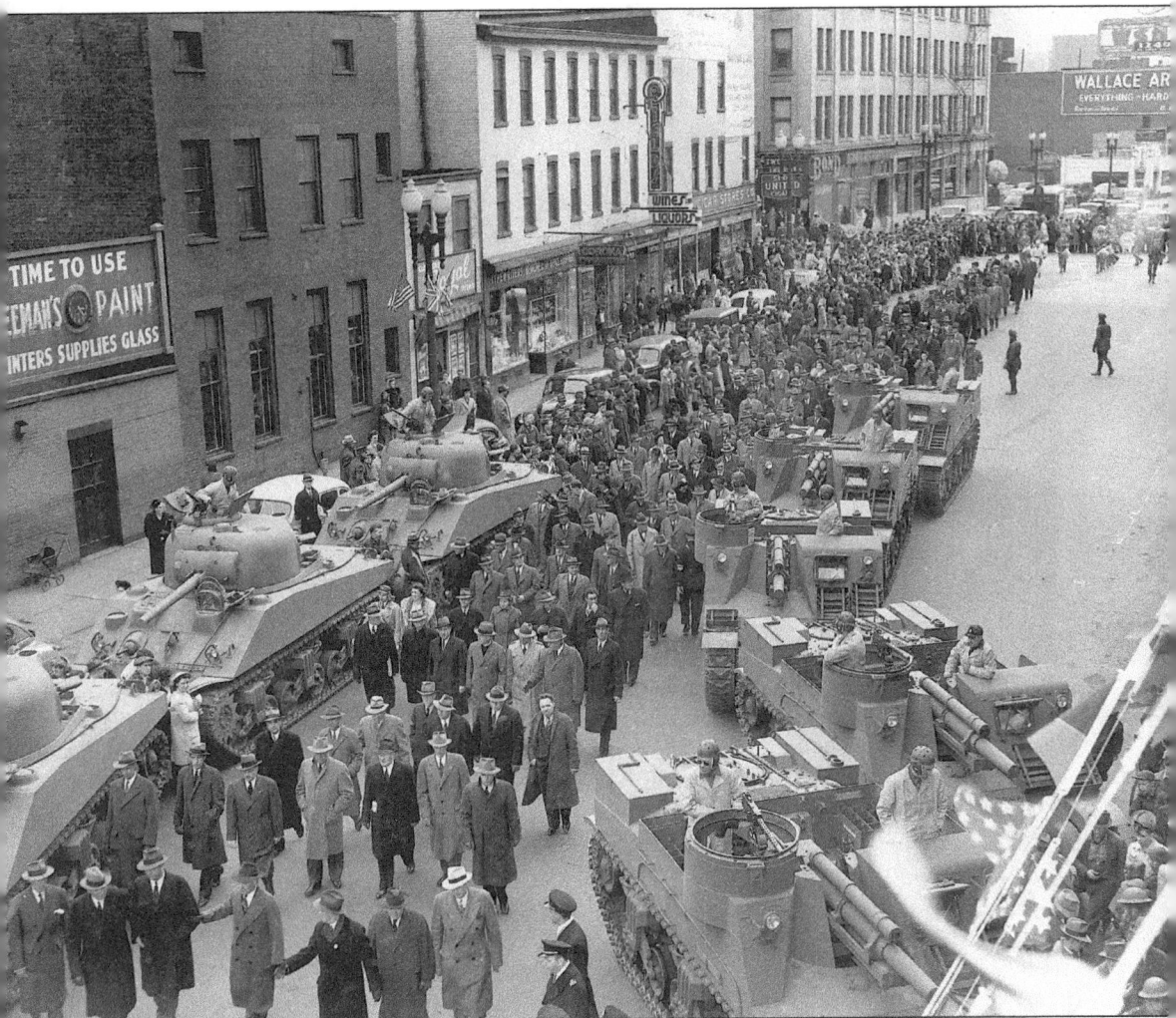

Mayor Mills Ten Eyck, front row to the left of the man in a white hat, and other dignitaries lead the M-7 Tank Day Parade down Erie Boulevard from State Street toward Liberty Street in April 1943. British 8th Army commanders came to Schenectady to honor ALCO, whose tanks had helped defeat German Field Marshal Erwin Rommel in North Africa. Visible are the 1919 Masonic Temple, toward the rear, and buildings that lined Erie Boulevard in front of Wall Street, on the left. (Efner History Research Center.)

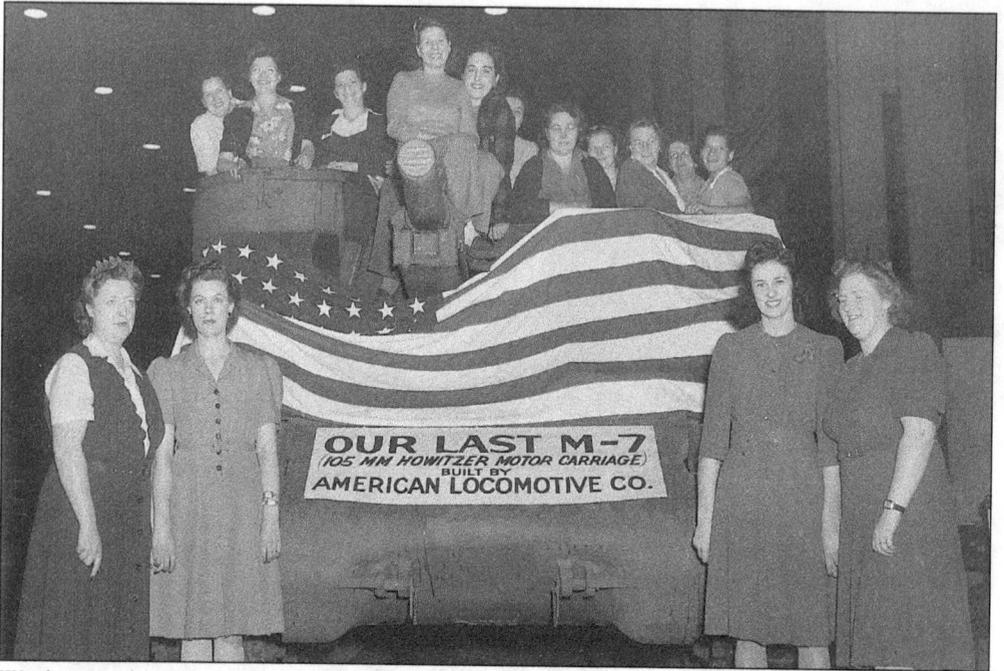

Workers at the American Locomotive Company pose by the last M-7 to come off the line on May 7, 1944. From left to right are Lillian Melita, Carrie Gray, Anna Infrate, Margret Fusco, Josephine Pratico, Lucille Foster, Marjorie Ellithorpe, Sarah Harris, Rosalie Hoag, Bertha DeFreest, Freda Myers, Gladys Terrell, Katherine Loumberia, and Mrs. Oran Baxter. (Efner History Research Center.)

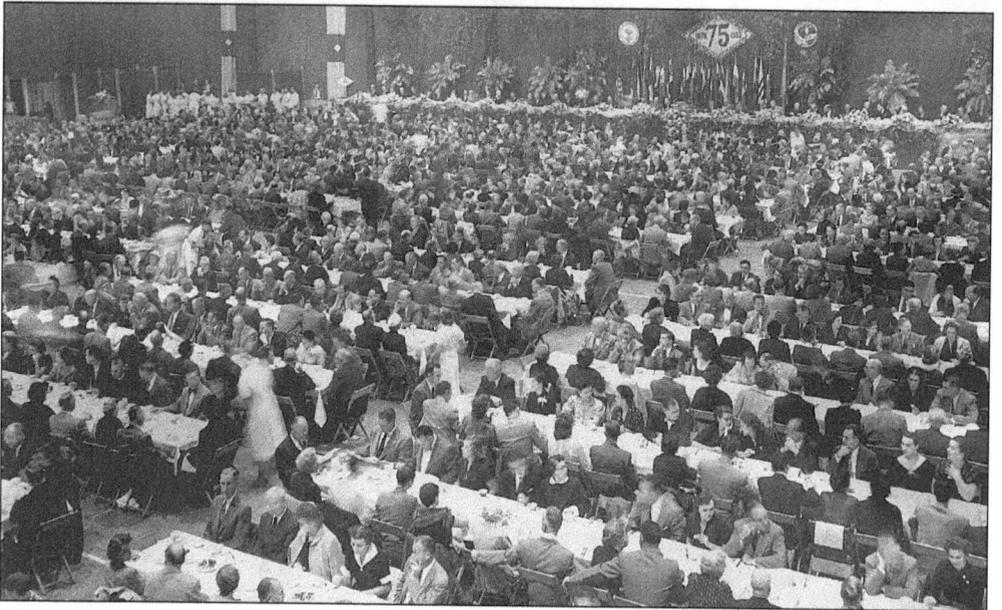

The *Union Star* ran this photograph in its Wednesday, October 7, 1953 edition. The caption read "2000 sit down to Chamber of Commerce Dinner Honoring G.E." The occasion was the 75th anniversary of General Electric, and the place was the Washington Avenue Armory. (Efner History Research Center.)

94

Six

IN PURSUIT
OF KNOWLEDGE

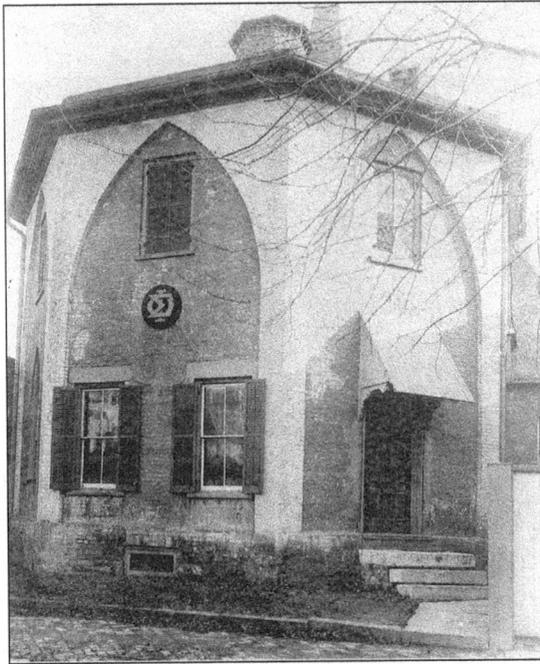

Schenectady Lyceum and Academy, erected in 1835 by Giles F. Yates, was a private school for boys whose parents could afford to pay. President Chester A. Arthur attended the school as a student. The building was an eight-sided wood-and-stucco structure located at 5 Yates Street on the corner of Union Street. From 1844 to 1856, it was leased by St. George's Masonic Lodge. The Masonic symbol is on the left of the building. After the Masons moved out, the building became a blacksmith's shop. The structure was razed in the summer of 1911. (Courtesy of St. George's Masonic Lodge.)

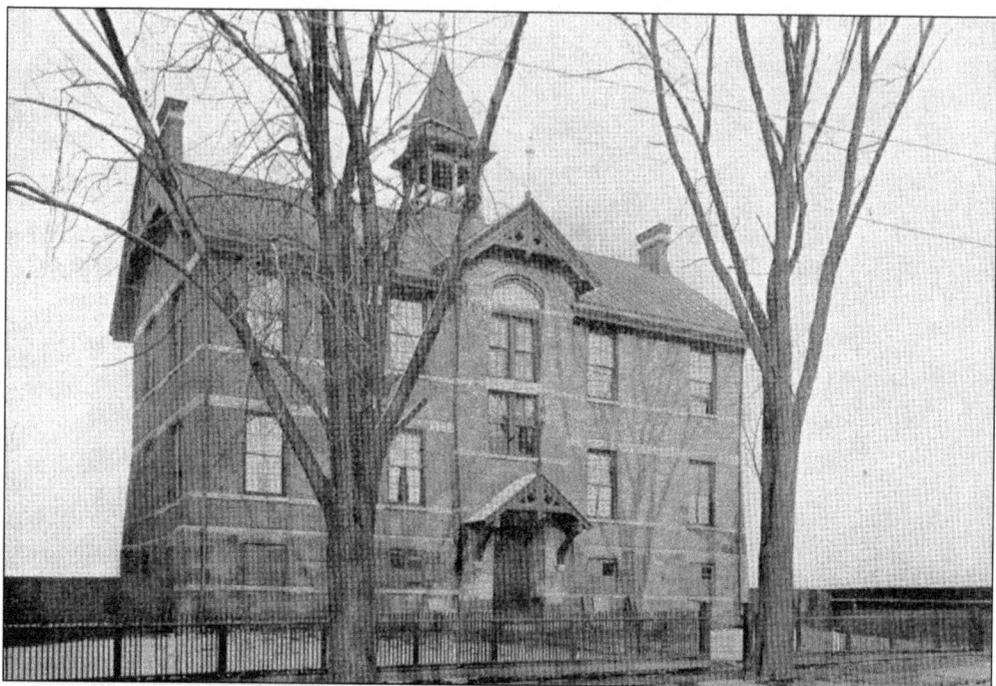

Erected in 1875, the Nott Street School was the second "free common school" to be built in Schenectady. (Efner History Research Center.)

Schenectady High School had north and south buildings, constructed in 1903 and 1911 respectively, that were joined by an enclosed bridge. After 1931, the school was renamed Nott Terrace High School. Students were offered a college preparatory course that included Greek, Latin, and elocution. The school was on the present-day site of Friendly's Restaurant. (Robson & Adee photograph/Efner History Research Center.)

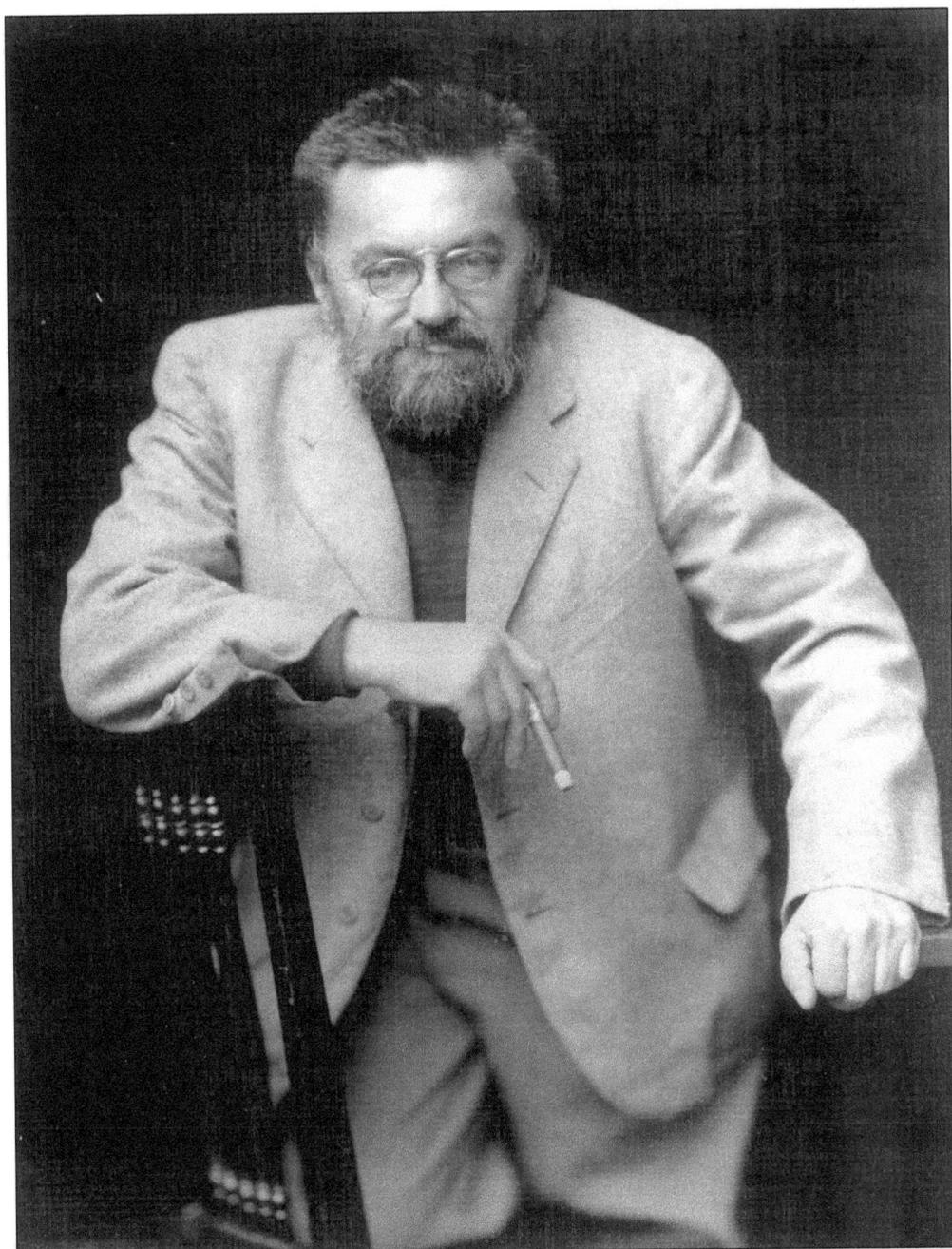

Electrical engineer Charles Steinmetz began his years of service on the Schenectady Board of Education under Mayor George Lunn's administration. Steinmetz served as president and remained on the board until his death in 1923. During his first term, three schools were started and two were enlarged. He campaigned for playgrounds, a lunch program, school nurses, and programs for the disadvantaged pupil. Many people believe that the improvement of Schenectady schools was one of his greatest accomplishments. In 1915, Steinmetz was elected to the common council and served as its president for two years. This official General Electric portrait dates from 1913. (Schenectady Museum/Hall of Electrical History.)

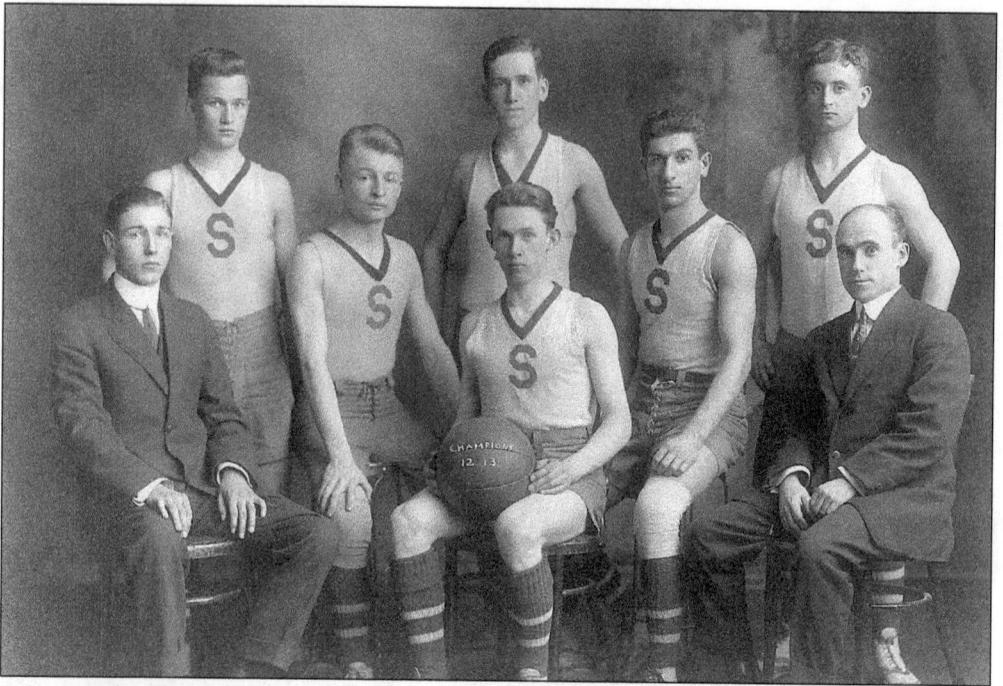

Schenectady High School basketball champions of 1912–13 pose with their coaches. (Efner History Research Center.)

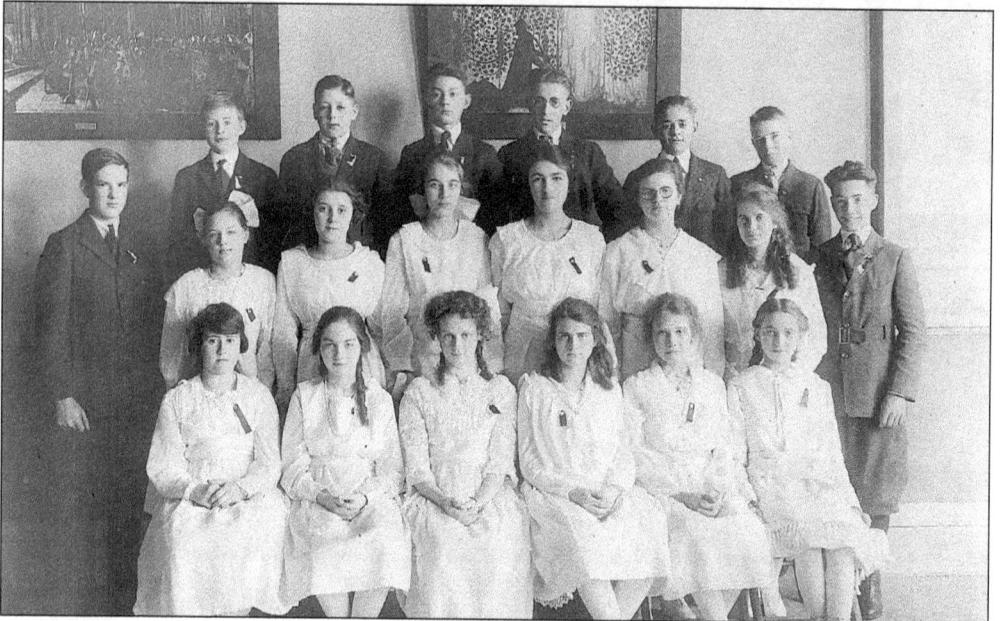

This January 1919 photograph shows students of Lincoln School, from left to right, as follows: (front row) unidentified, Mae Acker, Evelyn Tripp, Pauline Fisher, Elsie Troist, and Mae Perkins; (middle row) Elmer Arneel, Avada Glindmyer, Gladys Phillips, Genevive Robinson, Frances Strohmaier, Ella Smith, Emma Fisher, and Lawrence Tibbit; (back row) two unidentified students, Thomas Massoth, Leon Sherman, unidentified, and Harold Bradshaw. (Mabelle Primmer photograph/Efner History Research Center.)

This 1920s-era photograph of the Clinton Street School proves that little has changed in the building's facade. After the school system stopped using it as a school, the building became police headquarters and later became the corporate headquarters of Off Track Betting. (Board of Education Collection/Efner History Research Center.)

Once known as the Robinson Street School, this building on the corner of Robinson and Albany Streets is still being used and is now called Lincoln School. (White Studio photograph/Board of Education Collection/Efner History Research Center.)

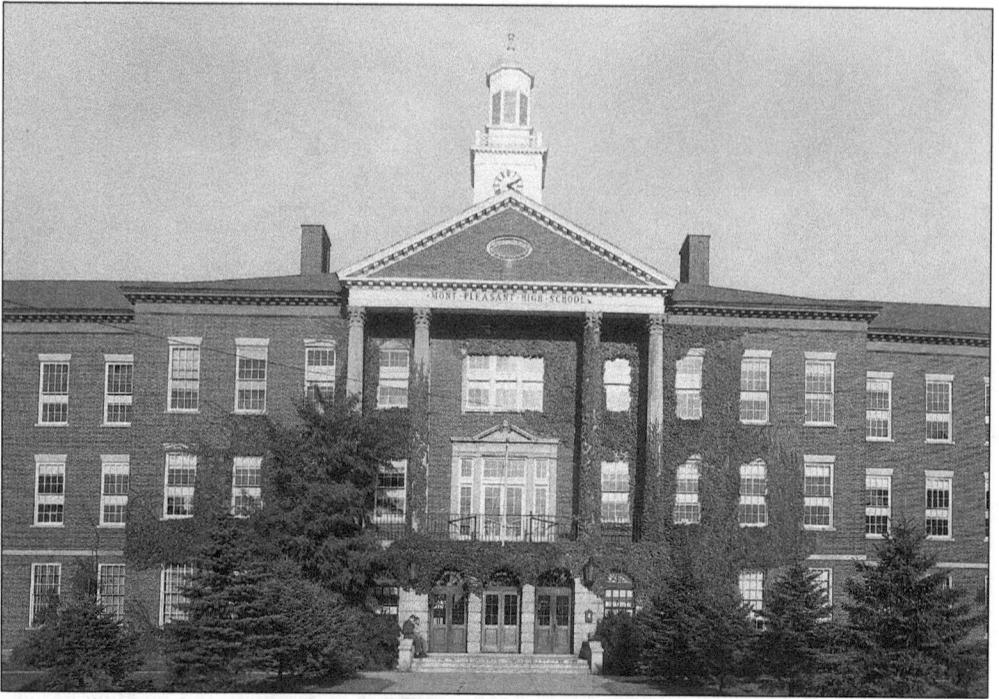

The 1931 Mont Pleasant High School building is shown here as it looked in the early 1950s. Located in Ward 9 on Forest Road in the Mont Pleasant section of the city, the school has gone through numerous expansions and today, it is one of the city's three middle schools that send students on to the new Schenectady High School on The Plaza. (Nat Boynton Collection/Efner History Research Center.)

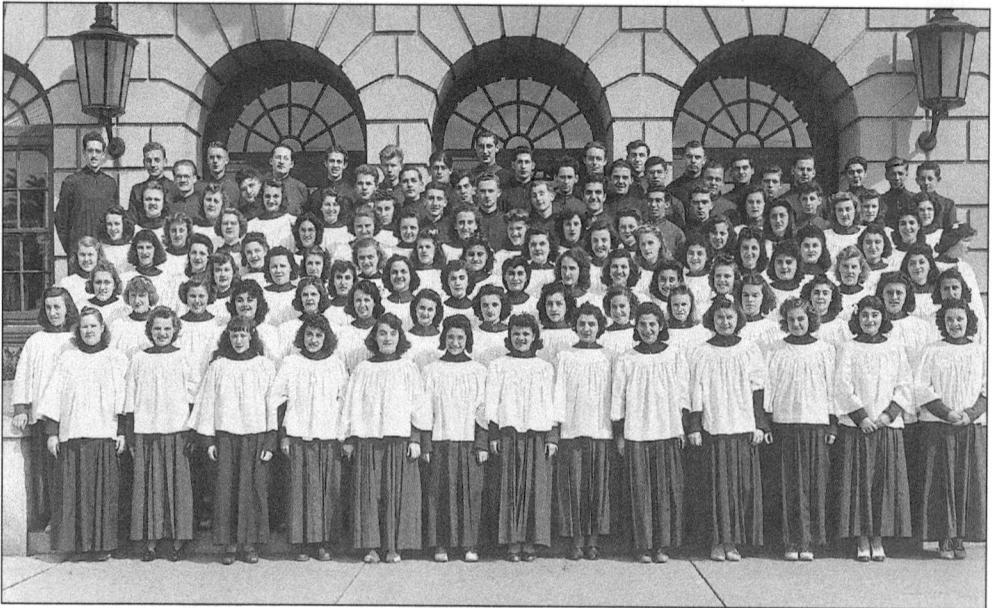

This photograph dating from c. 1939 shows the more than 100 members of Mont Pleasant's *a cappella* choir. A number of young women in the front row are wearing saddle shoes, which were popular into the 1950s. (Douglas Dales photograph/Efner History Research Center.)

100

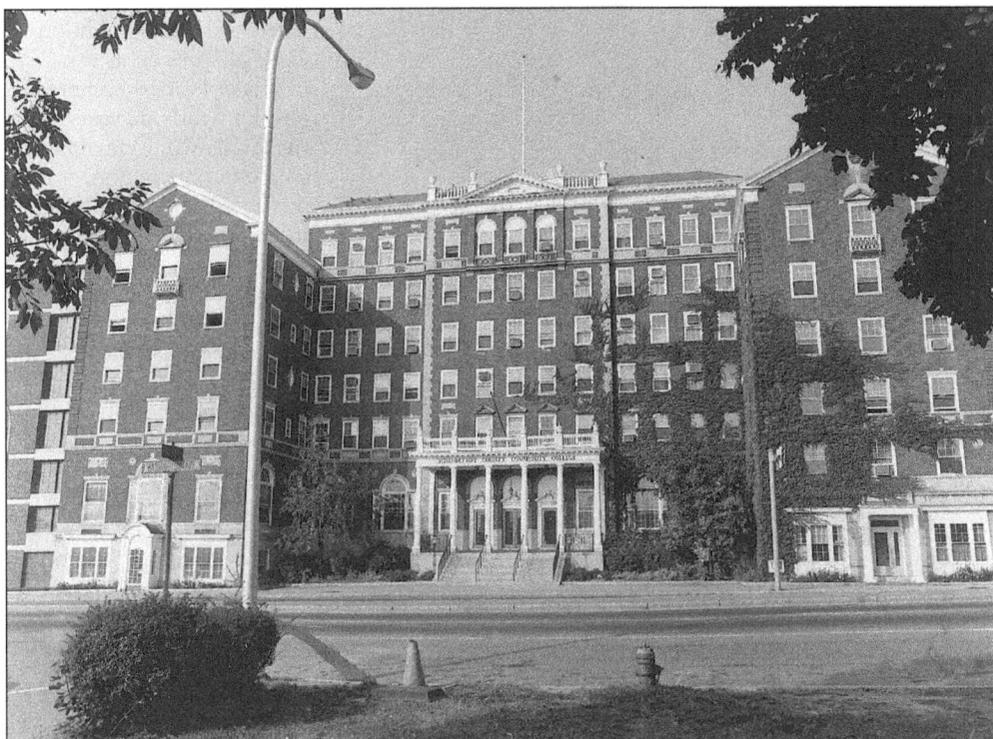

Located on Washington Avenue, this building has been the home of the Schenectady County Community College since 1969. It was originally the Hotel Van Curler, which during its heyday was touted as "the finest hotel on the Mohawk River." Although the college has made many alterations, the building still maintains the original classic style of the hotel. (Courtesy of Schenectady County Community College.)

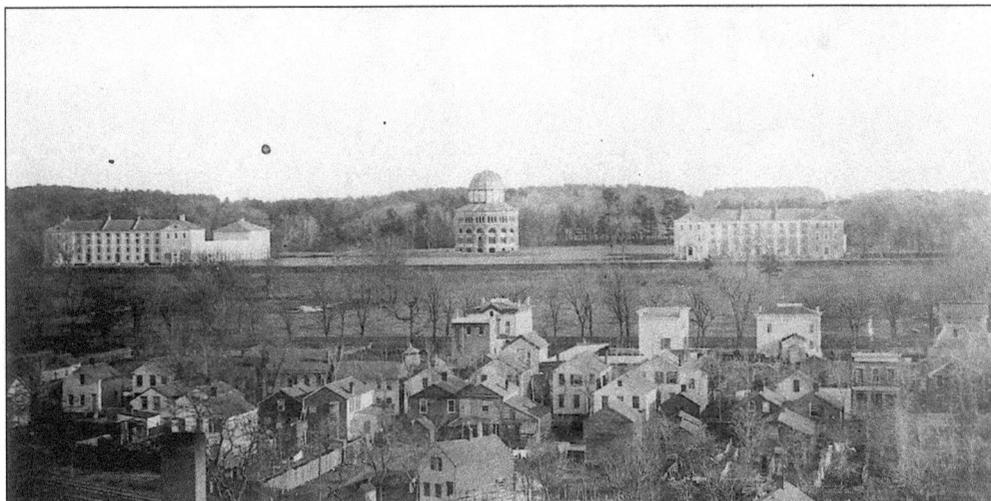

Union College was chartered in 1795 in conjunction with the Dutch Reformed Church and its Schenectady Academy. In 1814, the college relocated to its present-day site, the first planned college campus in America. The Nott Memorial was completed 80 years later, in 1875. Although unfenced, the college sat remote from the town by virtue of the fields and woods surrounding it. (Courtesy of Schaffer Library/Union College/Schenectady.)

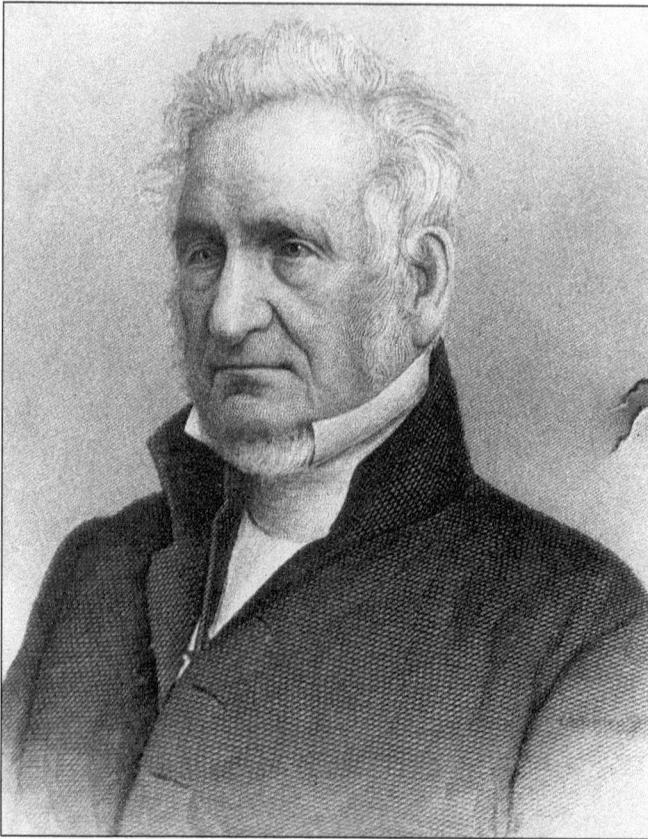

The best known of Union College's presidents was Eliphalet Nott, who held the post for nearly 62 years until the Civil War. One of Nott's greatest contributions was the invention of the Nott stove, which revolutionized the coal industry. Prior to this, coal-burning stoves were unable to maintain a high enough temperature to burn hard coal. The Nott stove burned both hard and soft coal and brought a very profitable industry to the Lehigh Valley of Pennsylvania. (Courtesy of Schaffer Library/Union College/Schenectady.)

This photograph shows a Union College dormitory room of the 1880s, furnished with potbellied stove, curtains with shamrocks, family photographs, and a study desk with books. These rooms remained unchanged for many years. (Courtesy of Scott Haefner.)

Many people who attended Union College have gone on to fame in industry, letters, and public service. One such person was William Henry Seward, Class of 1820, who became U.S. secretary of state. Seward was an expansionist who negotiated the purchase of Alaska with the Czar of Russia at the price of 1.9 cents per acre. (Courtesy of Schaffer Library/Union College/Schenectady)

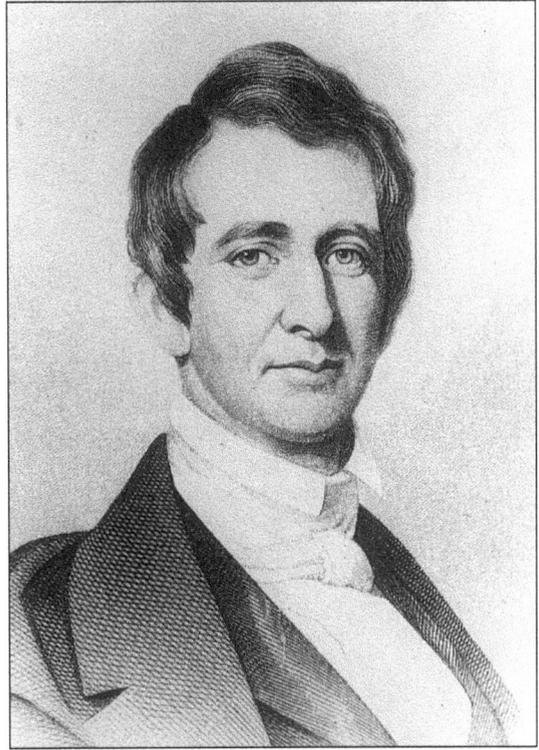

Chester A. Arthur graduated from Union College in 1848 and became the 21st president of the United States in 1881, after the assassination of James A. Garfield. While in office, Arthur supported the Pendleton Act, which created the Civil Service Commission. (Courtesy of Schaffer Library/Union College/Schenectady.)

103

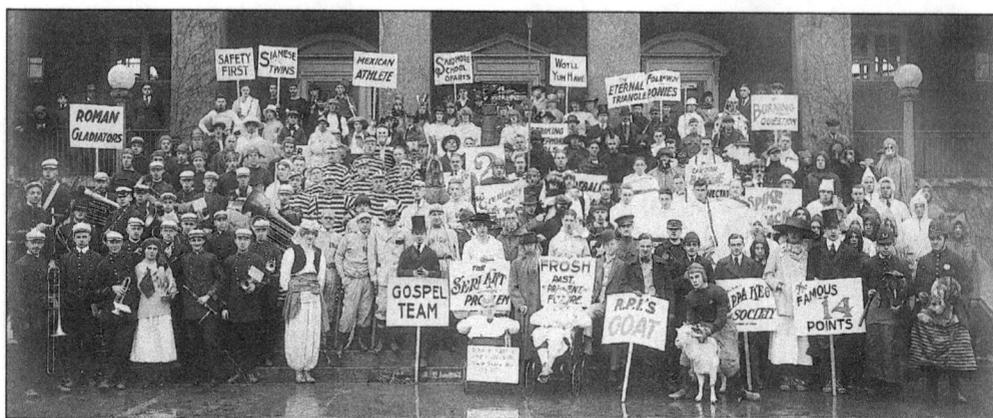

Taken *c.* 1918, this photograph depicts Union College students at their most playful in both word and attire, perhaps participating in homecoming weekend. The students pose on the steps of the Alumni Gymnasium, constructed in 1914. All of them are men—although some are in feminine costume—and all were probably members of the freshman class. (Efner History Research Center.)

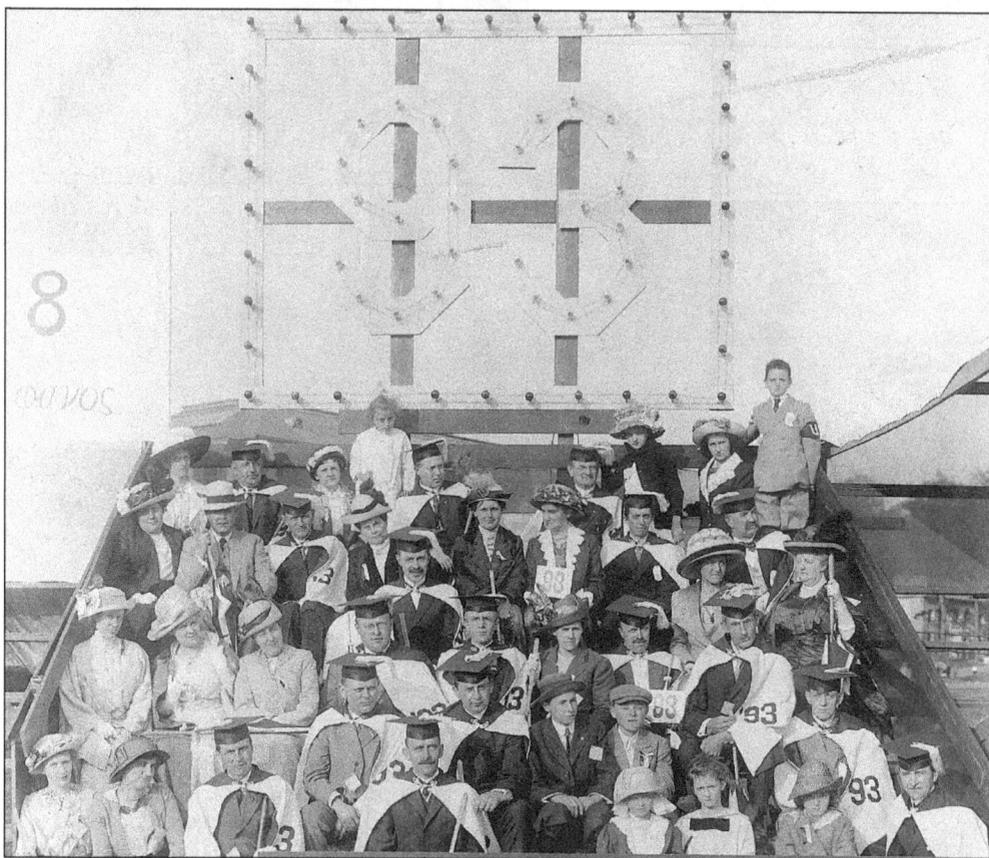

This more sedate group consists of graduates of the Union College Class of 1893 with their wives and children, posing on Alumni Day in 1915. This was an age when dressing well included the wearing of a hat. Union College did not become a coeducational institution until 1977. (Arthur J. White photograph/Efner History Research Center.)

Seven

LEISURE TIME

With the number of chemists, engineers, and professors in Schenectady, it is not surprising that a Schenectady Camera Club was formed. This 1889 photograph, taken in Van Horne Hall by W.E. Underhill, employed the first flash photography. The group included Frank Bissell, W.C. Vrooman, Eugene W. Veeder, W. Peckham, W. Talbot, Dr. O'Neil, Prof. M. Perkins, and John White. The club was a forerunner of the present-day Schenectady Photographic Society, formed in 1931 by nine men. (Courtesy of the Schenectady Historical Society.)

Pedestrians stroll through Crescent Park in the late 1800s. The First United Methodist Church, erected in 1872, faces the park across State Street. (A. Gayer photograph/Courtesy of Scott Haefner.)

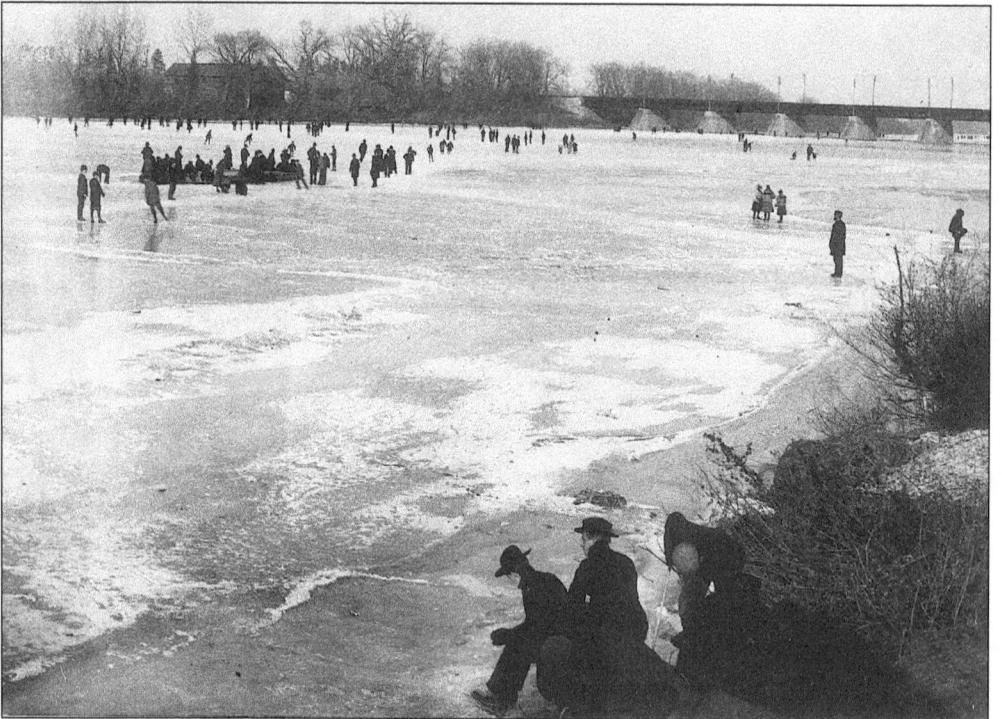

This photograph shows people ice-skating along the Mohawk River in 1896 or 1897. Scotia's shore is visible in the background, as is the New York Central rail bridge. (Efner History Research Center.)

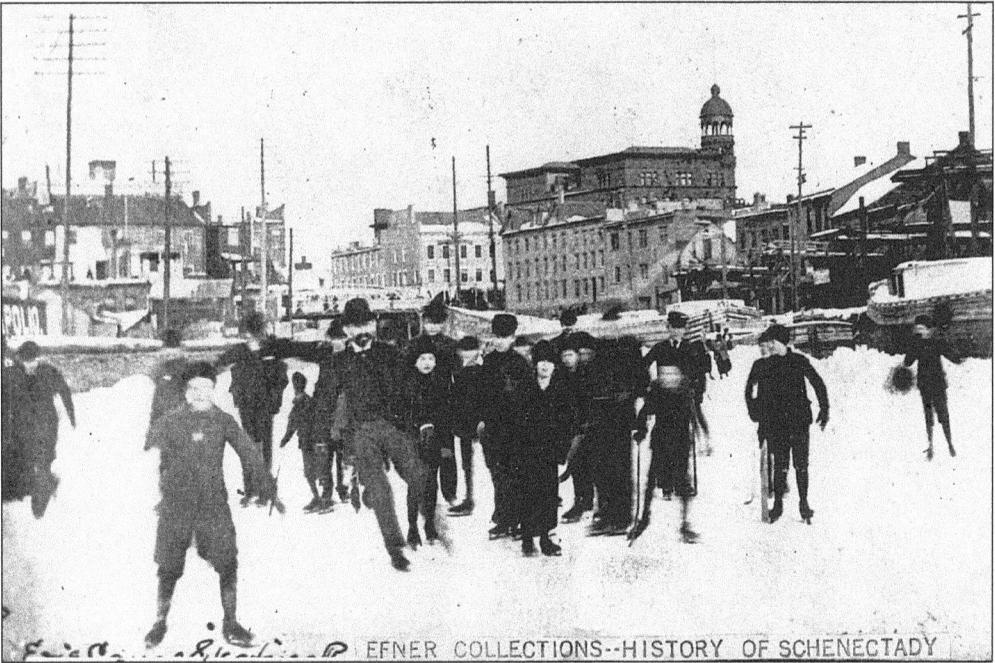

Skaters and curlers enjoy the ice on the Erie Canal in 1915. Canal boats are frozen in place for the winter. In the background, State Street crosses over the canal and the tower of the Hotel Edison rises. (Efner History Research Collection.)

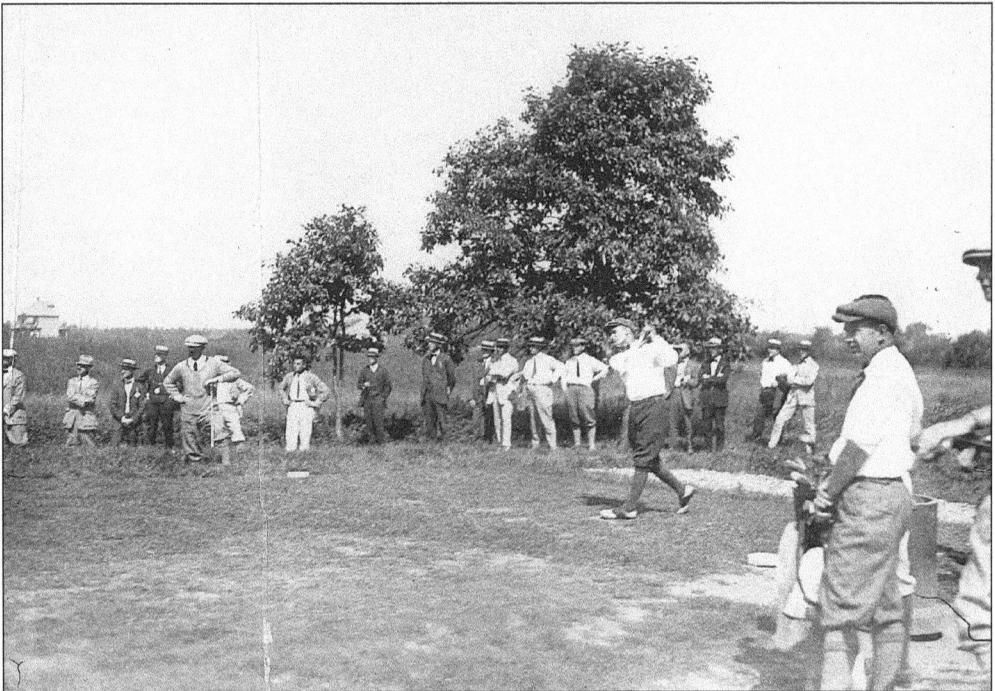

The Mohawk Golf Club at Lenox Road and Nott Street opened in 1898. This photograph was taken before 1906, when the land was sold for the new Ellis Hospital. (Courtesy of Scott Haefner.)

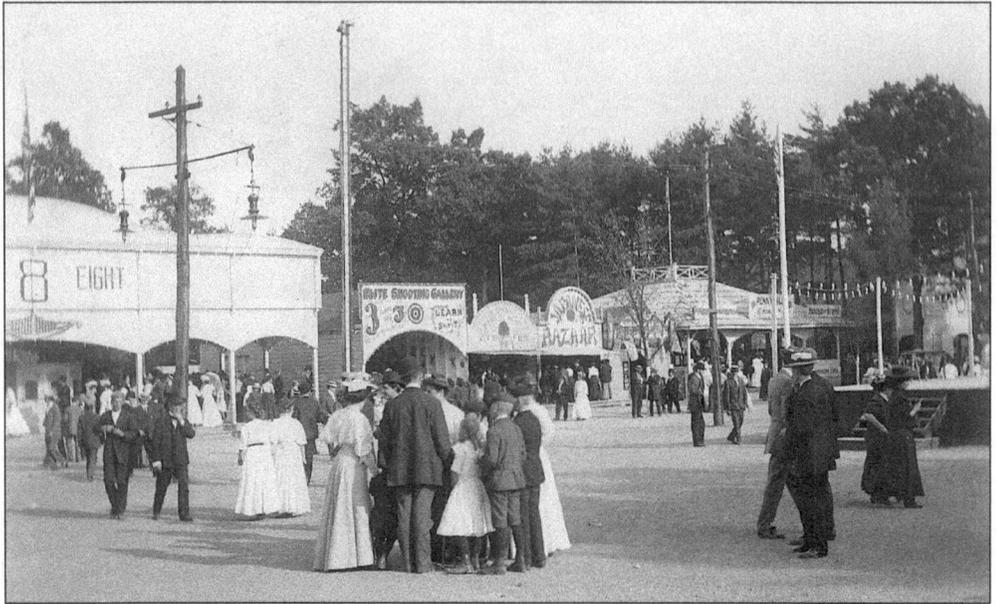

Luna Park operated from 1901 to 1935. It could be reached by the Van Vranken trolley line, which charged 5¢ for the ride. Over time, the park had five names—Luna Park, Dolle's Park, Colonnade Park, Palisades Park, and Rexford Park. This 1915 view is of the midway, where thousands of visitors spent their leisure hours. People came to the park for the free attractions, thrilling rides, prizes, and concessions. (Courtesy of Scott Haefner.)

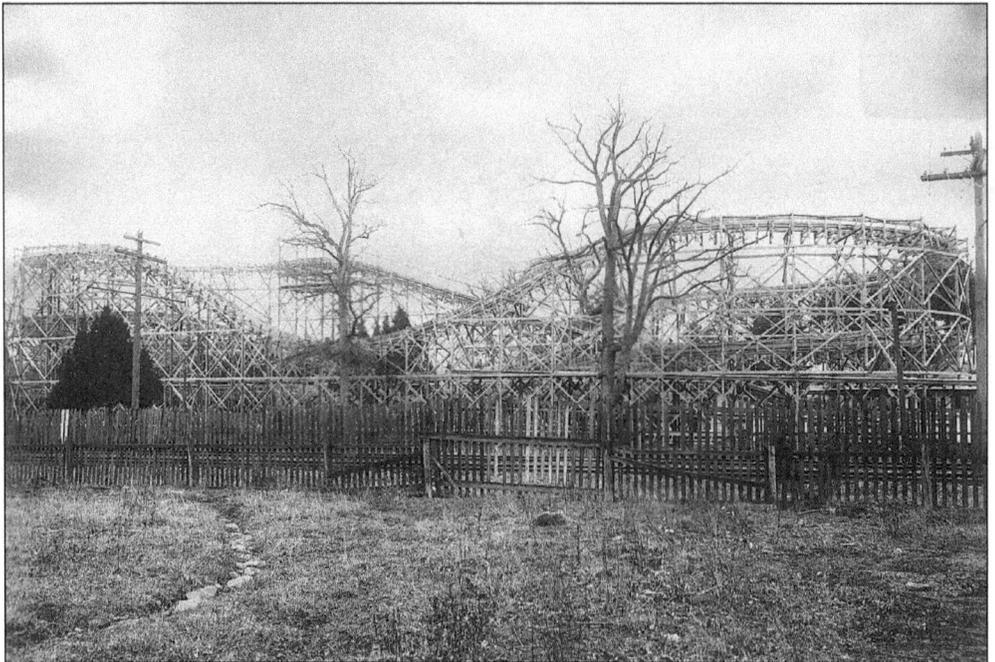

This photograph shows the frame for the roller coaster at Luna Park. There was also a boat slide. When rides had been around for a while and were considered too tame, new ones were built to keep the people coming. Patronage declined starting with the stock market crash of 1929. Afterward, new habits of entertainment emerged. (Courtesy of Scott Haefner.)

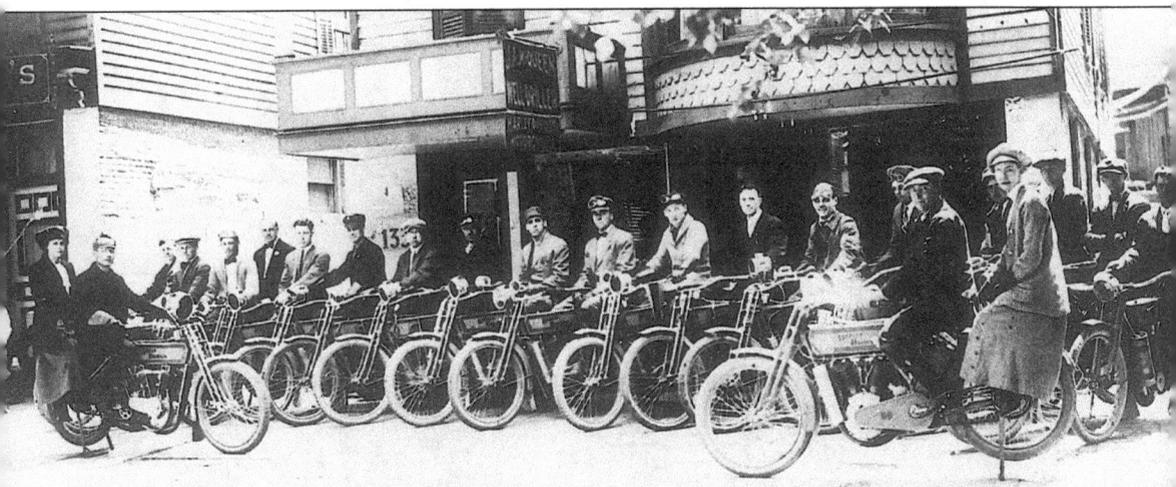

Members of the Schenectady Cycle Club pose with their transportation in front of James A. McQueen's Harley Motorcycle store *c.* 1919. (Courtesy of the Schenectady Historical Society.)

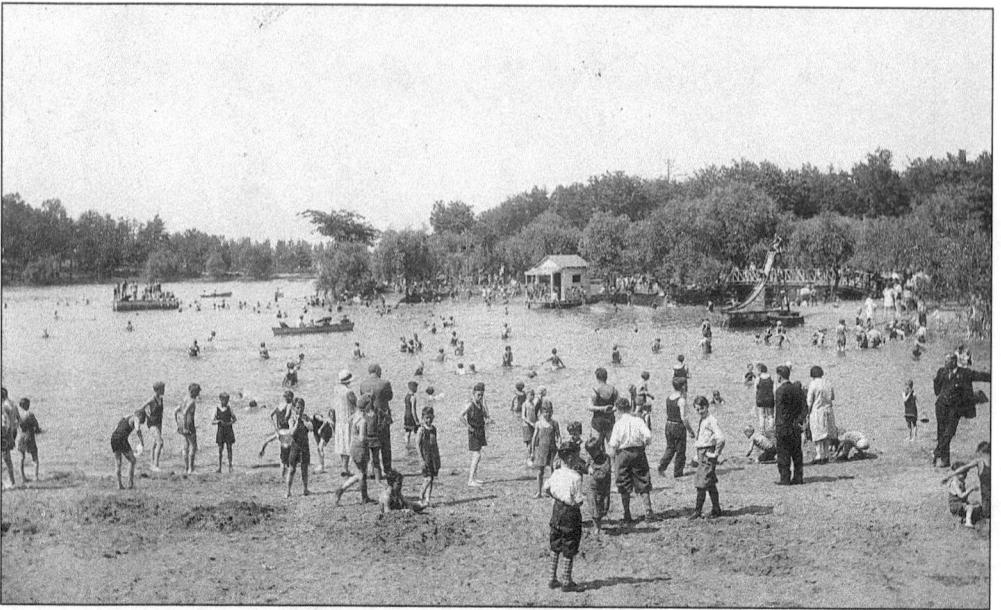

Here is Central Park in the late 1920s. The cool waters of Iroquois Lake attracted swimmers, sunbathers, and boating enthusiasts on summer days. Water slides were popular even then. (Efner History Research Center.)

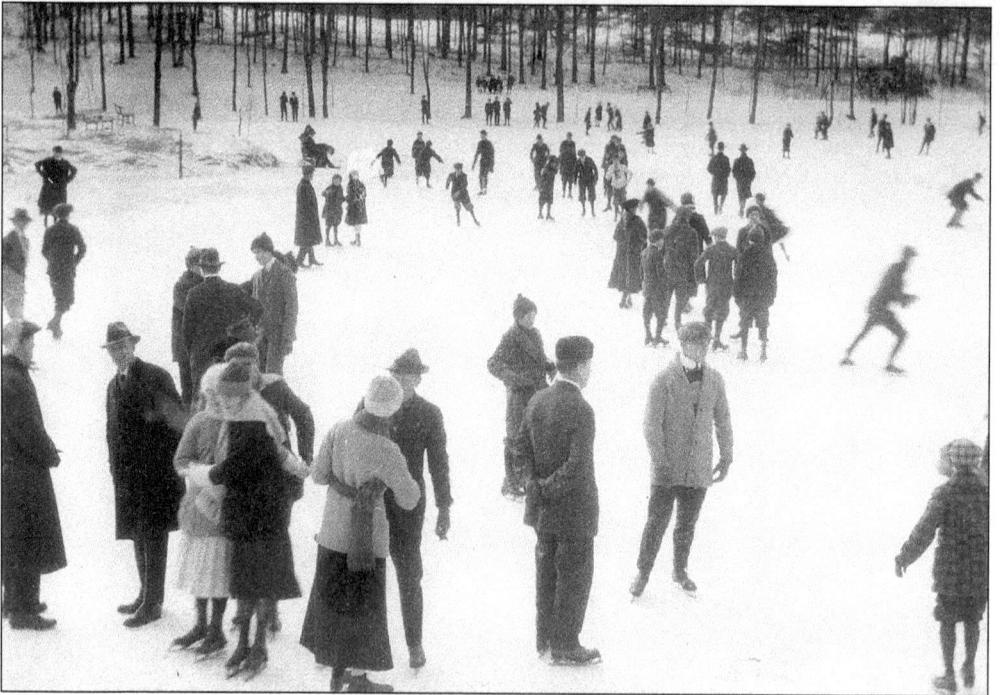

Ice-skating was also a pastime at Central Park, as shown in this photograph taken in 1922, four years after the park was completed. By then, caps and fedoras had replaced bowlers on the male skaters. This Central Park location vied with several others to be the site of the city's main park. It was an area out of town but still reachable by the trolleys' "belt lines." (Courtesy of Larry Hart.)

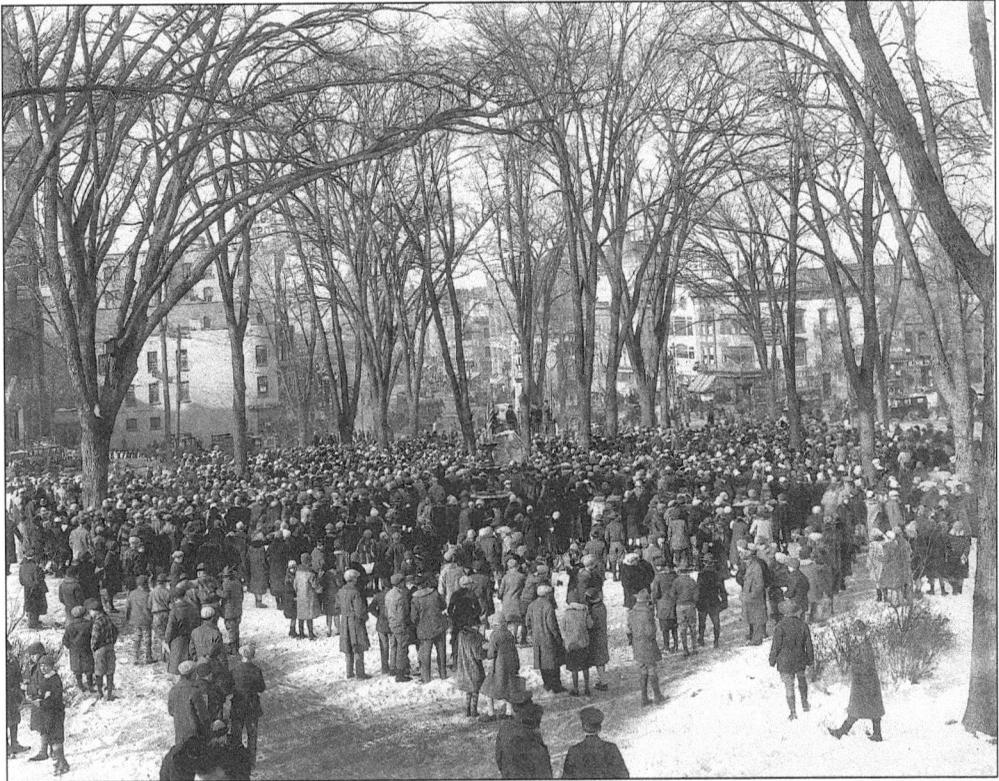

A large crowd gathers in Crescent Park for Christmas carol singing in 1926. Broadcasting of this event was sponsored by the Schenectady Chamber of Commerce. (Roland Tinning photograph/Schenectady Chamber of Commerce.)

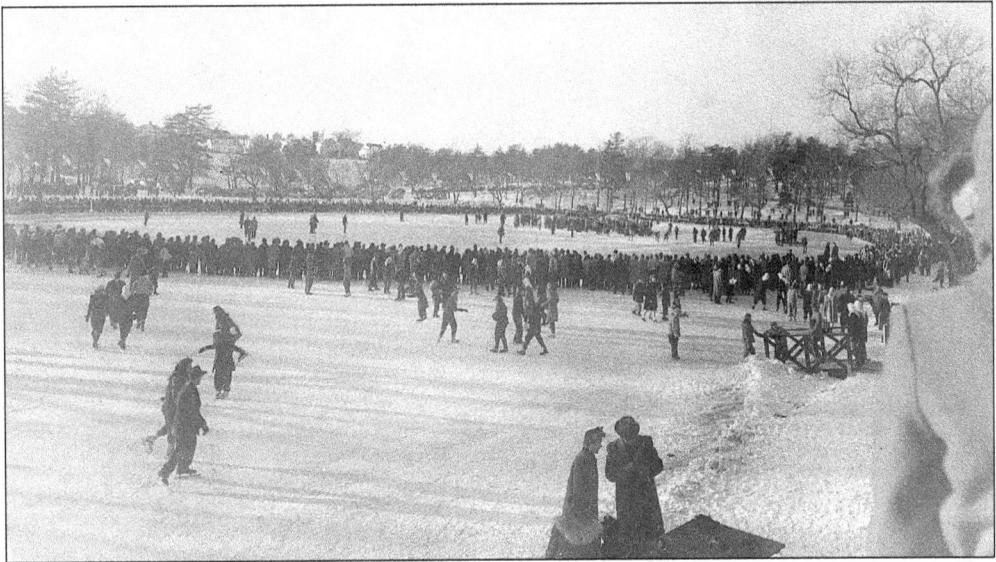

A very large crowd gathers in the 1940s in anticipation of the ice-skating races in Central Park. These races were commonplace in the 1930s and 1940s. (Efner History Research Center.)

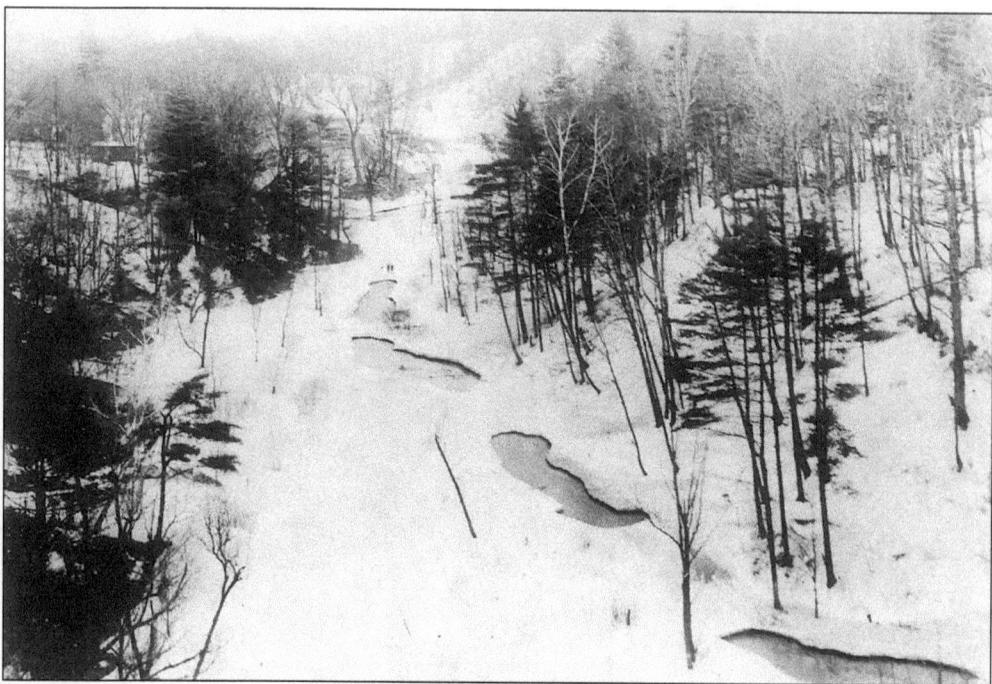

This early view of Pleasant Valley Park shows the Brandywine Mill Creek frozen in winter. Veeder Pond was removed in 1910 and the creek was later buried in an underground culvert. (Courtesy of Schaffer Library/Union College/Schenectady.)

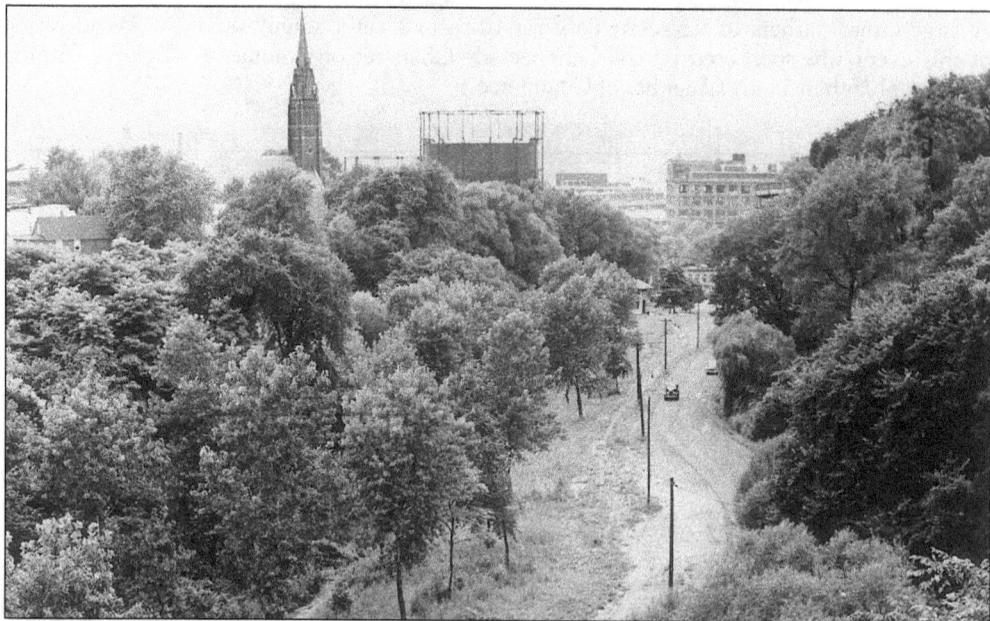

This photograph taken from the Hulett Street bridge shows cars traveling through Pleasant Valley. The area's irreversible transition from peaceful parkland to noisy thoroughfare has begun. The route became Interstate 890 in 1959. Visible in the distance are the steeple of St. Adalbert's Church and the storage tank for the Schenectady Gas Works. (Efner History Research Center.)

112

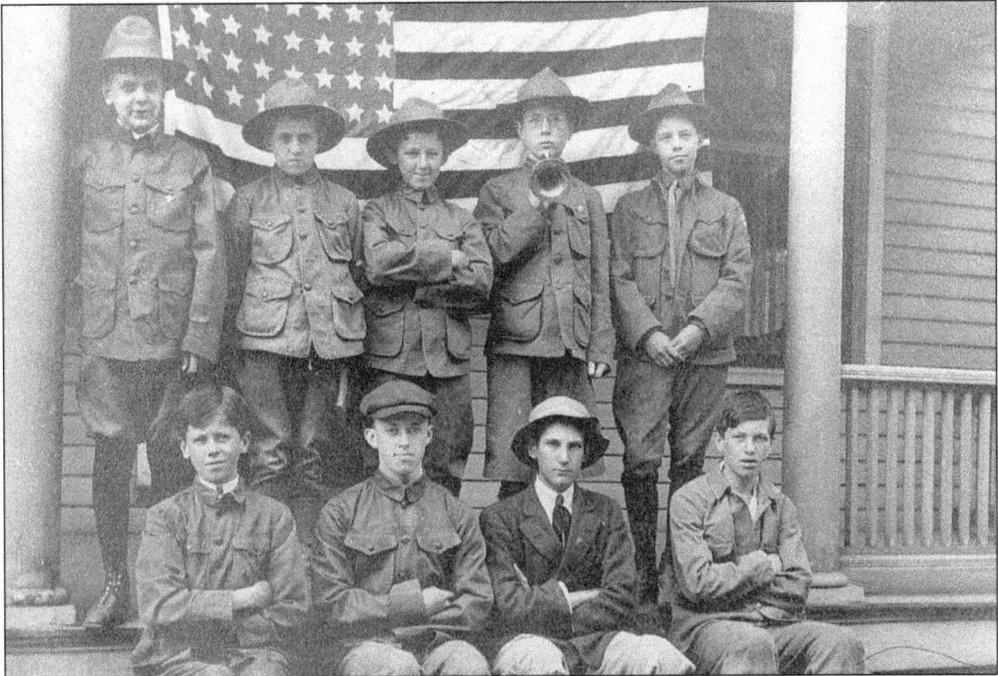

This 1913 photograph shows an early Boy Scout group. The Schenectady Council was officially formed in 1916. By 1917, there were 12 troops. Scouting and other organizations were well supported. They provided entertainment and a way to interact. The joys of solitary staring at a computer monitor or TV screen were still many years away. (Courtesy of Scott Haefner.)

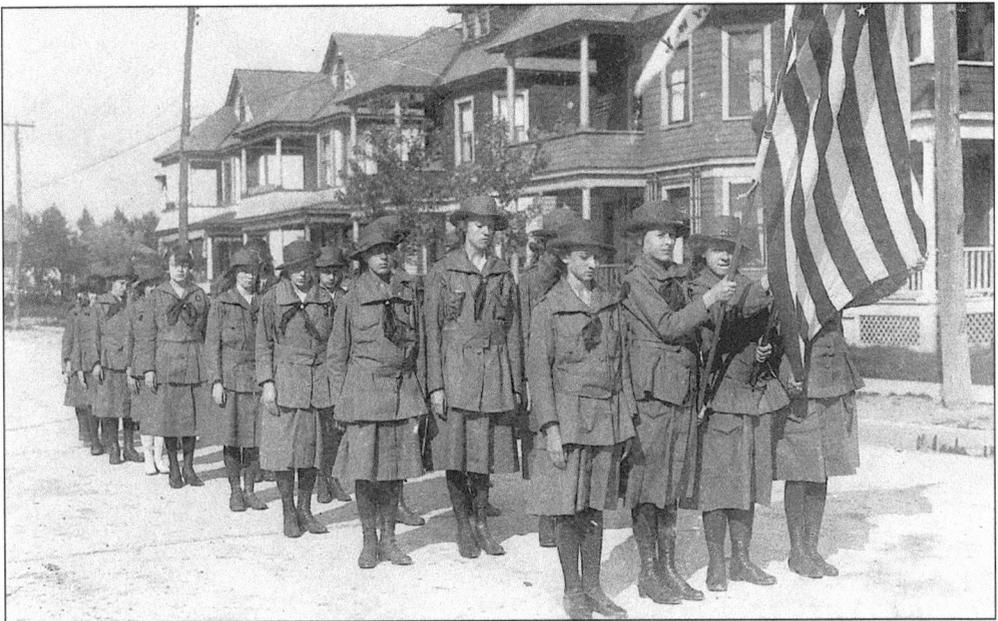

A troop of Girl Scouts waits to step off in the parade. During World War I, girls wanted to contribute something to the war effort; as a result, early Girl Scouting was modeled on the military. The first troop met at Howe School in March 1918 and was chartered four months later. (Courtesy of the Schenectady Historical Society.)

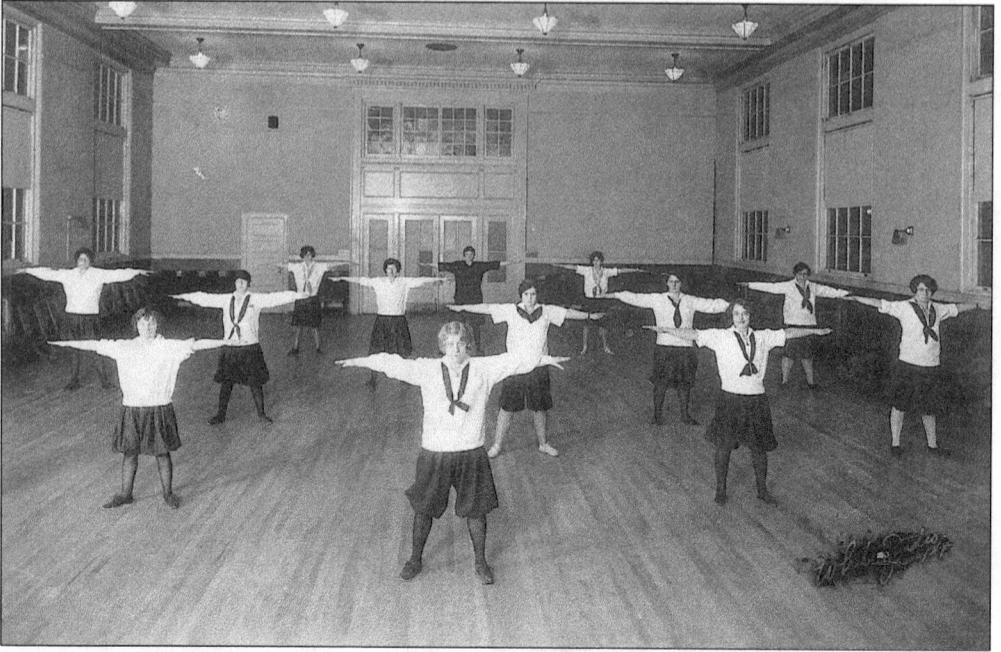

Here are a few of the 2,165 members of the YWCA in their gymnastics class at Edison Club Hall. This photograph appeared in a 1928 prospectus for a capital campaign to build a new YWCA for "Schenectady and her girls" at a cost of $500,000. Today's members can take tai chi, aerobics, step aerobics, and swimming. (White Studio photograph/Courtesy of the Schenectady YWCA.)

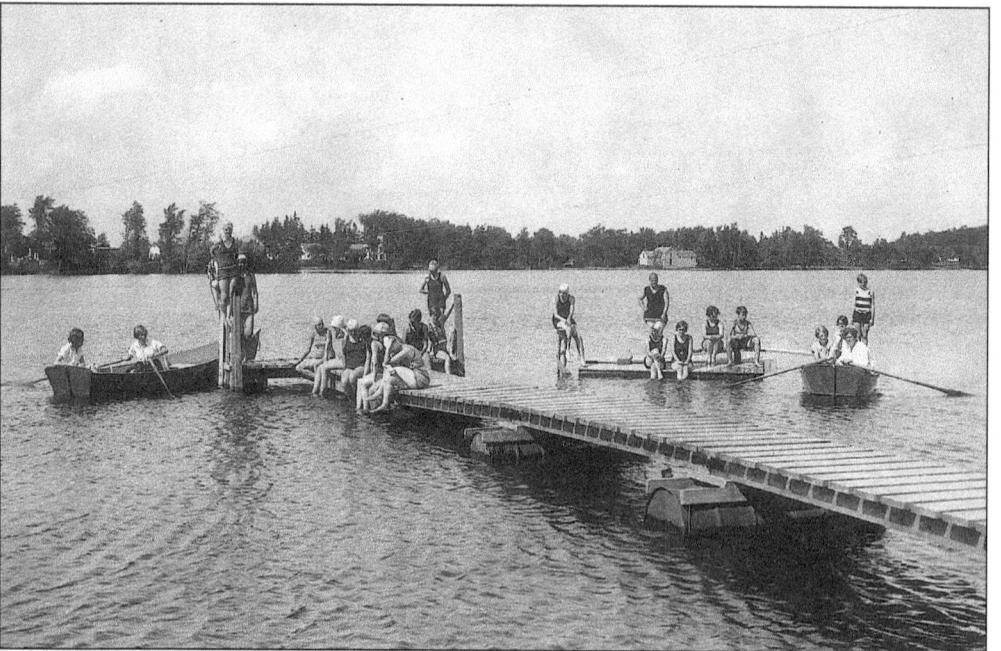

Young women enjoy the waters of Mariaville Lake at the YWCA Camp Inglenook. This is "where girls can enjoy the swimming and outdoor recreation program for strength in mind and body." (Courtesy of the Schenectady YWCA.)

114

This YMCA building, built in 1873, stood on the site of the present-day Spencer Business Institute. On January 9, a young man could bring his mother to dinner for only 25¢. The present YMCA, which opened in 1927, was built during the lower State Street building boom of the 1920s. (Courtesy of Scott Haefner.)

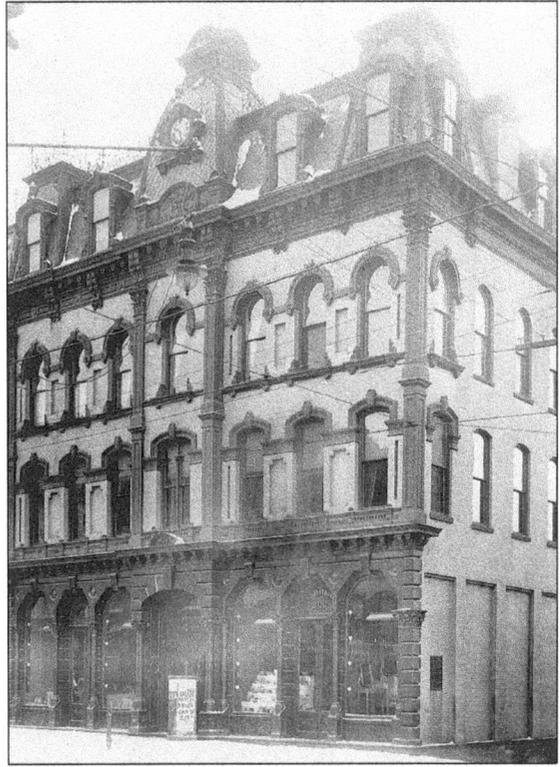

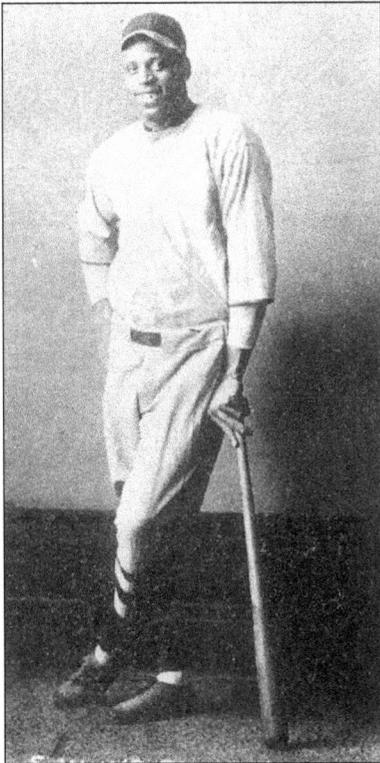

Buck Ewing, the popular catcher, played for the Schenectady's Mohawk Giants from 1923 to 1929. He was managed by Hank Bozzi, who was a barber in Schenectady for 60 years. Ewing was traded by Schenectady but later contacted his former team and was rehired as its manager. Ewing died in 1979 and a plaque was dedicated in his memory at Schenectady's Central Park ball field. The plaque reads, in part, "William H. 'Buck' Ewing, Schenectady's Own Hall of Famer." (Courtesy of Larry Hart.)

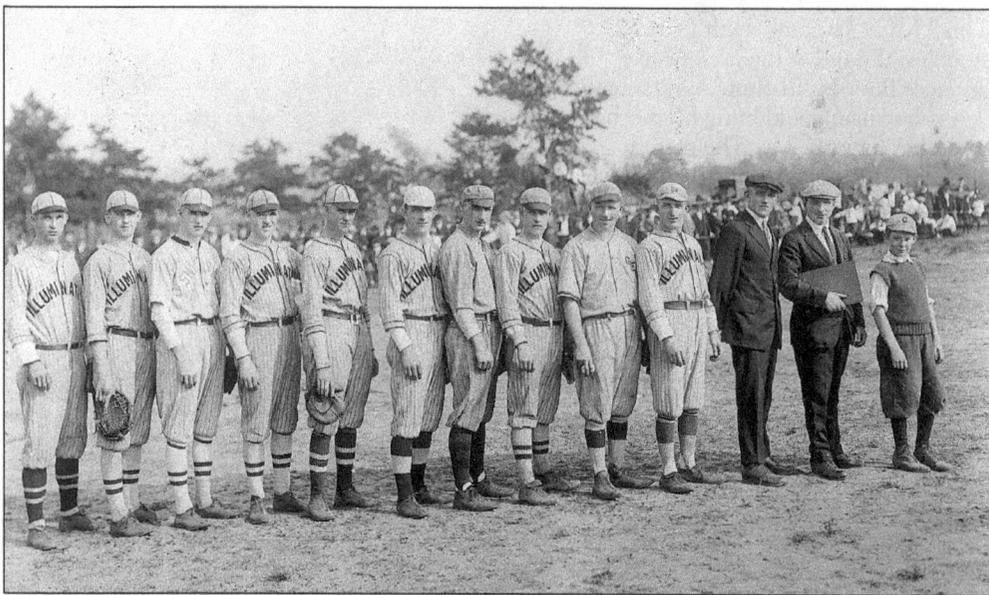

Here are members of General Electric's Illuminators baseball team of 1919, with coaches and batboy. Paul Slanksker is on the far left; George Conklin is sixth from the left; and Joe Apple is seventh from the left. Their home rivals were the Schenectady Merchants. (C.L. Burch photograph/Efner History Research Center.)

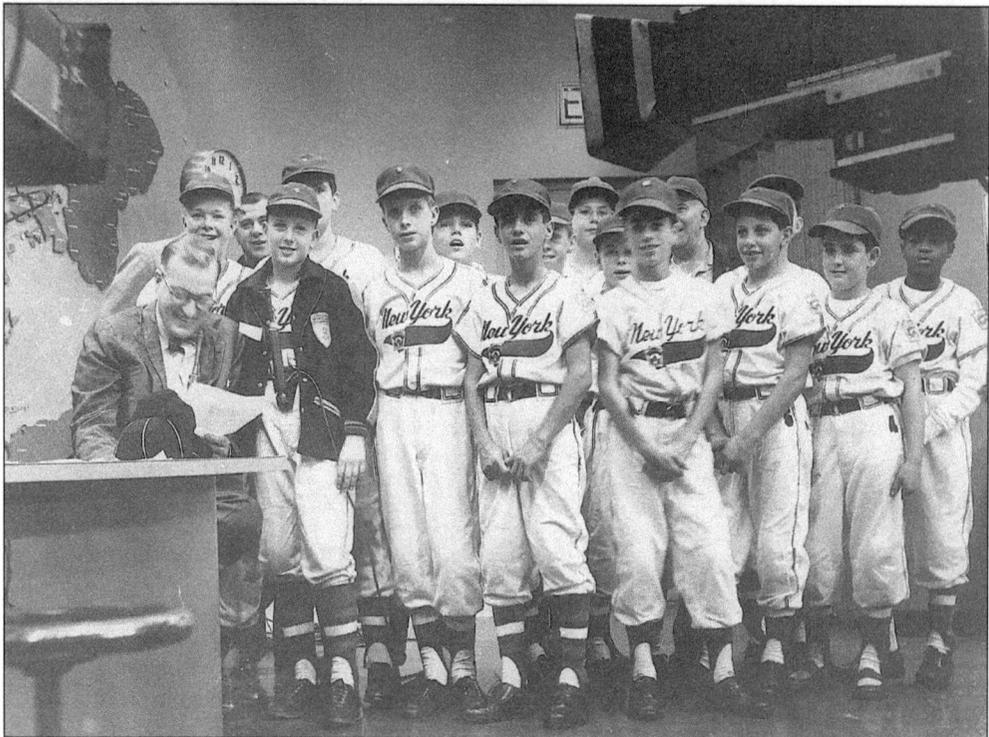

In October 1954, the Schenectady Little League champions appeared with Dave Garroway, a native of Schenectady, on the *Today Show* in New York City. The team won the World Series that year. (Courtesy of Larry Hart.)

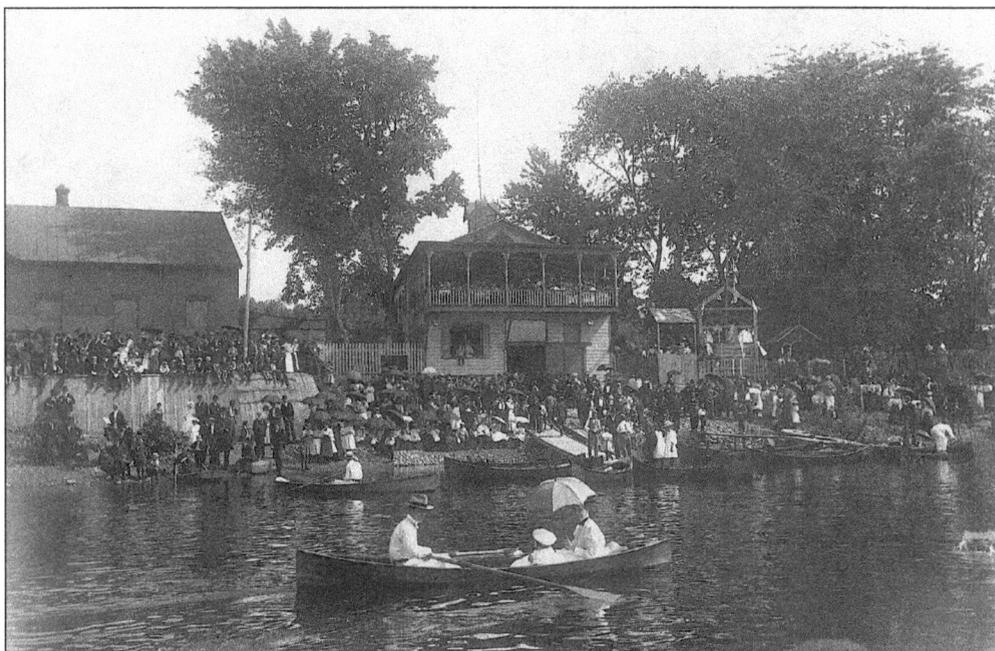

Since the time Arendt Van Curler and the other patentees bought land along the river from the Mohawks in 1660, Schenectady has had close ties to the Mohawk River. In the earliest days, the tie was commerce and later it was recreation. In this c. 1895 Steinmetz-Berg negative, throngs of people have turned out for Regatta Day on the Mohawk. The Yates Boathouse, in the rear, had a boat livery below and a dance floor above. (Efner History Research Center.)

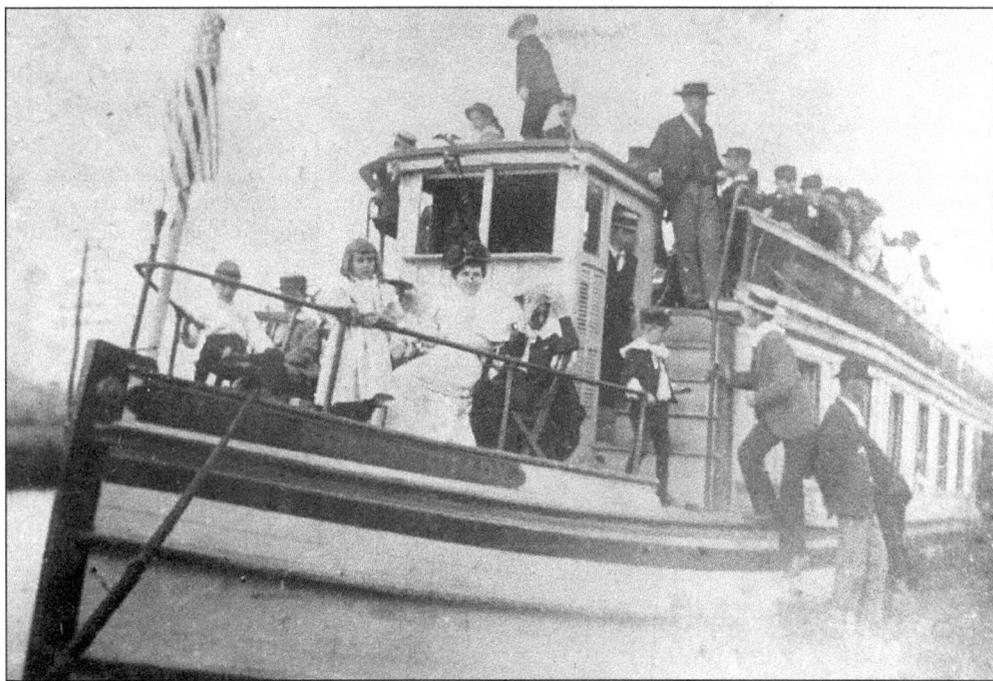

One of the local treats was a day's outing on the *City of Schenectady West* canal steamer. (Spoondogle Collection/Efner History Research Center.)

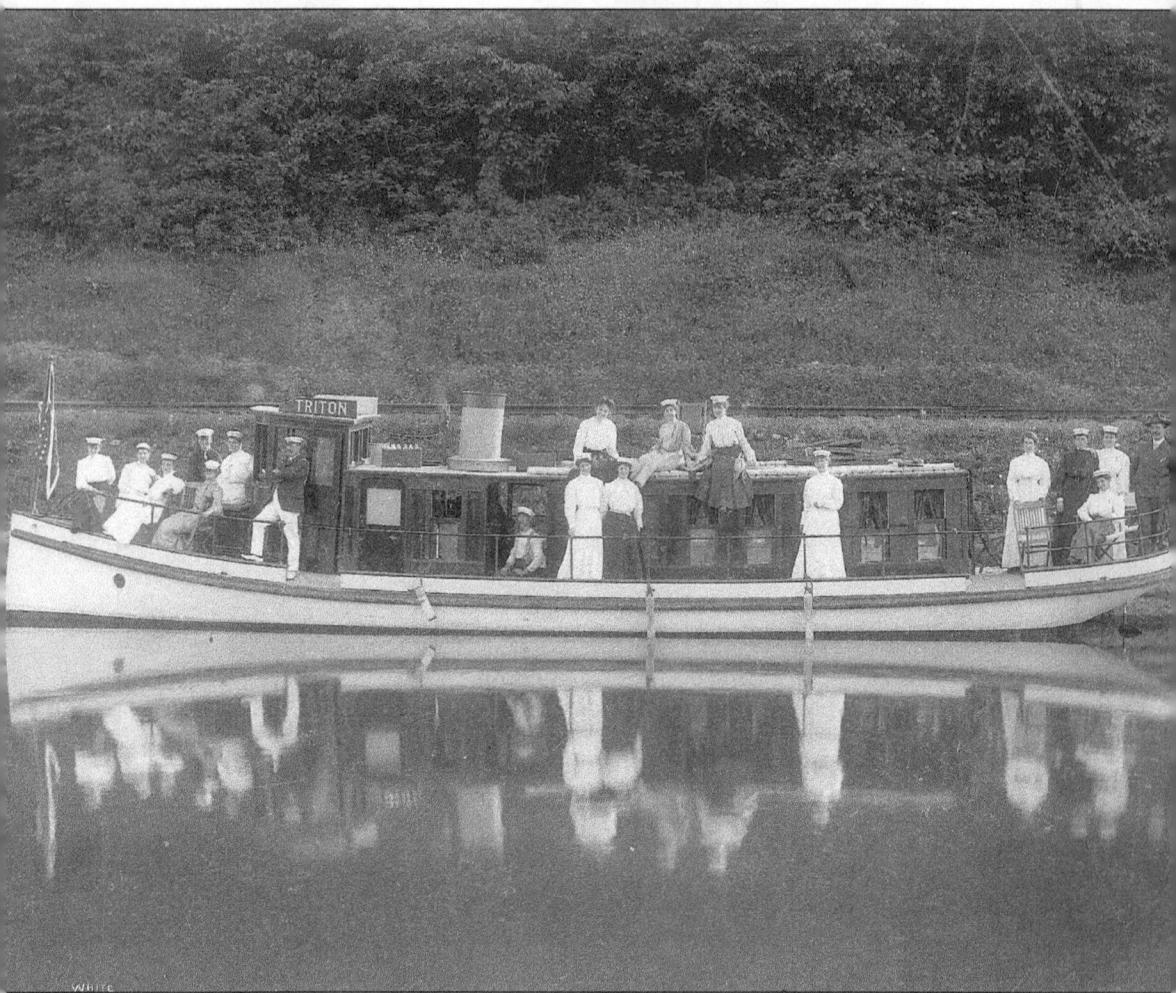

Ladies in boating costume take to the waters for a *Triton* outing on the Mohawk River. At this time, there were many business-owned steamers on the waters. Note the railroad tracks in the rear. (White Studio photograph/Efner History Research Center.)

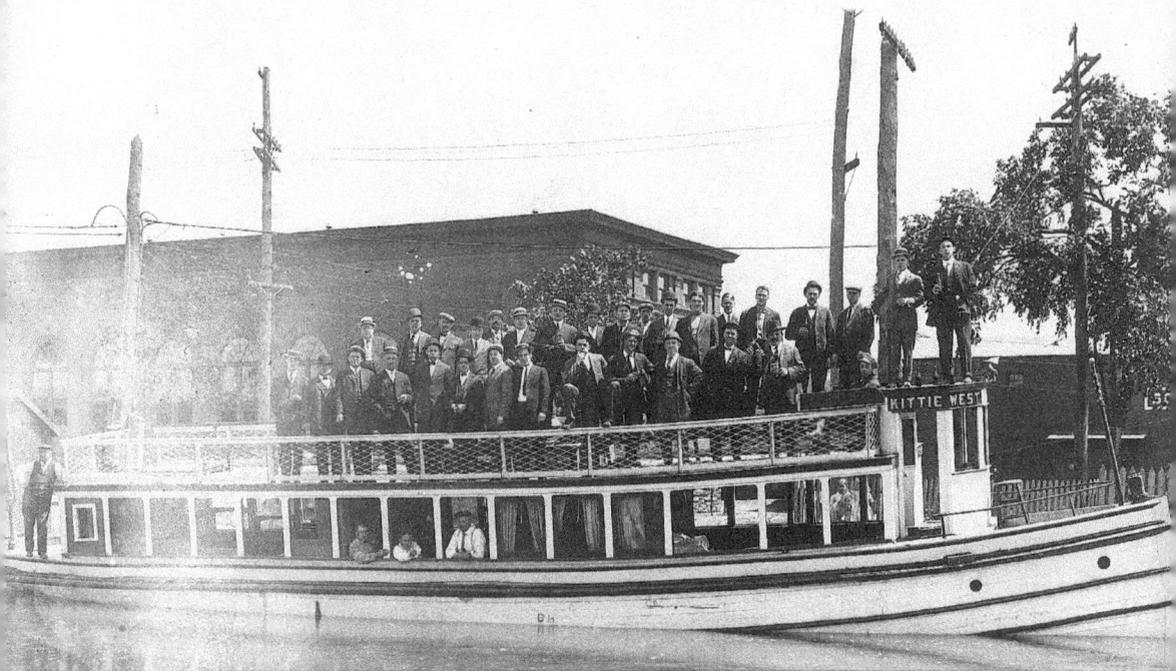

A group of men in hats hold cigars and beverages at a party on the *Kittie West* at Dock Street on the Erie Canal. The crew poses below, and three young girls peek through the lower right front window. This tour boat was used frequently for General Electric Company outings. The building in the background is the power station for the Schenectady Railway Company. (Efner History Research Center.)

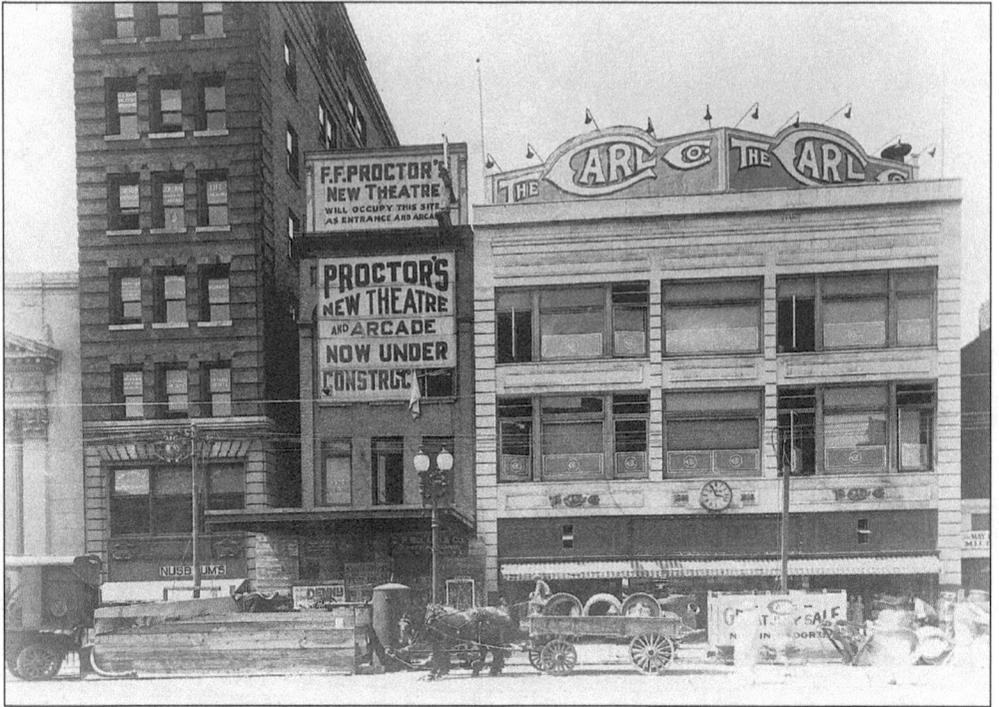

This photograph shows the construction site of Proctor's Theater and Arcade in July 1926. To the left is Nusbaum's Clothing Store, located in the Parker Building. To the right is one of Schenectady's three large department stores, the Carl Company. (Courtesy of Proctor's Theater.)

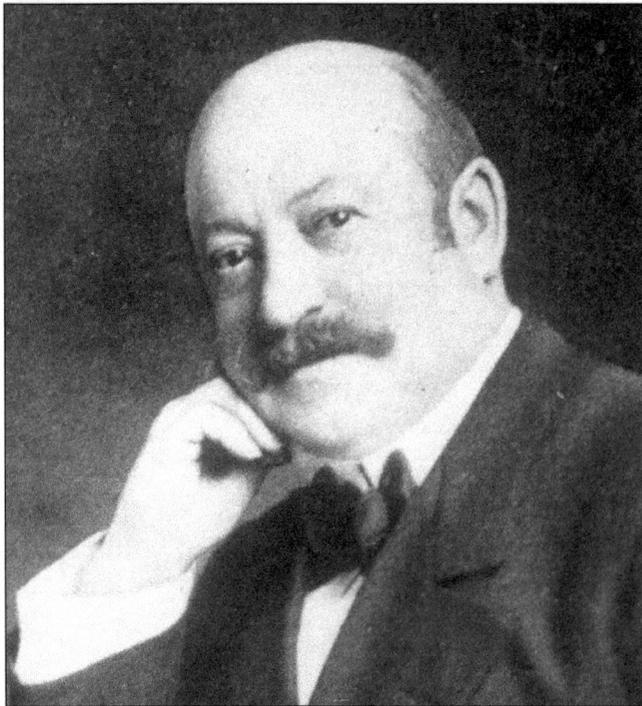

F.F. Proctor left the world of performing to build quality theaters for vaudeville. His first theater in Schenectady was built in 1912 off the Erie Canal. His new palace of vaudeville opened on Christmas Day of 1926. (Courtesy of Proctor's Theater.)

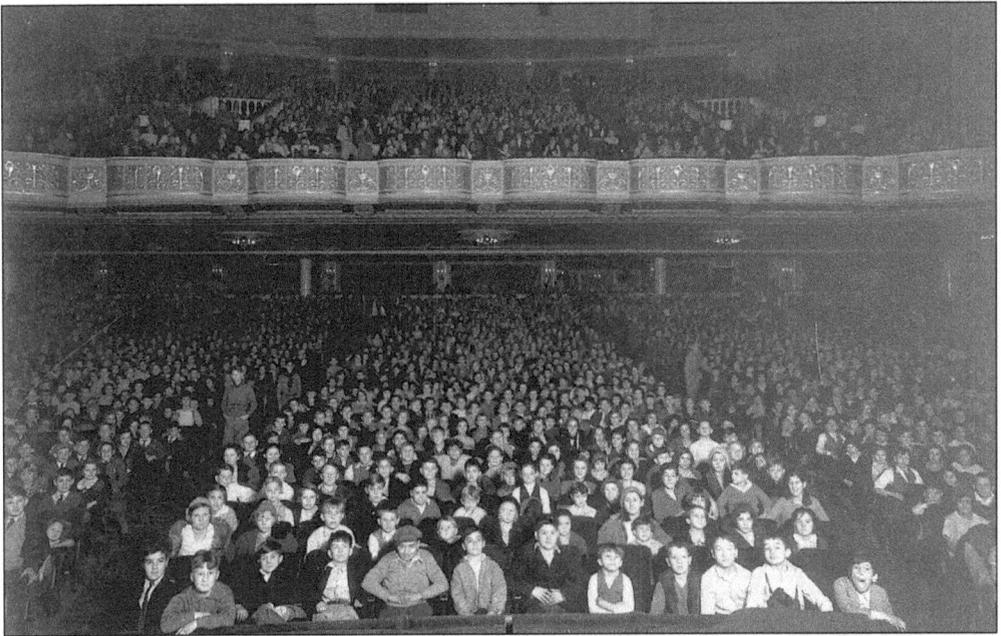

Proctor's Theater has a full house for the Saturday matinee, and not an adult is in sight. Saturday afternoon at the movies often included a double feature, cartoons, coming attractions, and perhaps a serial. The parents must have appreciated the free time. (White Studio photograph/Courtesy of Proctor's Theater.)

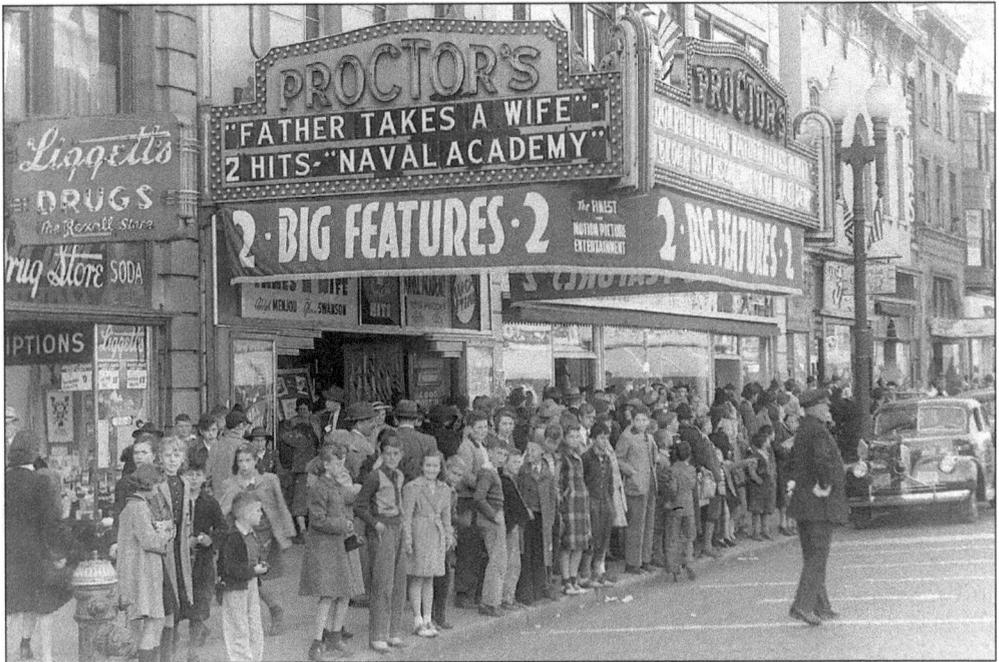

After the show, children wait outside Proctor's to cross State Street in the 1940s. Proctor's was one of the big three theaters, along with the State and the Plaza. Over the years, Schenectady had many other theaters, including the Strand, Orpheum, Palace, Barcli, Van Curler, Empire, Crescent, Art, Star, Park, and Wedgeway. (Efner History Research Center.)

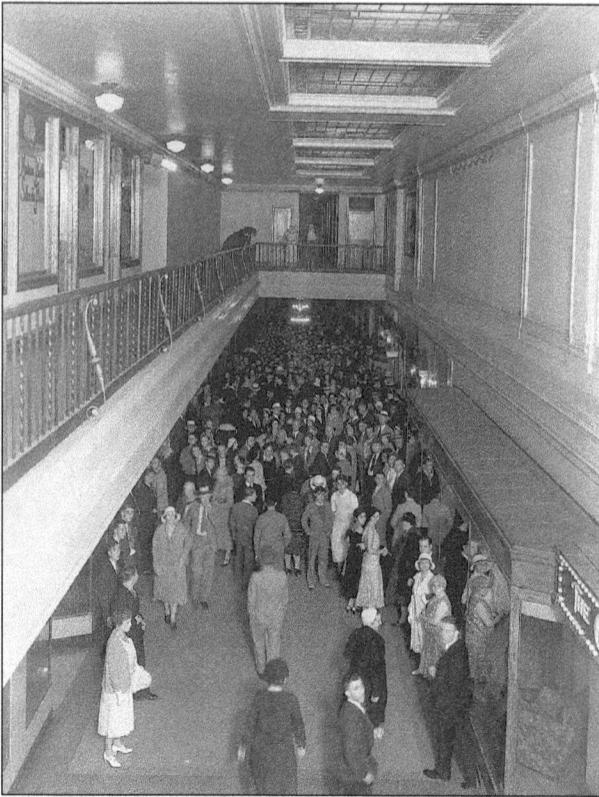

Men in straw hats and boys in white linen knickers are among the people waiting in Proctor's lobby for a show on this summer day in the 1930s. (White Studio photograph/Courtesy of Proctor's Theater.)

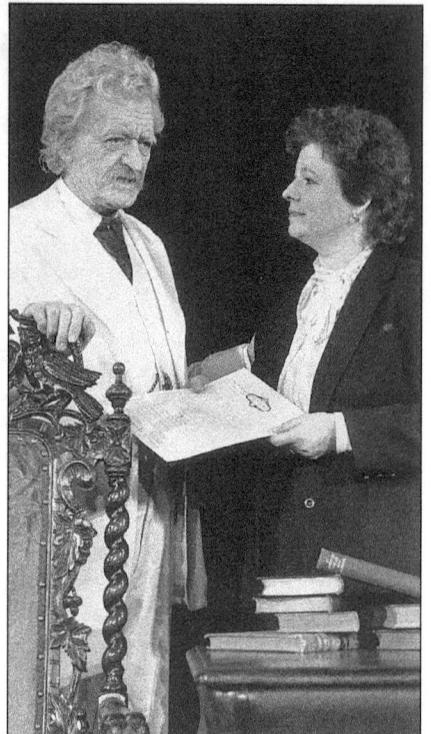

Only Proctor's remains, thanks to the efforts of the Arts Centre and Theatre of Schenectady and many supporters who saved the theater from demolition in 1979. Here, Mayor Karen Johnson acknowledges the important role played by actor Hal Holbrook, dressed as Mark Twain. Holbrook, considered by many to be Proctor's patron saint, was awarded the city's highest honor of Schenectady Patroon in 1984. (Schenectady Gazette photograph/Courtesy of Proctor's Theater.)

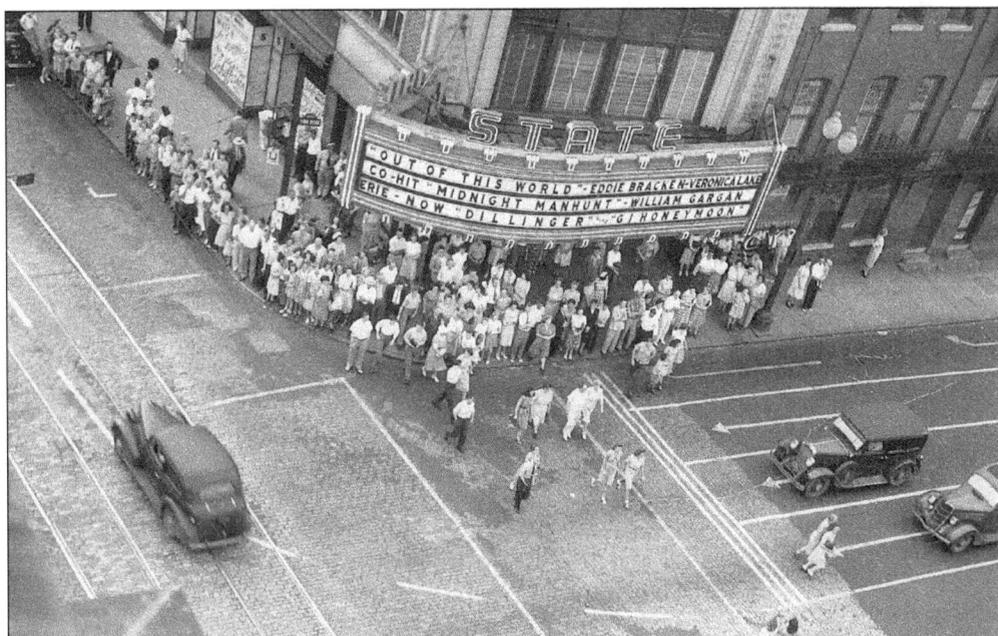

The State Theater on the corner of State and Erie Streets showed first run movies that attracted throngs of people in the days before television. (Efner History Research Center.)

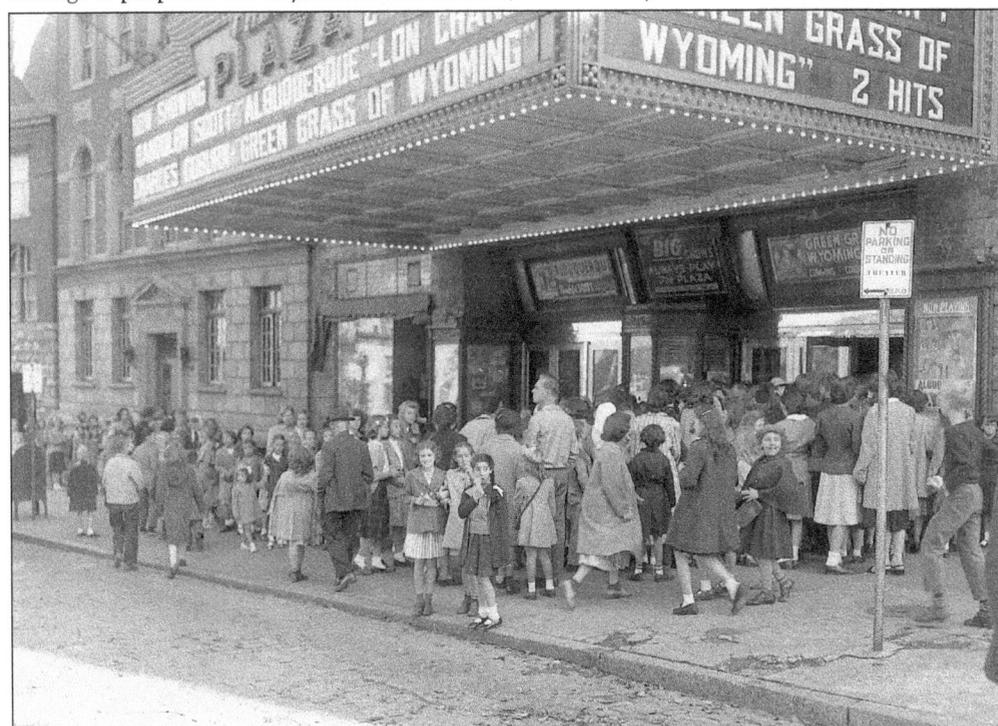

The Plaza Theater opened on August 26, 1931, and was demolished in 1964. It was located on the hill across from Veterans Park and the county courthouse. The theater had moving clouds and twinkling stars on the ceiling and Grecian gardens on the sidewalls. This photograph dates from 1948. (Larry Hart photograph/Courtesy of Larry Hart.)

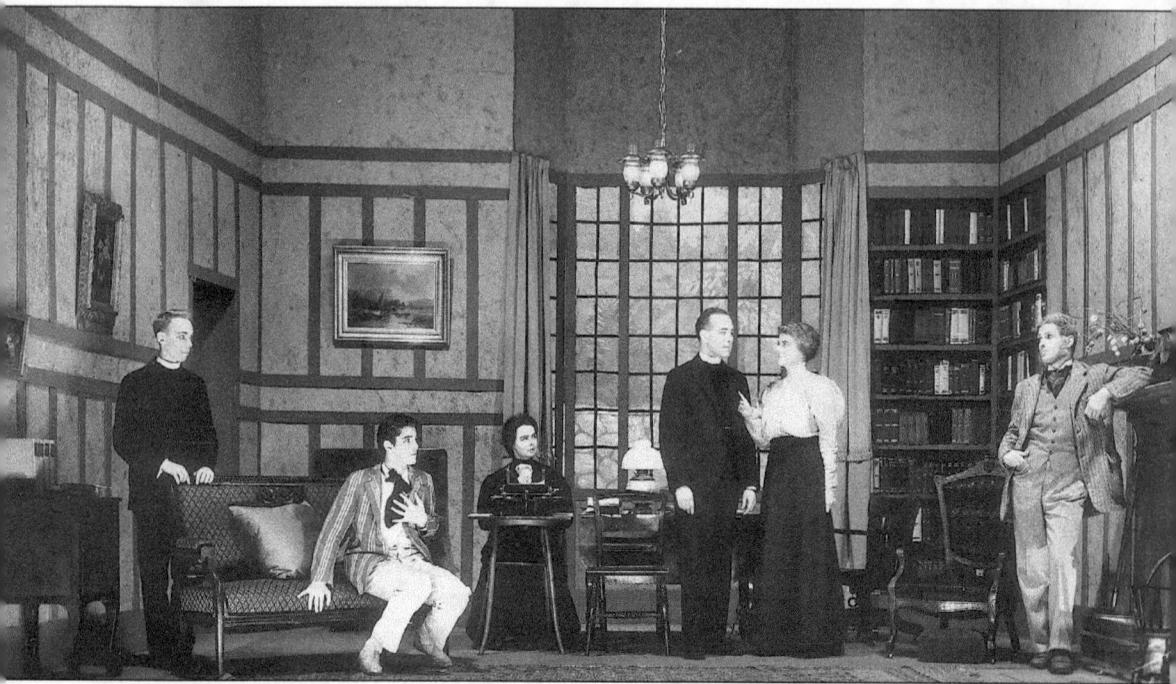

The Schenectady Civic Players, a group of amateur theater enthusiasts, was organized in 1929. Since that time the group has been in continuous operation, performing dramas, comedies, and musicals at 12 South Church Street, the former Masonic Temple. This 1931 photograph shows the cast of *Candida*, from left to right, Cyril Dixon, Nigel Altman, Dr. Katherine Blodgett, W.H. Norris Jr., Mrs. Scott Bulton, and Jeremy Bagster-Collins. (White Studio photograph/Courtesy of Schenectady Civic Players.)

Schenectady has always had a number of hotels to house visitors to local industries. In this early spring photograph, the tower of the Edison Hotel rises behind the railroad bridge. The Givens Hotel was on this site until 1889, when it was razed to make way for the new Edison Hotel, which opened in 1890. (Schenectady Chamber of Commerce.)

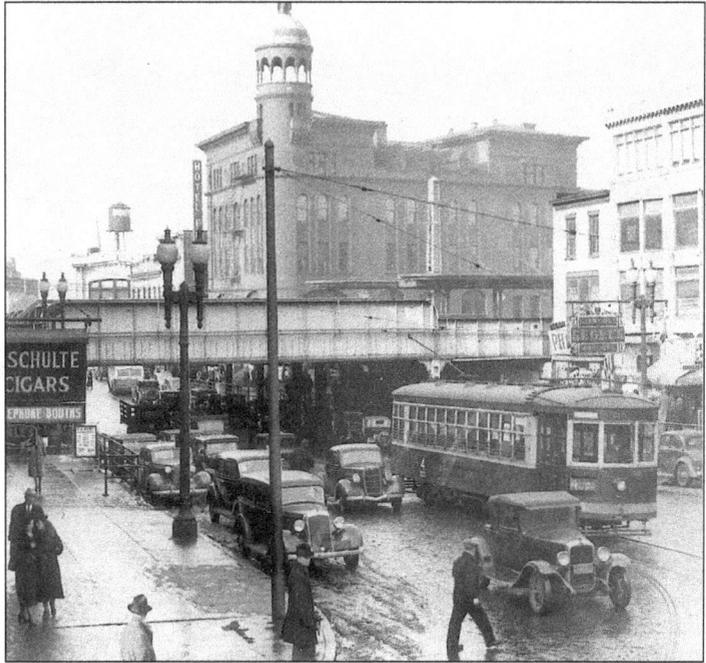

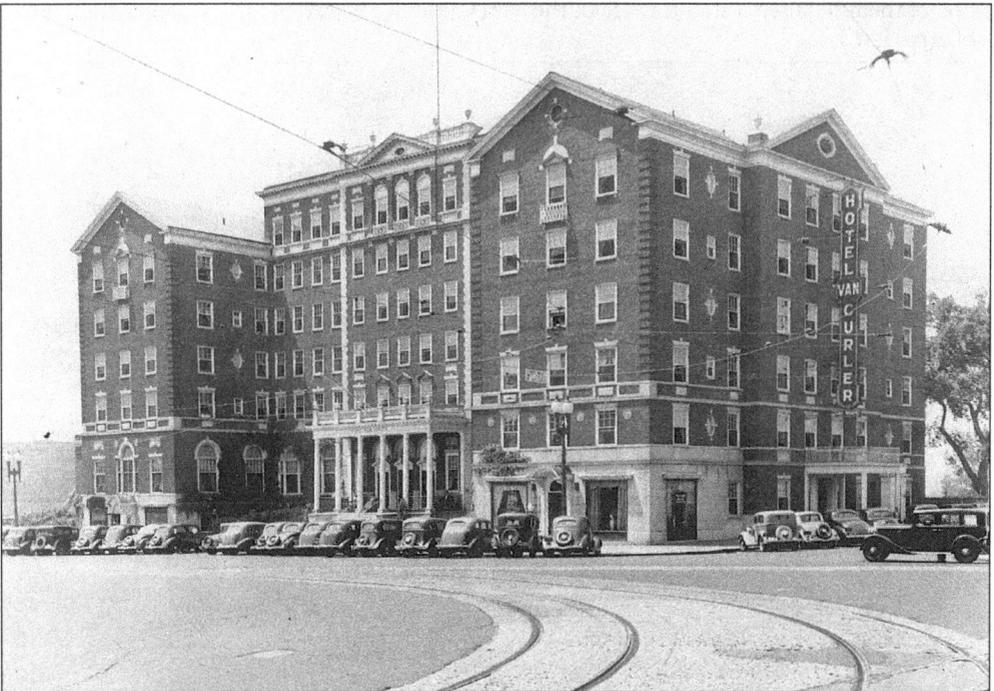

The Van Curler Hotel was completed in 1925. Although there were a number of hotels in the city, General Electric needed first-class accommodations for its visitors. Two U.S. presidents, Richard Nixon and Ronald Reagan, stayed here. The Van Curler was designed by H.L. Stevens & Co. of New York and Chicago. It was billed as modern, fireproof, and first-class. On June 10, 1968, the county purchased the hotel for a community college and renamed it Elston Hall. (John Papp Collection/Efner History Research Center.)

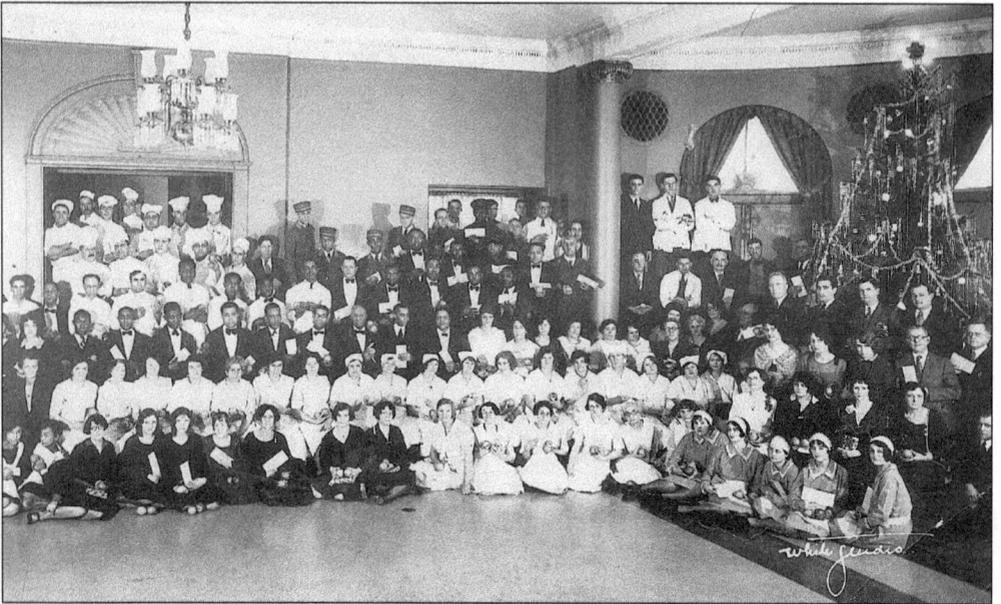

Employees of the Van Curler Hotel celebrate at the 1925 staff Christmas party in the hotel ballroom. Schenectady had a number of other hotels, such as the Givens and the Vendome, but none of them required a staff the size of the Van Curler's. (White Studio photograph/Courtesy of Larry Hart.)

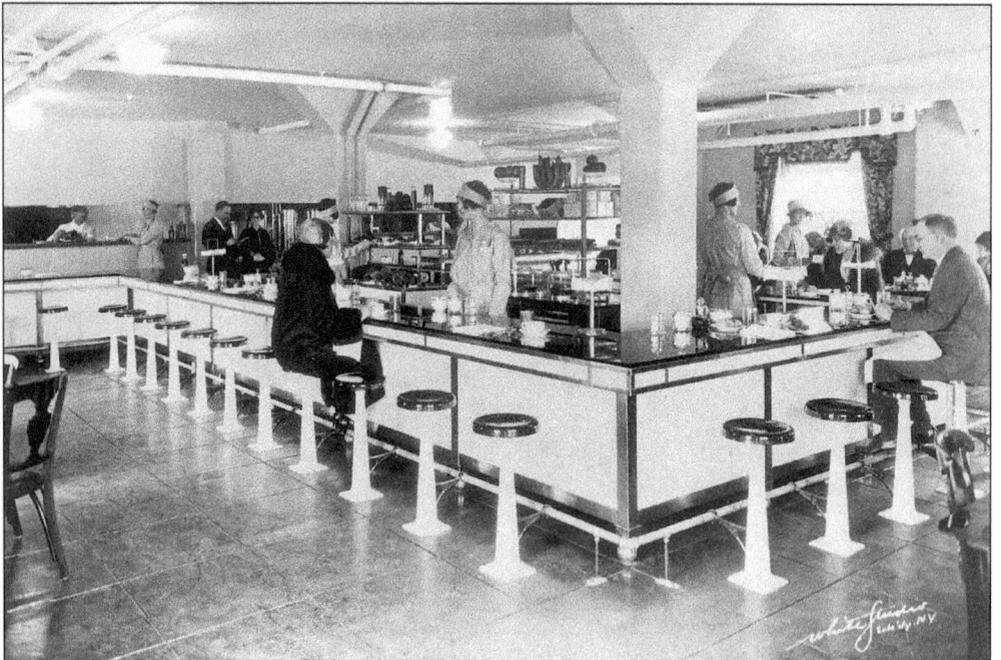

This photograph shows the Van Curler Hotel coffee shop on the ground floor c. 1926. The space is now occupied by the Schenectady County Community College bookstore. The hotel also had a grand ballroom, a terrace porch for tea, conference rooms, a taproom, a lounge, and a dining room. (White Studio photograph/Courtesy of Schenectady County Community College.)

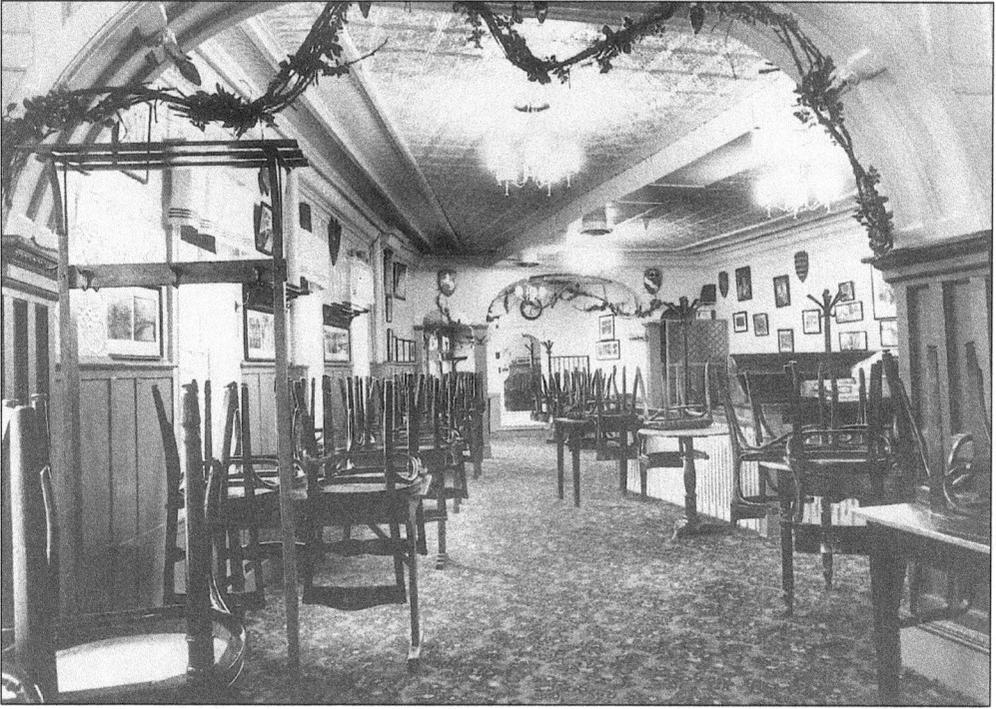

Louis and Sophie Nicholaus purchased the old Stroebel saloon in 1895 and renamed it Nicholaus Hotel and Restaurant. The building's location beside the State Street canal bridge brought it much business over the years from the boats docked there in summer and the people skating by in the winter. The present-day building was erected in 1901. (Efner History Research Center.)

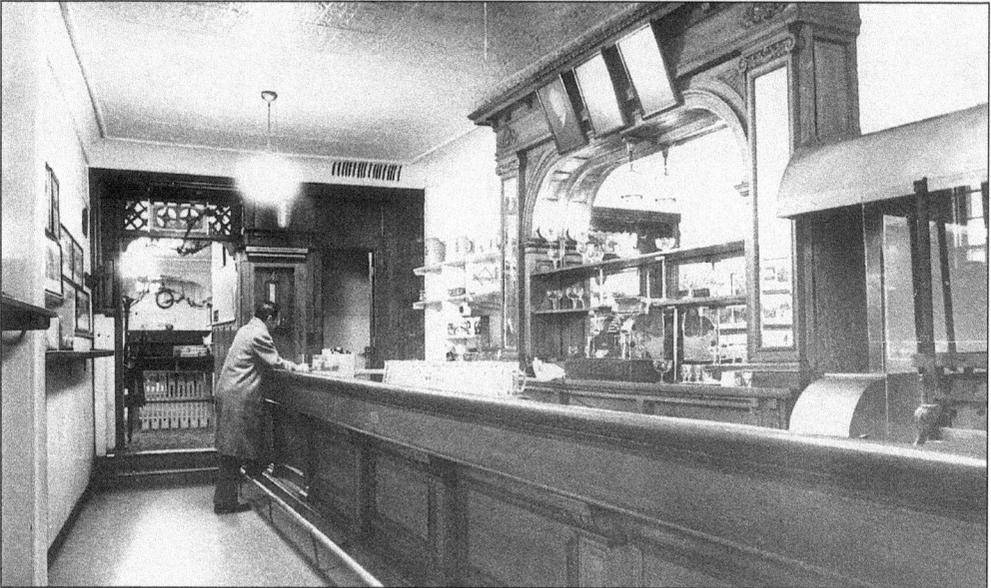

This interior photograph was taken in December 1975 when the Nicholaus Restaurant closed. Not long afterward it reopened as Maurice's Redi-Foods. The gentleman posing in the men's bar is Larry Hart, Schenectady county historian. (Efner History Research Center.)

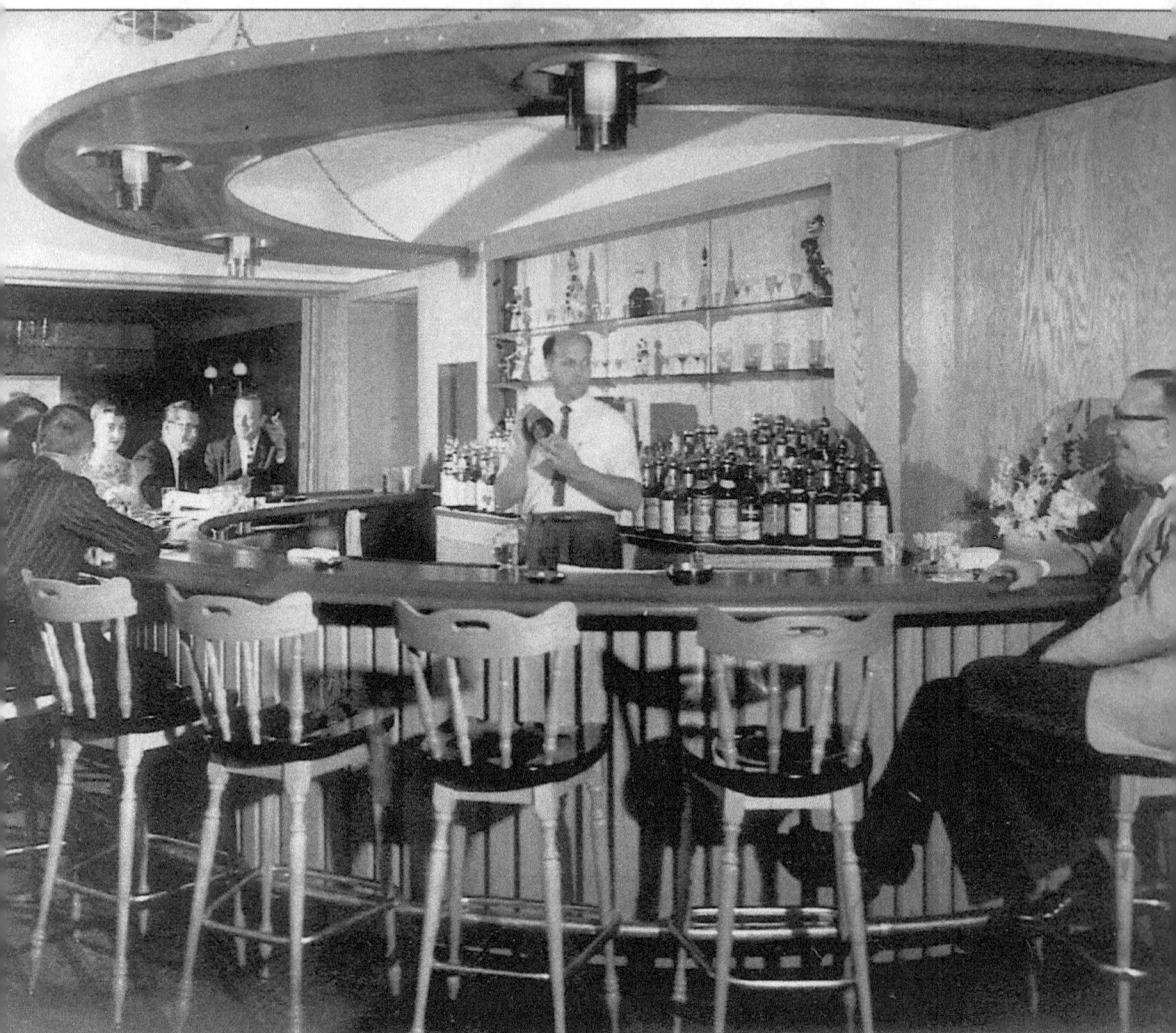

Here is the original Van Dyck Bar in the late 1950s. For many years it was owned and operated by Marvin Friedman, who did much to sponsor the arts in Schenectady. Then, as now, the bar offered a venue for the best in jazz entertainment. When the restaurant was redone in 1997, the bar was moved to the second floor and a micro brewery was added to the rear of the building. (Courtesy Van Dyck Restaurant.)

www.ingramcontent.com/pod-product-compliance
Lightning Source LLC
Chambersburg PA
CBHW050924150426
42812CB00051B/2188